African Safari Photography

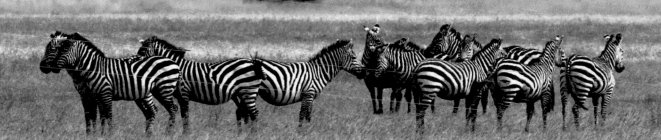

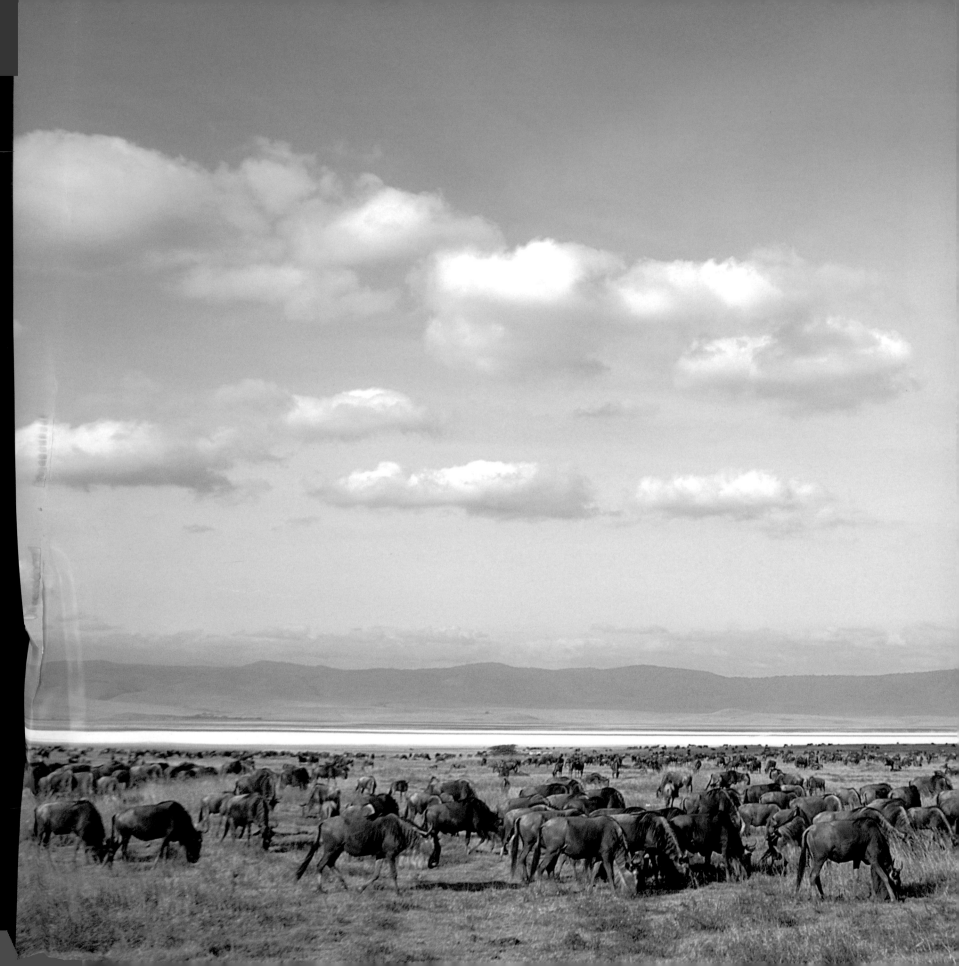

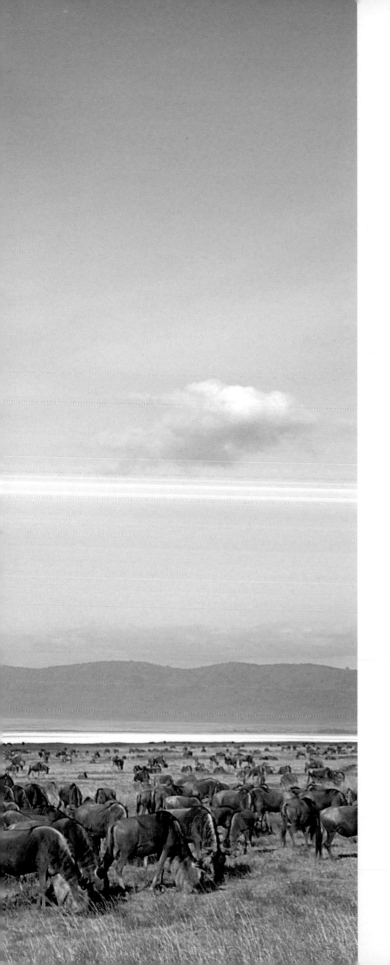

African Safari Photography

Chris Weston

photographers'
pip
institute press

First published 2006 by
Photographers' Institute Press / PIP
an imprint of the Guild of Master Craftsman Publications Ltd
Castle Place, 166 High Street,
Lewes, East Sussex BN7 1XU

ISBN 1 86108 442 0

A catalogue record for this book is available from the British Library.

Managing Editor: Gerrie Purcell
Production Manager: Hilary MacCallum
Photography Books Editor: James Beattie
Managing Art Editor: Gilda Pacitti
Designer: Chris Halls, www.mindseyedesign.co.uk
Illustrator: Martin Darlison, Encompass Graphics

Set in Frutiger

Colour origination by Wyndeham Graphics
Printed in China by Hing Yip Printing Co. Ltd.

Acknowledgements

I would like to thank all those that made this book possible, not least the animals. Also my friends and colleagues throughout Africa, in particular, Stuart, Justyna, John, Ann, Riaan, Israel, West and Julius. As well as those photographers around the world who continue to inspire me, I would like to thank Vera Cheal and The Africa Guide, for their information on countries, and the scientists and conservationists who helped me research various species.

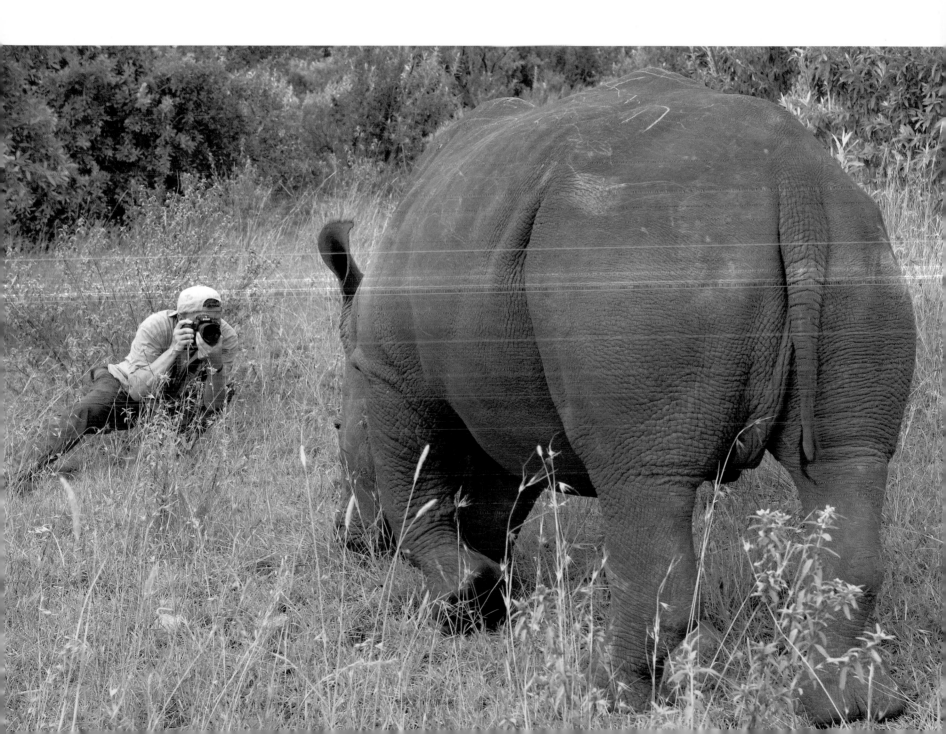

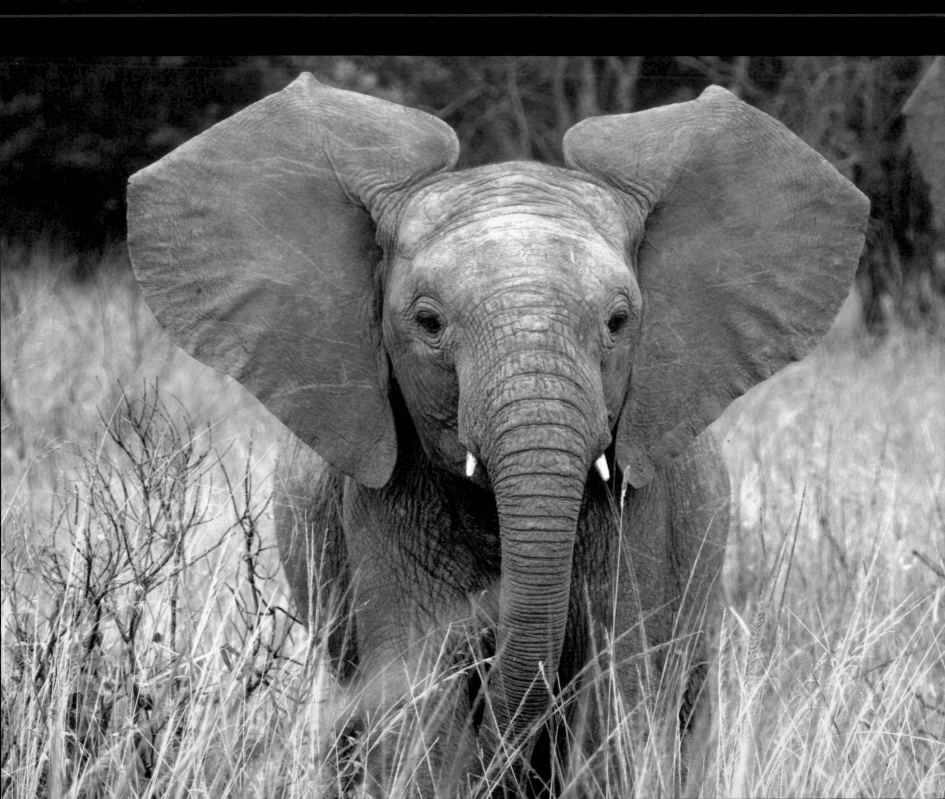

Part I *Ng-oa safari Afrika* – Journey through Africa

Part II *Hifadyiwa* – National Parks and Wildlife Reserves

Part III *Hayawani* – Wildlife

Part IV *Sanii* – Photographic Techniques

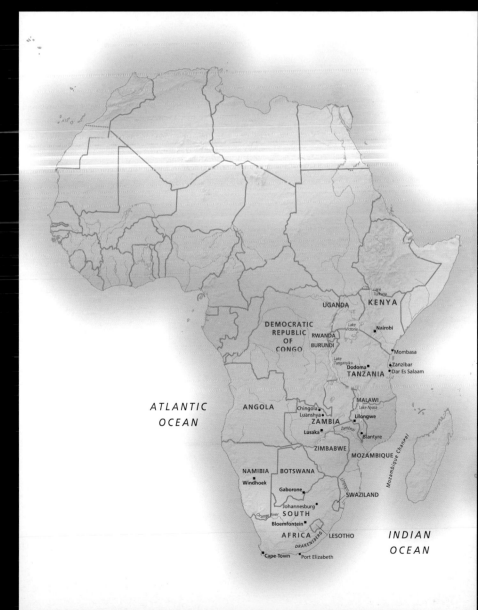

Africa today is the apex of more than 100 million years of climatic, geological and biological evolution brought about when a large lump of rock emerged from the ancient super-continent Gondwana. As the splinters of rock that were to become South America, Australia, India, the Middle East, South-East Asia and Antarctica were scattered across the oceans of the southern hemisphere, Africa drifted northwards in isolation before crashing into Eurasia around 30 million years ago.

Many of the species unique to Africa were able to develop over those millions of years, undisturbed on a continent that contains a quarter of the world's total landmass. The calm shifts in climate, dampened by the warm Equator, encouraged change and resisted catastrophe. In the multitude of disparate habitats life claimed a foothold from which it would go on to flourish.

▷ *Due to the distribution of wildlife throughout Africa this book concentrates on those countries that are associated with safaris, generally in the south and east of the continent.*

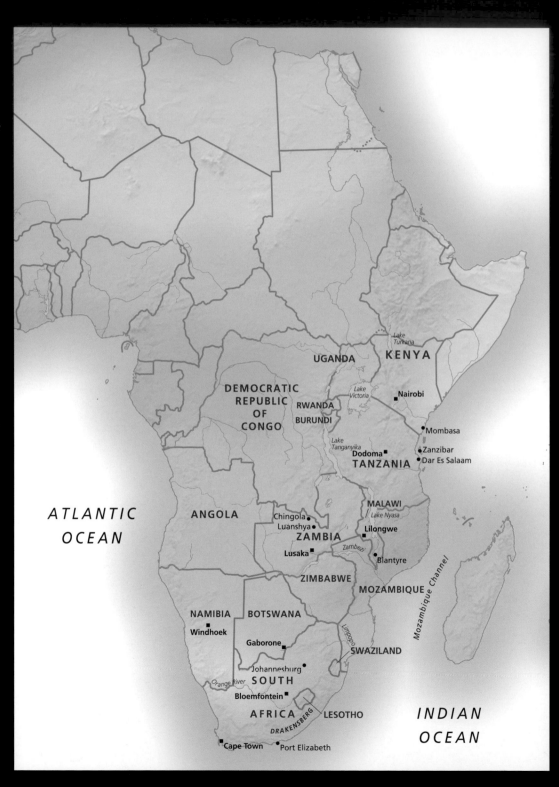

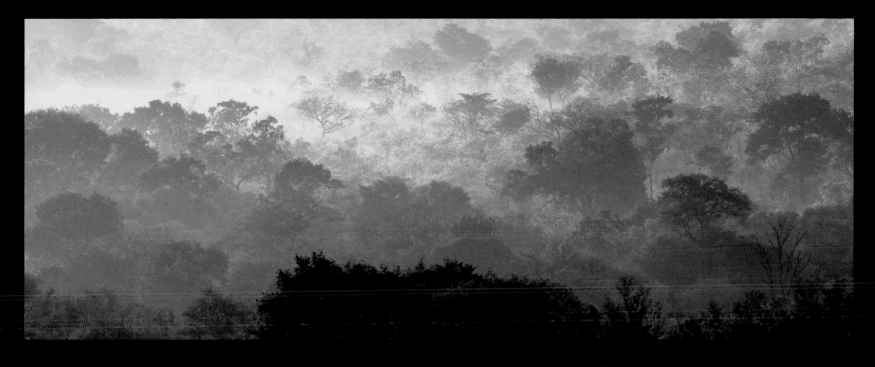

▲ *Africa today has many distinct environments, from coastal margins to dense forest (as shown here). Each presents the photographer with unique challenges and opportunities.*

Today, Africa remains a land of contrasts; its flora and fauna inhabit six principal environments: the coastal margins, mountains, wetlands, deserts, forests and savannahs. Each presents its own unique physical and biological challenges to survival. Africa's coasts are a multi-faceted world of coral reefs, mangrove swamps, desert shores, forested creeks and battered cliffs. Elsewhere on the continent the land undulates between ancient mountains, young volcanoes, like the famous Kilimanjaro – the world's tallest freestanding mountain – and enormous inland lakes, deltas and floodplains that sustain some of the most prolific and colourful tapestries of life on earth. Four mighty rivers – the Nile, Congo, Zambezi and Niger – drain the continent.

In the Tropics copious amounts of sunshine and rainfall fuel lush rainforests. While these tropical oases receive ample precipitation, much of the rest of Africa thirsts for moisture and mighty deserts – including the world's largest expanse of arid land, the Sahara, and its oldest, the Namib – dominate the landscape.

Trapped between the two extremes of desert and forest Africa's newest environment has formed. Savannahs are energetic, ever-changing habitats of woodlands and short-grass plains, fed by seasonal rains and blessed with sunshine. Here we find the largest concentration of mammals on earth and, in a peculiar twist of fate, the cradle that nurtured the ancestors of the planet's most successful mammal – humankind.

Climate

Africa's location astride the Equator and its evenly balanced extensions into the northern and southern hemispheres are largely responsible for the continent's climatic zones, which, except where altitude exerts a moderating influence on temperature or precipitation, can be categorized into six distinct regions.

Regions close to the Equator and on the windward shores of south-east Madagascar have a tropical rainforest climate, with significant precipitation and high temperatures throughout the year. To the north and south of the rainforest are belts of tropical savannah, with high temperatures all year round and a seasonal distribution of rain throughout the summer.

Further into both hemispheres the savannah gives way to a region of semi-arid steppe that has limited summer rainfall, and then to the arid zones of the Sahara in the north and the Kalahari in the south. On the pole-ward sides of the main deserts, belts of semi-arid steppe with limited winter rain occur. At the northern and southern extremities of the continent narrow belts with subtropical temperatures and a concentration of rainfall, mostly during autumn and winter, have a Mediterranean climate.

Population

Continental Africa is home to over 12 per cent of the world's population. Historically, Africans distinguished themselves via a myriad of traditional monarchies, chiefdoms and other societies forming around 190 cultural groups and hundreds of diverse, independent groups with no common history, culture, language or religion. Modern Africa was born out of colonialism and many of the countries that exist today, formed by geometric lines, lines of latitude and longitude and other straight lines and arcs, were imposed on the African people by the main colonial powers of the time. In all, over 10,000 African polities were amalgamated into 40 European colonies and protectorates.

Today, the population of Africa is distributed among 54 nations, and is further distinguishable in terms of linguistic and cultural groups, which number around 1,000. The Sahara Desert forms a major ethnic divide. To the north Arabs predominate along the coast, while Berbers, including the Tuareg, and Tibbu are the principal peoples of the interior. Sub-Saharan Africa is occupied by a diversity of ethnicities, including the Amhara, Mossi, Fulani, Yoruba, Igbo, Kongo, Zulu, Akan, Oromo, Masai and Hausa.

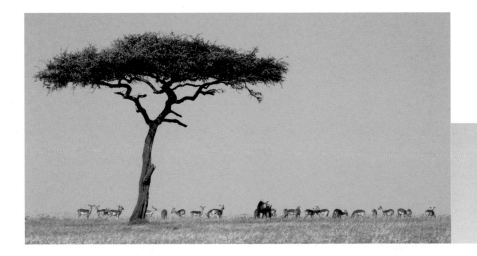

◀ *The relationship between animal and environment is key to the way that Africa's wildlife has developed. It has given rise to the day-to-day action that you will see on safari, as well as some of the world's most spectacular natural sights such as the Great Migration (see page 120).*

Africans of European origin are concentrated in regions with subtropical climates and tropical climates modified by altitude. In the south are descendents of the Dutch and British, while the north-west hosts those with French, Italian and Spanish ancestry. Lebanese people constitute a significant minority community throughout west Africa, while people of Indian origin populate many coastal towns in south and east Africa. There are also significant Arab populations in east and west Africa.

Most of continental Africa is sparsely populated. The most dense populations are in the Ethiopian Highlands, Nigeria, the Nile Valley and around the Great Lakes. The largest and most densely populated cities in Africa are usually national capitals or major ports, and often contain a disproportionately high percentage of the national populations. Cairo and Alexandria in Egypt, Lagos in Nigeria, Kinshasa in the Democratic Republic of Congo and Casablanca in Morocco have the largest populations.

▲ *The current population of Africa is distributed among 54 nations, the culmination of colonial impositions that split the myriad of traditional monarchies, chiefdoms and other societies by geometric divisions.*

Economy

Although much of Africa's population lives in rural areas agricultural production is low by world standards, with the exception of cash crops such as cocoa and peanuts (Africa produces three quarters of the world's cocoa beans and about one third of its peanuts).

Rare and precious minerals, including many of the world's diamonds, are abundant in the continent's ancient crystalline rocks, which are found mainly to the south and east of a line joining the Gulf of Guinea and the Sinai Peninsula. Extensive oil, gas and phosphate deposits occur in sedimentary rocks to the north and west of the Gulf of Guinea-Sinai Peninsular line.

Manufacturing is concentrated in the Republic of South Africa and in north Africa, in particular Egypt and Algeria. Despite the continent's great potential for producing hydroelectric power only a relatively small amount has so far been developed.

The coastline limits the numbers of natural harbours and the shallow coastal waters make it difficult for large ships to approach the shore. To compensate, deepwater ports protected by breakwaters have been constructed offshore to facilitate commerce and trade.

Major fishing grounds are found over the wider sections of the continental shelf, off north-west, south-west, South Africa and north-west Madagascar.

Country tour

While the individual characteristics of national parks and game reserves are covered in detail in Part II *Hifadyiwa – National Parks and Wildlife Reserves*, this country tour serves to give a brief oversight of the major countries in which you can safari.

Kenya

Kenya bestrides the equator on the eastern coast of Africa. It is bordered in the north by Sudan and Ethiopia, in the east by Somalia, to the south-east by the Indian Ocean, in the south-west by Tanzania and to the west by Lake Victoria and Uganda.

The country is notable for its diverse geography. Fringed with coral reefs and islands, Kenya's fertile coastal region gives way to a gradually rising coastal plain, a dry savannah and thornbush.

At an altitude of around 4,950ft (1,525m) and 300 miles (480km) inland the plain in the south-west gives way to a high plateau, rising in parts to 9,900ft (3,050m), within which are concentrated about 85 per cent of the population and the majority of economic enterprises.

The northern section of Kenya forms 60 per cent of the whole territory, and is an arid semi-desert, as is the bulk of the south-eastern quarter. In the high plateau, known as the Kenya Highlands, lie Mount Kenya (16,900ft/5,200m), Mount Elgon (14,046ft/ 4,322m) and the Aberdare Range (12,880ft/3,963m).

The plateau is bisected from north to south by the Rift Valley, part of the great geological fracture that can be traced from Syria through the Red Sea and east Africa to Mozambique. In the north of Kenya, the valley is broad and shallow, embracing the 160 mile (256km) long Lake Turkana, while further south it narrows and deepens and is walled by escarpments of 1,983–3,023ft (610–930m).

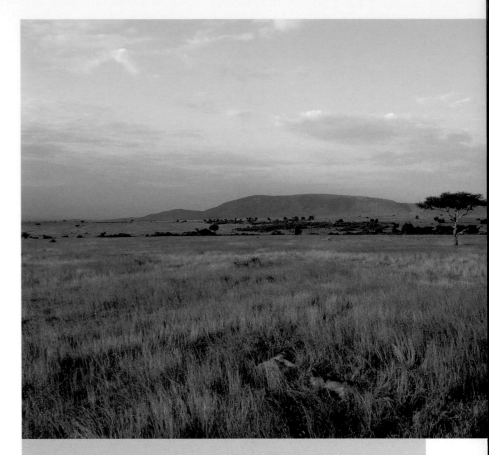

▲ *Kenya's fertile coastal region with its coral reefs and islands gives way to the wildlife-rich savannah and thornbush popular with photographers and filmmakers the world over.*

West of the Rift Valley, the plateau descends to the plains that border Lake Victoria. The principal rivers are the Tana and the Athi, flowing south-east to the Indian Ocean, the Ewaso Ngiro, flowing north-east to the swamps of the Lorian Plain and the Nzoia, Yala and Gori, which drain eastwards into Lake Victoria.

Tanzania

Situated in east Africa, just south of the Equator, mainland Tanzania lies between the area of the great lakes – Victoria, Tanganyika and Malawi – with the Indian Ocean on its eastern coast. It has land borders with Uganda and Kenya to the north, Mozambique and Malawi to the south, Zambia to the south-west and Zaire, Burundi and Rwanda to the west.

Apart from a coastal strip 10–40 miles (15–65km) wide the country has an altitude of over 1,000ft (310m) above sea level, and mostly consists of a 3,000–4,500ft (920–1,385m) high plateau. The Pare and Usambara mountain ranges are in the north-east and the Livingstone Mountains in the south-west. At 19,340ft (5,950m) Mount Kilimanjaro in the north is the highest mountain in Africa and the largest freestanding mountain in the world.

Tanzania borders three large lakes: Victoria, the second largest freshwater lake in the world; Tanganyika, second only to Lake Baikal as the deepest in the world; and Lake Malawi. Other significant lakes include Natron (famous for its flamingos), Eyasi, Manyara and Rukwa.

Even though three great African rivers – the Nile, the Zaire and the Zambezi – have their origins in Tanzania, the country has few permanent rivers. For half of the year the central plateau has no running water, but often floods during the summer.

▶ *Tanzania is home to some of the world's great wildlife wonders: the Ngorongoro Crater (shown), the highest freestanding mountain on Earth, Kilimanjaro, and is bordered by the world's second largest freshwater lake (Victoria) and its second deepest (Tanganyika).*

Malawi

Located in south-eastern Africa and lying within the Great Rift Valley system, Malawi is landlocked and bordered to the north and east by Tanzania, to the east, south and south-west by Mozambique and to the west by Zambia.

Lake Malawi, 360 miles (575km) long and about 1,500ft (460m) above sea level, is its most prominent physical feature. Much of the land surface is a plateau between 2,925–3,965ft (900–1,220m) above sea level. Elevations rise to 7,930ft (2,440m) at the Nyika Plateau in the north and in the regions of Mount Mulanje (9,912ft/3,050m) and Mount Zomba (6,938ft/2,135m). The Shire Highlands in the south are lower at 1,982–2,925ft (610–900m).

To the north lie rugged highlands with rolling hills in the Nyika and Vwanza Plateaus, while in the south, traversing the escarpment that forms part of the Great Rift Valley, are the lowlands of the Shire Valley. Lake Malawi is the main photographic attraction, which boasts palm-fringed beaches enclosed by sheer mountains.

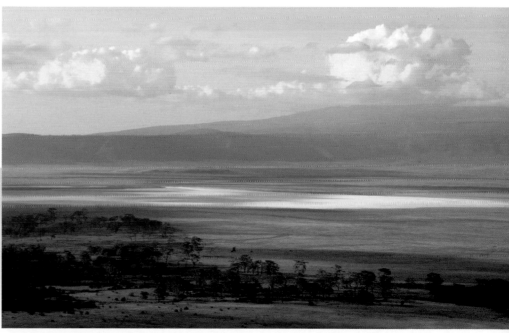

▼ *The overwhelming sight of the immense Victoria Falls can be seen from both Zambia and Zimbabwe. Many consider that the view from Zimbabwe is the better of the two options but recent political events in that country have persuaded more people to consider the equally impressive vistas from Zambia.*

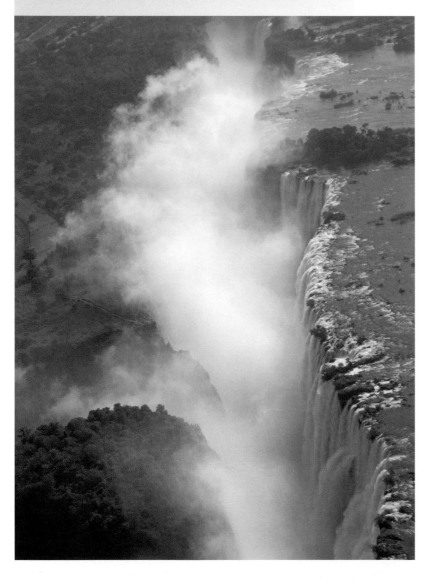

Zambia

Zambia lies between the southern rim of the Zaire Basin and the Zambezi River. It borders Tanzania to the north-east, Malawi to the east, Mozambique and Zimbabwe to the south-east, Botswana and Namibia to the south, Angola to the west and Zaire to the north-west.

Most of the landmass in Zambia is a high plateau, lying between 3,500–4,500ft (1,0175–1385m) above sea level. In the north-east the Muchinga Mountains exceed 7,000ft (2,150m) in height. Elevations lower than 2,000ft (615m) are found in the valleys of the major river systems.

Plateaus in the north-eastern and eastern regions are carved by the low-lying Luangwa River and in the western half by the Kafue River. Both rivers are tributaries of the upper Zambezi and the frequent occurrences of rapids and falls prevent navigation of this, the main waterway of the area.

There are three large natural lakes: Banweulu, Mweru and Tanganyika, all situated in the northern region. Lake Bangweulu and its southern swamps cover an area of 3,800 sq. miles (6,080km²), and are drained by the Luapula River. The Copperbelt, which at one time was responsible for most of Zambia's wealth, lies in the Western Province bordering Zaire.

Zimbabwe

Lying between the Zambezi River in the north and the Limpopo River in the south, Zimbabwe is another landlocked African state. It borders Mozambique to the north and east, South Africa to the south, Botswana to the south-west and Zambia to the north-west and north.

Most of the country's habitat is rolling plateau, with over 75 per cent of it lying between 1,980ft (610m) and 4,955ft (1,525m) above sea level. In fact, almost the entire country is above 990ft (305m).

The area of high plateau, known as the high veld, is some 400 miles (640km) long by 50 miles (80km) wide and stretches north-east to south-west at 3,965ft (1,220m) to 5,447ft (1,676m) above sea level. The high veld ends in the north-east at the Udizi and Inyanga mountains, reaching the country's highest point at Mount Inyangani (8,437ft/2,596m).

▼ *Botswana is perhaps best known for the wildlife haven of the Okavango Delta, which is best navigated by canoe. Elsewhere, the Kalahari Desert and Makarikari Salt Pans make the country an idyllic place for wildlife photography.*

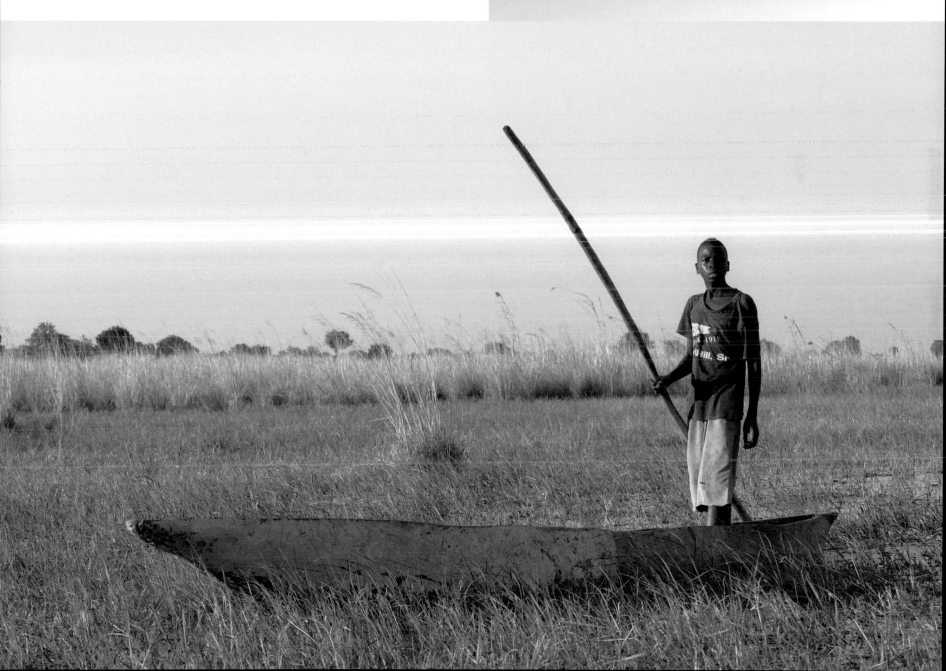

The middle veld is a plateau ranging from 1,980ft (610m) to 3,965ft (1,220m) above sea level. Below 1,980ft (610m) the habitat consists of areas of low veld – wide and sandy plains in the Zambezi and the Limpopo river basins.

Mountain ranges isolate Zimbabwe from the eastern plains. The central ridge of the high veld is the country's watershed, and streams flow south-east to the Limpopo and Sabi rivers and north-west to the Zambezi River. Deep river valleys bisect the middle veld. Despite having many rivers only the larger ones flow all year round.

At the time of writing Zimbabwe is suffering from political unrest. Given the current situation in the country it has been omitted from this book in any detail. Travel to Zimbabwe is not recommended by many national governments.

Botswana

Located in southern Africa, Botswana is landlocked and shares its borders with Zimbabwe in the north-east, South Africa in the south and south-east and with Namibia in the west.

The habitat is a broad tableland with an average altitude of 3,300ft (1,015m). A vast plateau about 4,000ft (1,230m) high and extending north from close to Kanye up to the Zimbabwean border divides the country into two distinct topographical regions.

The eastern region is hilly bush country and grassland (veld). To the west lie the Okavango swamps and the Kalahari Desert. The only sources of permanent surface water are the Chobe River in the north, the Limpopo River in the east, and the Okavango in the north-west. In seasons of heavy rainfall, floodwaters flow into the Makarikari Salt Pans and Lake Ngami.

Namibia

Namibia lies in south-west Africa and borders the South Atlantic Ocean to the west, Angola to the north, Zambia in the north-east, Botswana in south-east and South Africa in the south.

The country encompasses broad geographical variations and can be divided into four regions. The dunes and desert coastal plains of Namib, the Skeleton Coast, the Kalahari Basin and the bushveld of Kavango and Caprivi.

South Africa

South Africa lies at the southernmost tip of the African continent. It is bordered to the north by Botswana and Zimbabwe, to the north-east by Mozambique and Swaziland and to the north-west by Namibia. On the east coast lies the Indian Ocean, while on the southern coast is the confluence of the Indian and Atlantic Oceans. The Atlantic Ocean lies off the western coast.

Most of South Africa has elevations of over 2,970ft (915m) and at least 40 per cent of the surface is above 3,965ft (1,220m). Resembling an inverted saucer, the land rises steadily from west to east to the Drakensburg Mountains, the tallest of which is Mont-aux-Sources at 10,725ft (3,300m).

The coastal belt in the west and south varies from 3–30 miles (5–50 km) in width and is 494–592ft (152–182m) above sea level. It is richly fertile, producing citrus fruits and grapes, particularly in the Western Cape. North of the coastal belt stretch the semi-arid-to-arid Little and Great Karoo, which are bounded by mountains and lie higher than the coastal belt, and finally join the Kalahari.

The high-grass prairie, or veld, of the Orange Free State and the Transvaal is famous for its mineral deposits. From the Drakensburg Mountains, the land drops towards the Indian Ocean via the hills and valleys of Natal, which are covered with rich vegetation.

Mozambique

Mozambique is located on the south-eastern coast of Africa and is bordered by Tanzania to the north, South Africa and Swaziland to the south, Zimbabwe to the west and Zambia and Malawi to the north-west.

The country's habitat consists mainly of coastal lowlands rising in the west to a plateau ranging from 500–2,000ft (155–615m) above sea level and, on the western border, to a higher plateau of 6,000–8,000ft (1,845–2,460m). Mountains in the north reach heights close to 8,000ft (2,460m), the highest being Namuli (7,936ft/2,441m) followed by Binga (7,992ft/2,459m) on the Zimbabwean border and Serra Zuira (7,306ft/2,248m) in Sofala Province.

The most important rivers are the Zambezi, flowing south-east across the centre of Mozambique into the Indian Ocean, the Limpopo in the south, the Save in the middle and the Lugfenda in the north. The most important lake is the navigable Lake Niassa. In the river valleys and deltas the soil is rich and fertile but southern and central Mozambique has poor and sandy soil, and parts of the interior are dry.

▶ *The largest concentration of elephants in Africa can be found in the Chobe River area of Botswana. As the sun rises over Botswana's predominant river a small herd marches over the dry, dusty ground towards the life-giving water.*

Planning your trip

As with any trip there are a wealth of considerations such as innoculations and insurance to name but two, and you should check your requirements for these well before you plan to depart. This section offers advice on how to plan the specifics of a photographic safari.

Choosing a safari operator

When planning a package safari it is important that it is geared towards photography rather than simply spotting. Finding photographic opportunities demands more of the guide and driver than just locating wildlife. You may need to spend hours, even days at a single location, and an all-purpose safari may not allow this. If your fellow travellers are unwilling to be patient before moving on to the next attraction or if the whole group has a strict itinerary, the best photo opportunities will often be missed.

A safari guide with a basic understanding of good photographic technique is invaluable. Knowing exactly where to position the vehicle to achieve an ideal perspective and make best use of the available light will save precious moments, making it more likely that you get the perfect shot. Otherwise, you will often find that the vehicle is parked for the driver's benefit, albeit unwittingly, and precious moments can be lost as explanations are given as to why the vehicle needs to be more suitably positioned.

The location is equally important. While many safari operators can guarantee wildlife sightings, as a photographer you will also be interested in photographic potential. I have spent time in many regions of Africa where I have seen some remarkable sights but where the ability to photograph them well (or at all) has been limited, for example by the density of the vegetation or the inability to get close enough to the action.

The duration of game drives should also be unlimited, other than by official park/reserve operating times. Many operators cost for a two-hour game drive in the morning and another in the afternoon, with any additional outings incurring a supplementary fee. A photographic safari should provide the option for remaining out all day to maximize shooting potential. For example, cheetahs often hunt around noon when the other large predators are resting. If your group is back in the camp having lunch then you're unlikely to see cheetahs attempting to catch theirs!

◀ *A ranger in a private wildlife reserve points out a spider's den during a morning game walk. In most parts of Africa, rangers must be qualified before leading safari tours. They should be knowledgeable both in the flora, fauna and ecology of the area and in health and safety.*

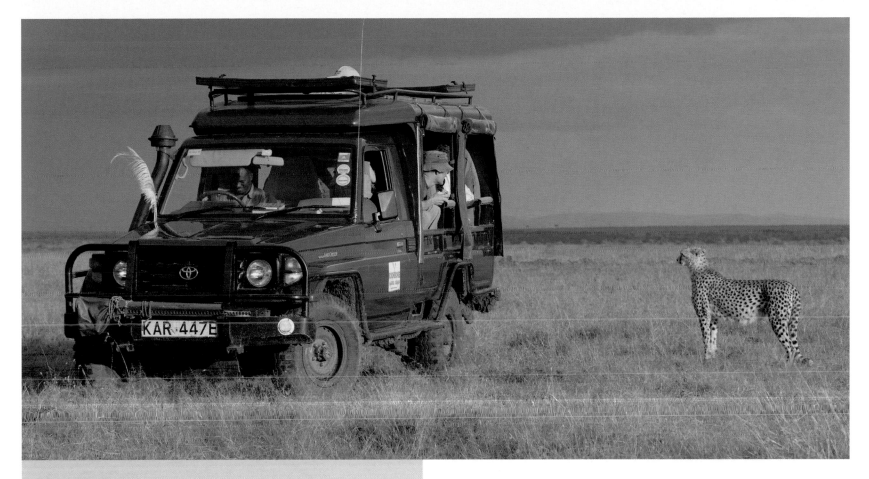

▲ *For good photography a safari vehicle should provide an unobstructed view both through the windows and, preferably, through the roof. A good operator will never fill a vehicle to capacity, allowing everyone in the party a window seat and room for storing camera packs.*

Group numbers and the type of vehicle used are two other considerations. Only open-sided vehicles should be considered for photography, as they provide plenty of room to manoeuvre your camera. Some vehicles will have an additional opening in the roof, which can be an advantage. Most jeeps used for safaris will be either six- or nine-seat vehicles, being either two or three benches of three travellers. However, for photographic purposes, ideally no one should be seated in the middle of the bench as this restricts camera use and cramps all photographers. With a six-seat vehicle the maximum number of passengers should be four and there should be no more than six passengers when a nine-seat vehicle is utilized.

A very few safari camps provide vehicles with special camera platforms attached, which facilitate the use of tripods and make it easier to use long super-telephoto lenses. However, such luxuries are rare and it is possible that park restrictions will forbid their use without acquiring special permits, which are expensive and often require professional accreditation before they are issued.

The following checklist provides a quick guide to the questions you should ask of your booking agent or, if travelling independently, of the safari camp being considered before confirming your trip:

1 Is the daily itinerary flexible and changeable depending on wildlife activity and photographic opportunities? If not, then you may fail to find suitable subjects and miss out on the best of the action.

2 Does the guide have knowledge both of the area, its flora and fauna and of photographic technique – alternatively are there two guides who share the necessary knowledge: a professional photographic guide and a wildlife guide? Having guides familiar only to escorting tourists on a general safari will limit photographic opportunities and miss the potential within a scene.

3 Are the guides licensed to operate in the area you're visiting? Most parks and official reserves have standards that are strictly adhered to for the quality of guides operating within their boundaries.

4 Is the camp being considered in a location that provides suitable opportunities for photography without the need for specialist equipment or travelling long distances? Not all camps are geared towards photography and distances in Africa can be deceptive. What may seem a short distance on a main highway can take a long time to cover when driving on dirt tracks across a savannah.

5 Does the camp provide the facility for all-day game drives as opposed to time-limited morning and evening drives only? Although morning and evening are the best times of the day for both seeing and

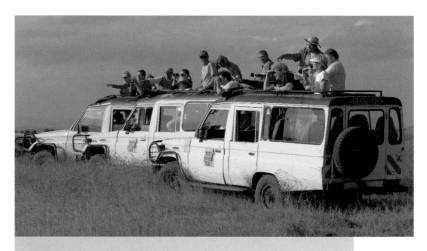

▲ *Avoid large groups – some tour operators charge less by catering for large groups. This limits your flexibility in the field and disturbs the wildlife, reducing photographic opportunities.*

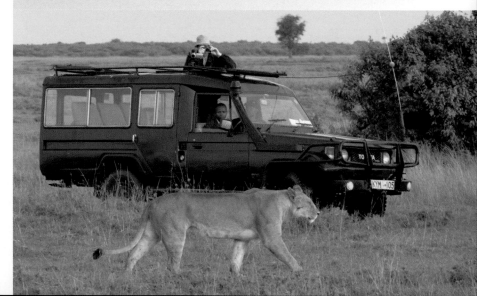

▼ *A good safari guide will take the time to find the best locations for photography and get into positions that are less likely to disturb the wildlife, providing for closer encounters and better photography.*

photographing wildlife, limiting game viewing to these periods will restrict many of your photographic opportunities.

6 What are the group sizes? Small groups will ensure that everyone has a window seat on the vehicle and room to store camera bags and equipment without compromising other photographers' space. Maximum numbers for optimum photographic convenience should not exceed four passengers in a six-seat vehicle and six passengers in a nine-seat vehicle.

7 If you are travelling as a group, do you have a private vehicle? It is not unknown for safari operators to mix lone travellers or couples with small groups to maximize the efficiency of vehicles and drivers. This will lead only to disruption for both your party and the others in the group.

8 Are the vehicles suitable for the terrain and do they have open sides for flexible camera access? Wildlife action can happen anywhere and it is not always possible to reposition the vehicle in time or without disturbing the animals. Flexible access for cameras through large window openings will minimize the need to keep moving the vehicle. Roof openings and camera platforms are an added bonus but are not essential for good photography.

9 Are the vehicles in good order and is a back-up vehicle available? The last thing you want is to break down when following a pride of lions or a herd of elephants.

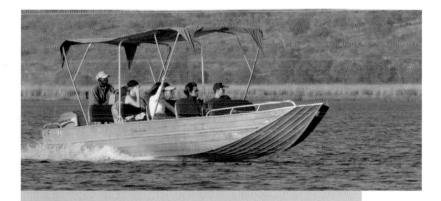

▲ *Four-wheel drive vehicles are not the only way of travelling in Africa. Small motorboats are an ideal way of watching and photographing wildlife in areas such as Chobe National Park in Botswana.*

▼ *Before booking a safari, always ask the age of the vehicles used. There is nothing more frustrating than having your day interrupted by a broken-down jeep.*

Before you go

Professional wildlife photographers never travel anywhere without having thoroughly researched their destination. This saves time in the field, particularly when that time is limited to a week- or fortnight-long safari. The Internet is an amazing tool and has large amounts of information that are easily accessible. In addition, read books on both the location and the subjects you'll be photographing, and, if possible, talk to other travellers that have been to the same location. The section in this book covering national parks and game reserves (see pages 26–113) provides some useful information about times of year to visit for good game viewing and the species of wildlife you are likely to see.

You could probably write a whole book on what to take, but the following is a guide to the essential equipment that you require.

Cameras

An SLR-type camera in the 35mm or digital format (below left) is ideal, being both portable and adaptable. Film or digital is a personal choice and both have disadvantages and advantages. The immediacy of digital cameras makes them ideal for wildlife photography, but dust on the sensor can affect image quality unless adequately prepared for. Film is less affected by the dusty environment but can suffer from the extreme fluctuations in temperature found in some parts of Africa and is inconvenient to carry around and store. Invariably, you'll get to the end of a roll of film just as the action gets interesting. For the record, I'm a digital convert and shoot exclusively on digital media.

Lenses

Don't restrict your choice of lenses and take a variety of focal lengths (below), either as prime lenses or a smaller range of zoom lenses, from wideangle to long telephoto.

© Nikon

© Hasselblad

The maximum focal length needed for most photographic safaris is 500mm with the option of a 1.4x teleconverter (giving a maximum focal length of 700mm). If you have a digital camera, zoom lenses limit the number of occasions you need to change optics and therefore the number of times the sensor is exposed to dust. Fast lenses – those with wide maximum apertures (for example f/2.8 and f/4) will increase your options when selecting exposure settings, particularly in the low light of early morning and late evening. Optical-stabilization technology (IS for Canon, VR for Nikon, OS for Sigma and AS for Konica Minolta) will help to prevent blur from camera shake when using a camera support is impractical.

Flash

A powerful flash unit (below) with an extender will help when attempting to capture action images. An off-camera bracket for attaching the flash will alleviate the possibility of red-eye or green-eye, and a battery pack will keep the flash operating at maximum capacity.

© Canon

Filters

Polarizing filters, 81-series warm-up filters, as well as graduated and plain neutral density filters in a variety of strengths and UV filters to protect the lens can all be useful (see pages 176–7).

Camera supports

Tripods often prove impractical on vehicle-based safaris, and monopods have limited effect on reducing camera shake. The ideal form of support is a large beanbag that is designed to fit over the lip of a window frame. When using a long telephoto lens a second, smaller beanbag can be placed on top of the lens to provide inertia. Fill beanbags on arrival with either rice or maize or a similar product. Polystyrene is light but will flatten with use and become ineffective. Vehicle clamps with attached tripod heads are an effective alternative but are less flexible than beanbags, which can be moved around easily. If you decide to take a tripod, a ball-and-socket head is ideal but a gymbal-type head is generally better when using super-telephoto lenses.

Other accessories

A remote shutter release will prove useful, and spare batteries are essential. I also carry with me a blob of adhesive putty and a roll of black-coloured electrical tape. Take a couple of lens-cleaning cloths and some swabs for cleaning digital sensors (if applicable). An inverter is useful for charging batteries on the move. Also be sure to take some spare memory cards as well as something with which to protect them if you are using a digital camera.

Film and digital memory cards

Although I rarely shoot film now, I recommend taking a mix of 100 ISO and 400 ISO films. My personal choice for wildlife photography is Fuji Provia 100F and 400F films, both of which can be up-rated by one stop and push-processed later with little effect on image quality. If shooting film I also carry a few rolls of Fuji Velvia 100F for landscapes. To ensure that you take enough rolls multiply the number of days spent in the field by 10, it is better to return home with spare film rather than missed opportunities.

For digital cameras I use 2GB CompactFlash cards made by Apacer. With my Nikon D2X each card holds around 100 RAW files or 200 compressed RAW files, a number I find I can manage effectively. I prefer not to have too many images on a single card in case it fails. In the case of digital cameras that create smaller files a number of 512MB (right) or 1GB memory cards of whichever type your camera accepts should provide enough space, without risking losing all of your images in one go.

Digital storage

A portable hard disk drive (right) with a minimum capacity of 40GB is ideal or, alternatively, a portable CD or DVD writer. A laptop computer can be useful but is more cumbersome and susceptible to damage.

Binoculars

A pair of binoculars (below) with a magnification of around 8x and an optical diameter of around 42 will give adequate light-gathering ability without being too cumbersome. A roof prism design makes the binoculars more streamlined and is typically better suited to safari conditions.

© Nikon

Torch

A torch is useful for night drives and for getting around the camp after dark. It is important that you take a torch with you that is not only sufficiently bright but that is also very well built as it may have to withstand many bumps and scrapes. It should also be well sealed so that the inevitable dust it will have to endure doesn't damage it. It should also be easy to operate, those models with twisting grips are ideal.

© Fujifilm

© Pentax

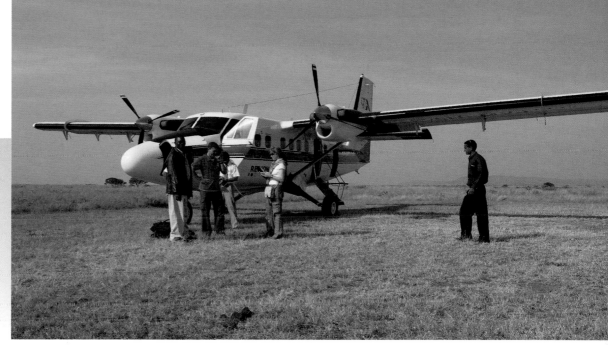

▶ *There are likely to be severe restrictions on what you can conveniently carry when you are on safari. Internal flights will place restrictions on weight, while land vehicles will have limited space for your luggage.*

Clothing

Clothing is best worn in layers so that items can be added or removed as the temperature changes throughout the day. Africa can get quite cold in the early morning and late evening, particularly in the winter months (June to August), so a warm jacket or pullover is recommended.

If travelling during the wet season then a good-quality waterproof jacket is essential. In the dry season, a lightweight jacket is recommended, as light rain is possible in some areas. A pair of comfortable walking shoes made of breathable material are important, as are a hat and sunglasses to keep the sun at bay, and a warm hat and gloves for early morning game drives.

Unless you are planning a walking safari then the colour of your clothing will have little or no impact on the quality of your wildlife viewing. However, to keep noise to a minimum, wear natural fabrics such as cotton and avoid Velcro fasteners.

Travelling light

Travelling by aeroplane with photographic equipment is an increasingly complex affair. I pack a carry-on regulation-size camera case with my main camera body, with memory card installed, two zoom lenses, a standard flash unit and a battery charger. I carry these essentials with me as they meet my basic requirements if my main case goes astray.

I pack my remaining lenses, spare camera body and various accessories into a large hard case that is placed inside an old knapsack to disguise it, and it is checked into the hold. My clothing, which is minimal to reduce weight, goes into a small soft case along with my tripod.

You should always carry film as hand luggage, never place it in the hold. Requests for hand searches are increasingly declined, particularly at busier airports, and the X-ray machines used for carry-on baggage rarely affect film. Placing the film upright in a container will minimize its exposure. Memory cards are unaffected by X-rays.

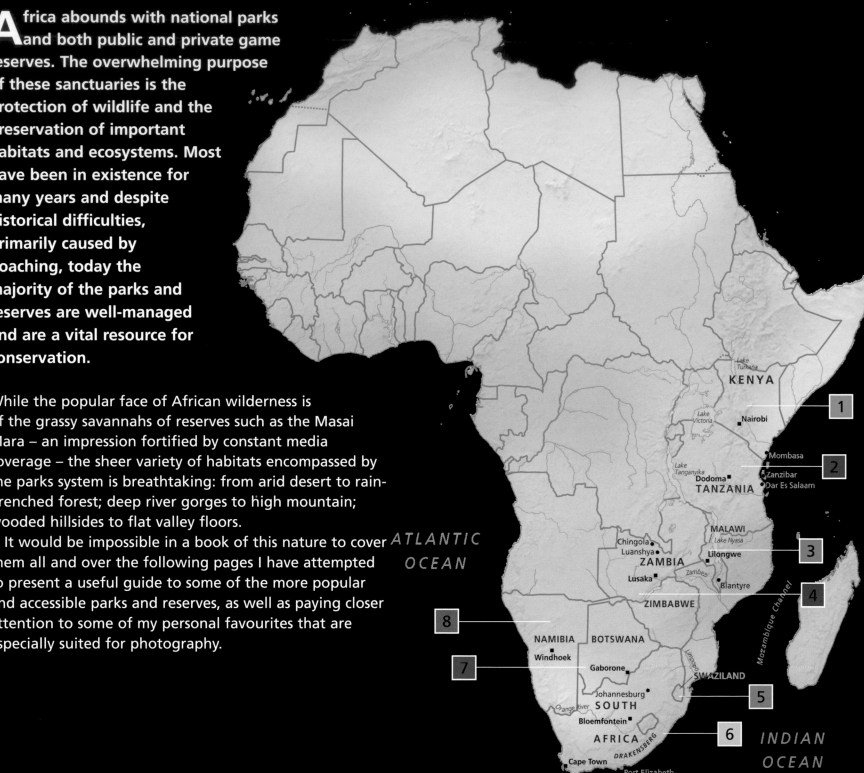

Africa abounds with national parks and both public and private game reserves. The overwhelming purpose of these sanctuaries is the protection of wildlife and the preservation of important habitats and ecosystems. Most have been in existence for many years and despite historical difficulties, primarily caused by poaching, today the majority of the parks and reserves are well-managed and are a vital resource for conservation.

While the popular face of African wilderness is of the grassy savannahs of reserves such as the Masai Mara – an impression fortified by constant media coverage – the sheer variety of habitats encompassed by the parks system is breathtaking: from arid desert to rain-drenched forest; deep river gorges to high mountain; wooded hillsides to flat valley floors.

It would be impossible in a book of this nature to cover them all and over the following pages I have attempted to present a useful guide to some of the more popular and accessible parks and reserves, as well as paying closer attention to some of my personal favourites that are especially suited for photography.

Safari Finder – A guide to the prominent parks and reserves

1 Kenya

Aberdare NP	Mount Kenya NP
Amboseli NP	Samburu, Buffalo Springs &
Lake Victoria & Ruma NP	Shaba
Lewa Wildlife Conservancy	Tsavo & Chyulu Hills NP
Masai Mara National Reserve	

2 Tanzania

Arusha NP	Ngorongoro Crater
Gombe Stream NP	Conservation Area
Katavi NP	Ruaha NP
Mount Kilimanjaro	Selous Game Reserve
Lake Manyara NP	Serengeti NP
Mahale Mountains NP	Tarangire NP

3 Malawi

Lake Malawi	Liwonde & Mvuu Wilderness

4 Zambia

	North Luangwa NP
Kafue NP	South Luangwa NP
Lower Zambezi NP	Mosi-ao Tunya NP

5 Swaziland

Hlane Game Reserve	Malolotja Nature Reserve

6 South Africa

Addo Elephant Park (Greater	Kruger NP
Addo National Park)	Maputaland Coastal
Blyde River Canyon Nature	Forest Reserve
Reserve	Mkuze Game Reserve
Cape Peninsula	Ndumo & Tembe
(Table Mountain) NP	Elephant Park
Drakensberg Mountains	Pilanesberg NP
Hluhluwe & Umfolozi Game	Saint Lucia Wetland Park
Reserves	Tsitsikama NP
Kalahari Gemsbok NP	West Coast NP

7 Botswana

Central Kalahari Game Reserve	Mashatu & Tuli Game Reserves
Chobe NP	Nxai Pan NP
Linyanti Reserve	Okavango Delta
Makgadikgadi Pan NP	Moremi Game Reserve
& Salt Pans	Savuti Channel & Savuti Marsh

8 Namibia

Damaraland & Brandberg	Namib Desert & Namib-
Etosha NP	Naukluft Park
Fish River Canyon & Ai-Ais	Skeleton Coast NP
Hot Springs	Waterberg Plateau

At the time of writing Zimbabwe is suffering from political unrest. Given the current situation in the country it has been omitted from this book in any detail. Travel to Zimbabwe is not recommended by a number of national governments at the time of writing.

The following is an index of national parks and wildlife reserves within each country, indicating for each the major game-viewing highlights and points of interest and identifying the key seasons for travel. This list is in no way exhaustive and covers the major parks and reserves of southern and east Africa.

▼ *An adult male elephant crosses the Chobe River in Chobe National Park, Botswana. Such sights are commonplace in the park, which is home to the largest concentration of elephants in Africa.*

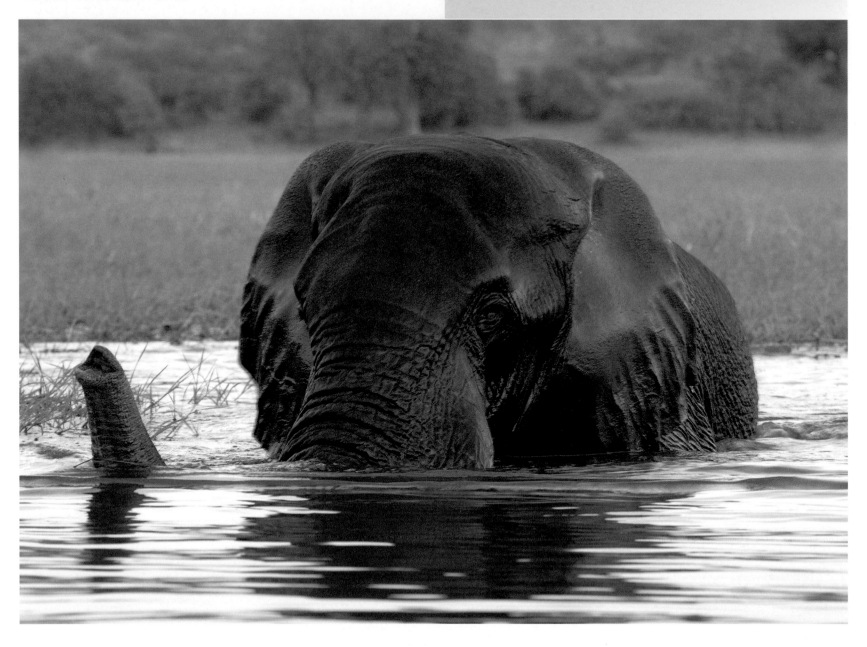

Aberdare and Amboseli National Parks, Kenya

 Highlights – Aberdare
Night and day game viewing at waterholes and salt licks
Wildlife viewing from above
Close-up elephants
Lions and leopards

 Seasons – Aberdare
Long rains: April–June
Short rains: November–December
Dry season: January–March and July–October

 Highlights – Amboseli
Mount Kilimanjaro backdrop
Large herds of elephants (over 100 strong), including old 'tuskers'

 Seasons – Amboseli
Long rains: April–June
Short rains: November–December
Dry season: January–March and July–October (best for game viewing)

Aberdare offers great opportunities for getting close to elephants, while Amboseli boast herds of over 100 strong

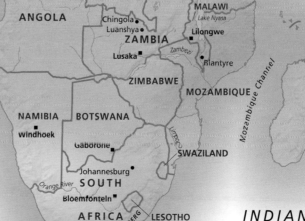

ATLANTIC OCEAN

INDIAN OCEAN

Lake Victoria & Ruma National Park, Kenya

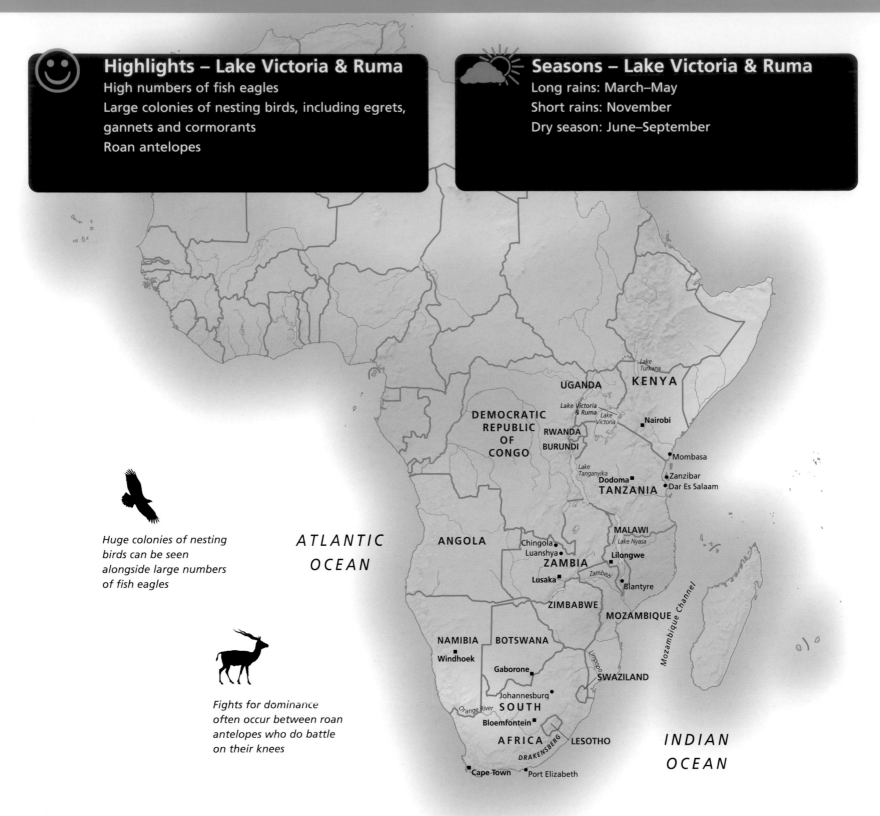

☺ **Highlights – Lake Victoria & Ruma**
High numbers of fish eagles
Large colonies of nesting birds, including egrets,
gannets and cormorants
Roan antelopes

Seasons – Lake Victoria & Ruma
Long rains: March–May
Short rains: November
Dry season: June–September

Huge colonies of nesting birds can be seen alongside large numbers of fish eagles

Fights for dominance often occur between roan antelopes who do battle on their knees

UGANDA

KENYA

Lake Turkana

Lake Victoria & Ruma

DEMOCRATIC REPUBLIC OF CONGO

Lake Victoria

Nairobi

RWANDA

BURUNDI

Mombasa

Lake Tanganyika

Zanzibar

Dodoma

Dar Es Salaam

TANZANIA

ATLANTIC OCEAN

ANGOLA

MALAWI

Lake Nyasa

Chingola

Luanshya

Lilongwe

ZAMBIA

Zambezi

Lusaka

Blantyre

ZIMBABWE

MOZAMBIQUE

Mozambique Channel

NAMIBIA

BOTSWANA

Windhoek

Gaborone

Limpopo

SWAZILAND

Johannesburg

Orange River

SOUTH

Bloemfontein

AFRICA

DRAKENSBERG

LESOTHO

INDIAN OCEAN

Cape Town

Port Elizabeth

Lewa Wildlife Conservancy, Kenya

Highlights – Lewa Wildlife Conservancy

Around 30 black rhinoceroses (one of Africa's healthiest populations)

White rhinoceroses

Grevy's zebras (around 25 per cent of the world's remaining population of about 3,000)

Aquatic Sitatunga antelopes (around 40 per cent of Kenya's remaining 50-strong population)

Seasons – Lewa Wildlife Conservancy

Long rains: April–June

Short rains: November–December

Dry season: January–March and July–October (this is the best time for game viewing)

A large population of black rhinoceroses as well as white rhinocersoses

The Situanga antelope is the most aquatic of all the antelope species

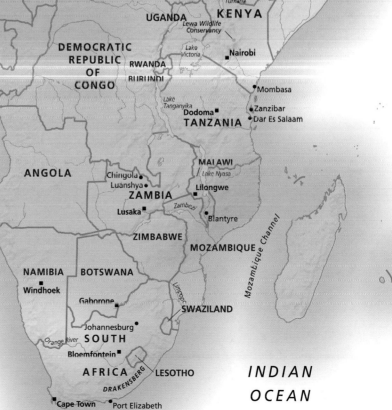

UGANDA

KENYA

Lake Turkana

Lewa Wildlife Conservancy

Lake Victoria

Nairobi

DEMOCRATIC REPUBLIC OF CONGO

RWANDA

BURUNDI

Lake Tanganyika

Mombasa

Dodoma

Zanzibar

Dar Es Salaam

TANZANIA

ATLANTIC OCEAN

ANGOLA

MALAWI

Lake Nyasa

Chingola

Luanshya

Lilongwe

ZAMBIA

Lusaka

Zambezi

Blantyre

ZIMBABWE

MOZAMBIQUE

Mozambique Channel

NAMIBIA

BOTSWANA

Windhoek

Gaborone

Limpopo

SWAZILAND

Johannesburg

SOUTH

Orange River

Bloemfontein

AFRICA

LESOTHO

DRAKENSBERG

INDIAN OCEAN

Cape Town

Port Elizabeth

Masai Mara National Reserve, Kenya

Highlights

Wildebeeste migration (best viewed in September)
Big cats, including lions, leopards and cheetahs
(filming location for the BBC's *Big Cat Diary* series)
Nile crocodiles in the Mara River

Seasons

Long rains: April–May
Short rains: November
Dry season: July–October

Game viewing

There are few places on earth better for wildlife viewing than the Masai Mara. Mammals predominate and although there exist around 450 different species of birds (including 53 species of raptor) the dispersed geography of the Reserve doesn't lend itself to bird photography in the way of areas such as Samburu, in northern Kenya, or the great lakeside sanctuaries.

Of the herbivores, wildebeeste, zebras and antelopes can be found in numbers reaching several thousands, particularly when the migration reaches the reserve after crossing the Mara River around September and before heading south back into Tanzania around November. Of the resident game, impalas, topis and giraffes are all prevalent and both black and white rhinoceroses inhabit the park.

With such large numbers of game it is little surprising that the Mara is the big cat capital of Africa. Large prides of lions are often seen, as are cheetahs, including some of the characters made famous by Jonathan Scott and Simon King and the BBC series *Big Cat Diary*. Don't be surprised if, during a game drive, you find Kike (pronounced key-kay) using the

▶ *Kike (pronounced key-kay) is a regular visitor to the bonnets of 4x4s in Masai Mara National Reserve. She is one of the stars of the BBC series 'Big Cat Diary' and uses the elevated vantage point to scout her environment, which is typical cheetah behaviour.*

hood of your jeep as a lookout. As always, leopards are harder to spot but are not uncommon, and they can be seen sleeping in leafy trees through the heat of daytime before setting out on nocturnal hunts. Of the other predators, hyenas are plentiful and often seen, sometimes in the vicinity of lions and vultures, as are jackals.

The Mara River is dominated by great pods of hippopotamuses and enormous Nile crocodiles, fattened on the feast of wildebeeste that presents itself every September.

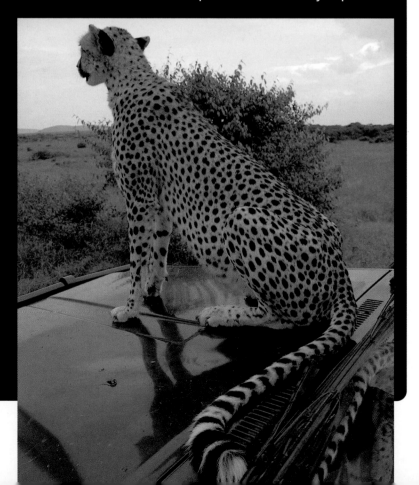

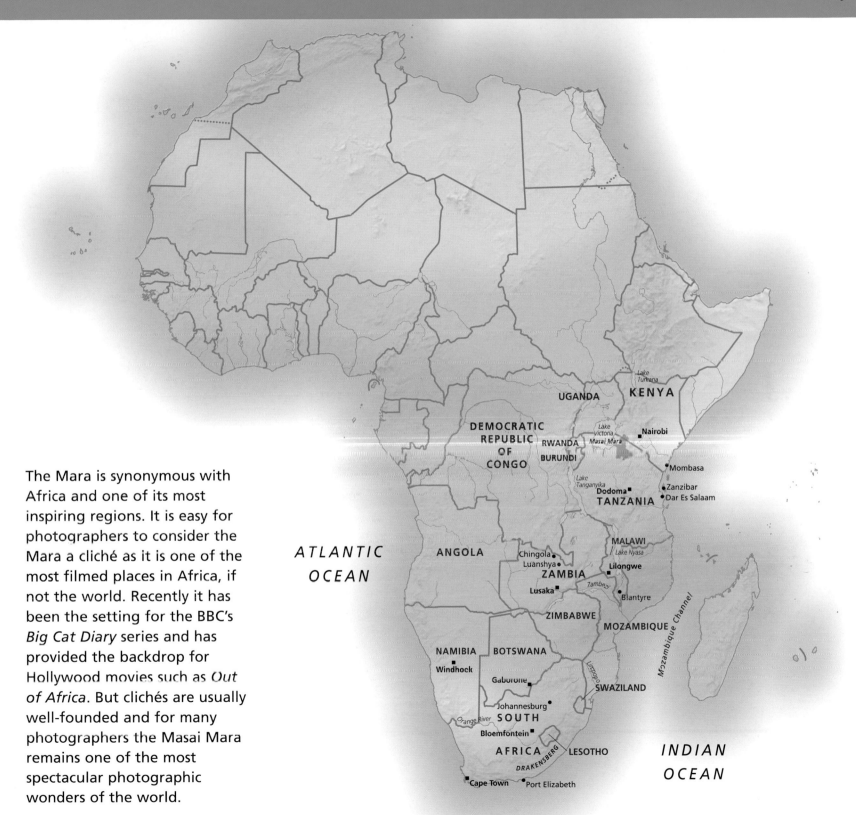

The Mara is synonymous with Africa and one of its most inspiring regions. It is easy for photographers to consider the Mara a cliché as it is one of the most filmed places in Africa, if not the world. Recently it has been the setting for the BBC's *Big Cat Diary* series and has provided the backdrop for Hollywood movies such as *Out of Africa*. But clichés are usually well-founded and for many photographers the Masai Mara remains one of the most spectacular photographic wonders of the world.

History and background

Locally, the Reserve has been party to controversy. Located to the west of the Great Rift Valley it was formed in 1961, partly in response to the uncontrolled killing by white hunters of Kenya's wildlife and because of game poaching, both of which were taking huge tolls on animal populations in the region. Its creation, however, caused the mass displacement of Masai communities that had used the lands for grazing and greatly disrupted the Masai's concepts of communal living, reducing further their territory, which had been gradually eroded since the nineteenth century due to foreign influences and the drive to establish lucrative trade routes.

These conflicts and concerns about the effects of tourism on traditional Masai practices are ongoing. However, continued protection for the area has been partially assured by attempts to reward the Masai by means of trade with tourists through campsite management and the sale of handicrafts and tours of manyattas, all of which provide a regular source of income and help to protect the Masai culture.

The Mara is a national reserve and not a national park and it is managed by local authorities as opposed to the Kenya Wildlife Service. The eastern sector falls under the jurisdiction of the Narok District, while responsibility for the western side falls on the Transmara District. Visiting the Reserve you are unlikely to be bothered by this detail except that technically speaking Reserve entry fees paid at one gate are for that district only. Normally such details are overlooked but it is wise to leave the Reserve via the gate of entry to avoid paying twice.

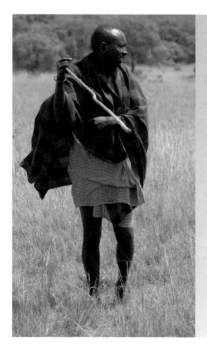

◀ *Masai pastoralists are seen frequently in the Masai Mara. When the reserve was established it caused severe disruption to the Masai way of life and an element of controversy remains. However, recent initiatives to integrate the needs of the Masai with that of tourism have helped to ensure the continued protection of the reserve's wildlife and habitat.*

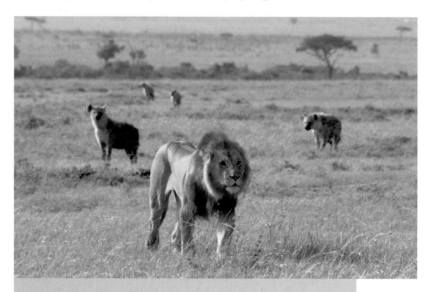

▲ *A pack of attentive hyenas follow a nomadic lion in the hope of benefiting from any successful kill. In reality, solitary male lions are less adept at hunting than a pride or coalition of nomadic males and, in this instance, the roles of the predator (lion) and the perceived scavenger (hyena) are likely to be reversed.*

Ecology and topography

The Masai Mara lies in the shadow of the Great Rift Valley, a fault line that travels 3,500 miles (5,600km) from Ethiopia's Red Sea through Kenya, Tanzania, Malawi and finally into Mozambique. There are four main types of topography: to the east are the Ngama hills with sandy soils and leafy bushes, a favourite of black rhinoceroses; forming the western boundary is the Oloololo Escarpment, which rises to a magnificent plateau rich in wildlife; the Mara Triangle bordering the Mara River, an area of lush grassland and acacia woodland supporting vast quantities of game, especially the famous migrating wildebeeste; and the Central Plains, which form the largest part of the reserve and consists of rolling grasslands with scattered bushes and boulders and is an area much inhabited by game.

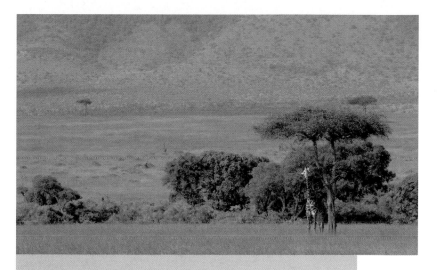

▲ *Because much of the Masai Mara is open savannah, wildlife takes shade wherever it can find it. Here a lone giraffe shelters from the mid-day heat under the umbrella-like canopy of an acacia tree.*

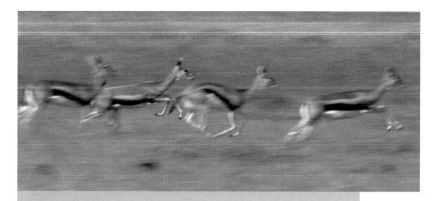

▲ *Thomson's gazelles are pretty much every predator's favourite food. In order to escape the unwanted attentions of a hungry lion, cheetah or leopard, they have been blessed with great agility and speed, which helps them to survive the harsh realities of life on the open savannah.*

▼ *The 'Duty Free' shop at an airstrip in the Masai Mara. The quickest route into the Mara from Nairobi is via light aircraft and several of these airstrips are found throughout the reserve.*

The Mara clock and calendar

Wildlife photography in the Mara is best during the early morning and late afternoon hours. At sunrise, nocturnal animals, such as leopards, remain active and the diurnal creatures, like cheetah, enjoy the cool temperatures for moving around chasing prey. This is also the time when you are most likely to witness a kill or at least see lions active rather than asleep and motionless under the shade of a tree.

▼ *A pride of lions makes the most of the cool temperatures of early morning in the Masai Mara to move around their territory. This particular pride consisted of fourteen lions including three females and eleven cubs, some just a few weeks old.*

As the day progresses and the temperature rises the heat instills a state of apathy that is apparent in the changing behaviour of the wildlife. Activity decreases and movement is slow and lethargic. However, many of the plains game enjoy the respite from the large predators and can be more relaxed and cheetah, the exception to the rule, will often hunt during this time as there is less competition from lions and leopards and it is less likely that they will lose their kill to scavenging hyenas.

The dry season between July and October is the best time of year to see wildlife in the Mara. During the wet summer months water is plentiful and game more dispersed. Longer grasses also mean that animals remain well hidden, even when active. Once the water supply has diminished wildlife is bound to the permanent waterholes and the tall summer grasses recede, making sightings more likely.

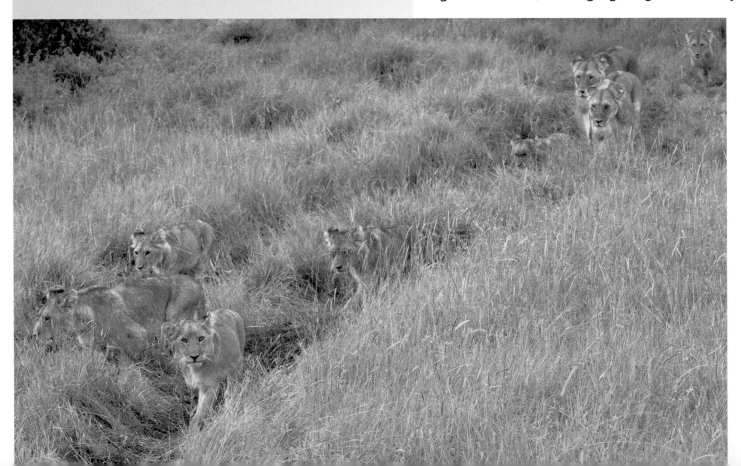

Mapping wildlife

Wildlife ignores human borders and boundaries, so any advice on locating wildlife can only ever be generic. Even so, time spent in the field will always reveal certain patterns, which are explained here.

The plains between the Mara River and the Oloololo Escarpment in the west are best for spotting the reserve's famous black-maned lions and the area is also a favourite haunt of cheetahs. The backdrop here is breathtaking, with flat-topped acacia trees blending with the distant blue-rock mountains. Lions are also prevalent in the Musiara Swamps and cheetahs can be seen in the Talek area, along the Sekenani–Talek road, and in the solitary prairies near Sand River.

Leopards are harder to spot, their nocturnal activities and tree-climbing exploits keeping them further from humans. However, there are large numbers within the reserve and patience with a small measure of luck will often be rewarded. Keep an eye on the high branches of the acacia canopies, particularly those close to rivers. Spotted hyenas are visible in most areas and during any time of the day. Often they will be mingling with the large game herds or keeping a watchful eye on the activities of

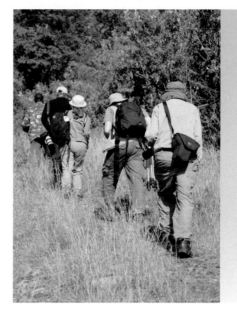

The smaller the group the better the level of tuition and the greater the chance of getting to see sights that are more difficult to encounter with a large number of people. Here a group of only four photographers is led on a game walk to see white rhinoceroses in Kenya's Masai Mara National Reserve.

vultures, which often betray the presence of a kill. Also, be mindful of hyena dens, which can be found in the side of banks and in culverts they are a hive of activity.

Elephants are often found feeding on foliage along the rivers and large family groups are regular visitors to the plains and the Musiara Swamps. Black rhinoceroses are harder to find and sightings are typically limited to distant silhouettes – not ideal for photography. There is a small area of the reserve set aside as a sanctuary for three white rhinoceroses imported from South Africa and this can be visited on foot with a guide.

The Mara pools around Mara Serene Lodge are good for hippopotamus sightings, as is the area next to the New Mara Bridge at the southern limit of the Reserve where a colony of basking crocodiles may also be seen.

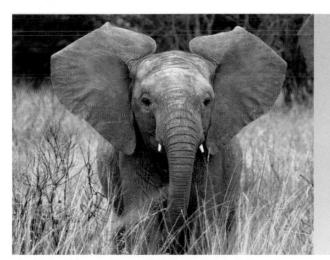

The Masai Mara is not the best African reserve for sighting elephants, although they are present and can often be found feeding on foliage along the rivers. Here a young elephant keeps an inquisitive eye on the camera.

The Masai People

The Masai people are synonymous with Africa and their culture is one of the oldest and most respected in the world today. To many, the popular conception of the Masai is of a fiercely independent tribe of legendary courage, who eschew modern ways in preference to their strongly protected traditional rites and customs. While this appreciation of Masai culture can be substantiated, in the wider concept and complexities of the tribe, its social structure and beliefs, there is a far more absorbing world to be discovered.

The name Masai derives from the language *Maa*, which they share with the Samburu and Njemps tribes, with whom the Masai have strong ancestral ties. Geographically, the range of the Masai once covered much of southern and central Kenya, extending north to Laikipia and south into Tanzania. Today, however, with modern demands on land, most of the population lives in the south-west region of Kenya.

Although politics and financial necessity has caused a small but growing move towards farming and agriculture, on the whole the Masai remain nomadic cattle herders. The bond between the Masai and their cattle takes on mythical proportions. Mythology tells of a time when the earth and sky were joined together until they were suddenly torn apart, with only the wild fig trees forming a bridge between the two disjointed parts. As a gift to the Masai, God – whom they call Enkai – sent to Earth herds of cattle through these trees.

Ever since, cattle have been considered a direct gift from the heavens and sacred. Equal reverence is reserved for grass and there is a Masai saying: 'Without grass there is no cattle, without cattle there is no Masai.' Today, when passing a fig tree, it is customary for the Masai to push handfuls of grass between its roots as homage to

▲ A young Masai girl carries her large, white beaded necklace. Unmarried girls will wear this necklace when dancing to show off the litheness of their young bodies to prospective suitors.

Wildlife too is considered sacred and the Masai live harmoniously with most species. Wildebeeste and zebras in particular are held in high esteem, as they aid the regeneration of the valuable grasses. Indeed, it is common for Masai cattle to be seen grazing among herds of these wild grazers. Lions, however, are another matter and are considered a potent threat to the cattle, which are enclosed at night in protective bomas made of thorn.

Lion hunts – *Olomayio* – are an integral part of Masai culture albeit less so modern life. Traditionally, hunts were extravagant ceremonial events, representing an opportunity for young warriors – *Morani* – to prove their courage. Hunting parties consisted of a group of moran, armed with spears and shields made from buffalo hide. Bells stuffed with grass were worn on the legs of each moran and the group would stalk silently to a resting lion before removing the grass from the bells and charging noisily into the bush. Inevitably the stalked lion would rise to face the hunters and meet the challenge.

On returning to their village, victorious moran would perform a spectacular dance called the *Engilakinoto*, consisting of deep, rhythmic chanting and exaggerated thrusting of the chest. As the dance progressed, moran would show their strength with a series of powerful, vertical leaps. Displayed for the benefit of tourists, the Engilakinoto is a remarkable sight, with gifted moran leaping as high as four feet off the ground. Similar dances such as the *Eoko* – a dance to bless cattle – and the *Eoko oo'njorin* – a traditional war dance – are causes for corresponding displays of strength.

The social structure of the tribe is based around a highly developed system of initiation and age sets. For males, circumcision forms the first initiation and is a time for great celebration. A period of convalescence follows during which time the boys wear black clothing and decorate their faces with white powder or paint. After this maiden initiation,

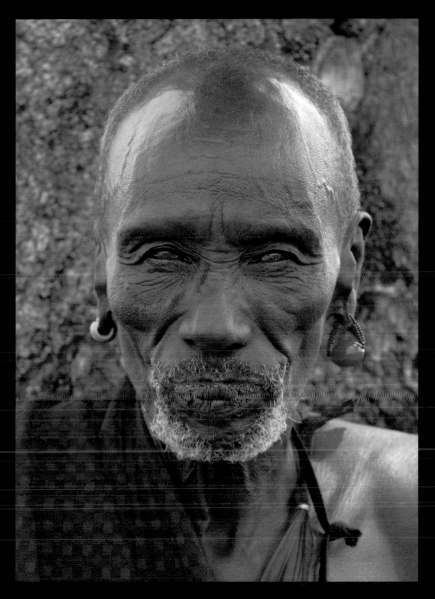

▲ *Masai society is based on a hierarchical social structure. A Masai man can become an elder only after marriage, after which his status and passage to senior elder is dependent on age.*

▲ *In traditional Masai culture, a successful lion hunt will culminate with the returning moran performing a dance, known as the Engilakinoto, consisting of chanting and thrusting of the chest, before they show their strength with powerful leaps – of which this image gives an abstract impression.*

the young men reach the status of junior moran. It is customary for moran to distend their earlobes and to grow their hair into long braids, often coloured with red ochre. The same red ochre is also spread copiously over the upper torso. Red is considered a sacred colour in Masai culture and forms always the predominant color of the shukka – the blanket worn around the shoulders by both sexes.

It is the mother's role to send her son to initiation. When she does she presents him with pendants known as *surutia*, which the boy will wear throughout his trials. Later he will return the surutia, which are then worn with great pride by the mother as a symbol of her son's status. She will continue to wear them throughout her life, removing them only in the event of her sons' death.

Once initiated, moran will roam freely across Masai lands visiting many communities during their travels. They return for the *Eunoto* – a ceremony that involves the shaving of the head by the mother and which marks their passage to the status of senior moran. Only now is it considered that they have reached marriageable age.

After marriage moran pass to the status of junior elder and the passage to senior elder subsequently is dictated by age. As a sign of their position within the community, elders carry a *rungu* – a large stick and, as with many indigenous peoples, their wisdom is highly regarded. Most revered of all elders are the *Laibon*s – traditional prophets, healers and 'seers', their role being of paramount importance in traditional Masai society.

Beading also plays an important part in Masai culture. Around 40 varieties of beadwork exist, crafted by women traditionally and worn by males and females. The commonest colours used are red, blue and green, symbolic of the Masai (red), Godliness (blue), directly reflecting the colour of the sky, and of God's greatest blessing to the Masai, fresh grass (green).

For women, one of the most popular adornments is a necklace in the form of a large, white flat disc that fully

surrounds the neck. They are crafted using rows of beads threaded onto wire, spaced and then secured with strips of cowhide. Unmarried girls wear the necklaces when dancing, using the motion of the disc to accentuate the litheness of their young bodies. A common dance acted by females is the *Olamal,* which is performed to elicit blessings from community leaders.

Ear decorations are of equal import to Masai women as men. Before marriage young girls may adorn only the upper ear, which is pierced to form a large hole and is fastened with beading. As she ages her ears are decorated with more adornments until, at adulthood, her lobes are pierced and gradually distended by the weight of the beads. On their wedding day Masai girls take great pride in displaying their finery. In addition to the many beaded necklaces and ornaments they will wear an elaborate knee-length necklace throughout the ceremony. The weight of so much jewelry can make the simple task of 'walking down the aisle' difficult. Once married, Masai women wear the *Nborro* – a long, blue beaded necklace and decorate their earlobes with long beaded ornaments. Often, a married woman will carry a snuff container threaded onto her necklaces.

The Masai greet every rite of passage of the living with elaborate and fanciful celebrations and ceremonies, which, in themselves, harbour numerous recurring customs. Many ceremonies require the ritual slaughter of cattle or goats, with meat being distributed among the community according to social rank. At other times, cattle are bled by opening a vein on the neck or flank with the point of an arrow. The blood is collected in a gourd, and the wound closed using ashes. The fresh blood is either drunk immediately or mixed with milk. Milk is also considered sacred by the Masai and either milk itself, or representative white dust, are used to bestow blessings.

On the open plains it is unwise to photograph Masai people without their express permission. They are a

▲ *As a sign of their status within the community Masai elders carry a large stick known as a rungu. As with many indigenous people, the wisdom of elders is highly regarded.*

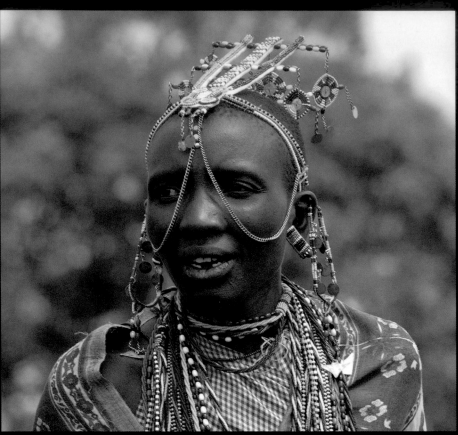

Ear adornments are of equal import to Masai women as men. At adulthood, a Masai woman's lobes are pierced and gradually distended by the weight of beads.

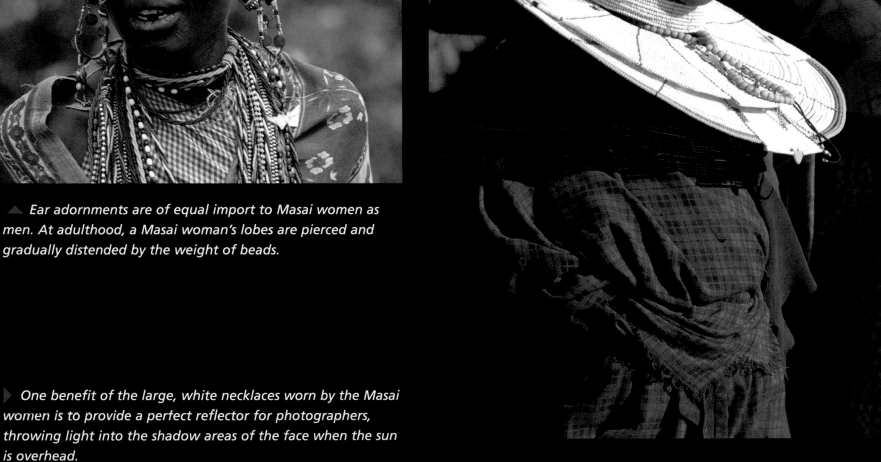

One benefit of the large, white necklaces worn by the Masai women is to provide a perfect reflector for photographers, throwing light into the shadow areas of the face when the sun is overhead.

typically shy people who value their privacy and visitors should respect these values. One of the most effective means of photographing the Masai and their customs is to visit a *manyatta* – a Masai village – that consists of a circular encampment of long, low rounded houses, created by daubing cattle dung over a framework of wooden poles. Guided visits are often better informed but you should take the opportunity to step away from

pre-set activities and use a medium telephoto lens to record some of the more candid moments that will undoubtedly present themselves. For anyone photographing with a digital camera you will find the villagers take a keen interest in the pictures you make and letting them enjoy the facilities of the playback function and LCD monitor often encourages greater participation from your subjects.

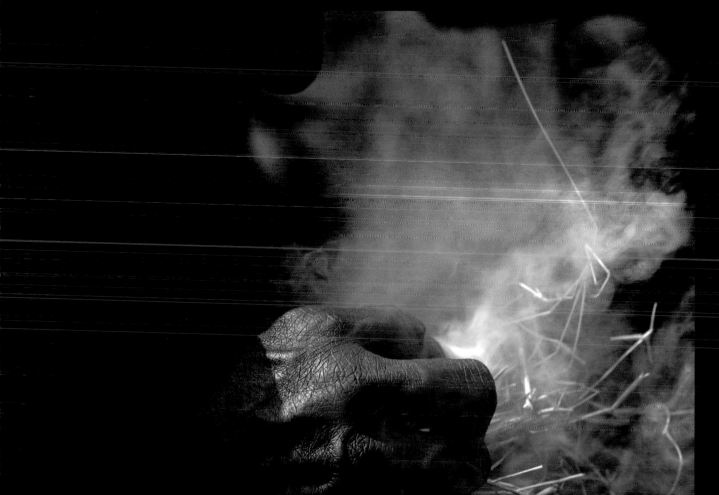

◀ *A Masai moran lights a fire using traditional methods of heat generated by friction. Although open to and embracing of some modern ways of life, the Masai retain their knowledge of living off the land.*

◀ *The best place to photograph Masai people is at a formal manyatta (village). On the open plains of the Masai Mara, Serengeti and Ngorongoro Conservation Area it is respectful to seek permission before taking photographs – and be prepared to be refused.*

◀ *A Masai elder takes time out to shape his rungu.*

Mount Kenya National Park, Kenya

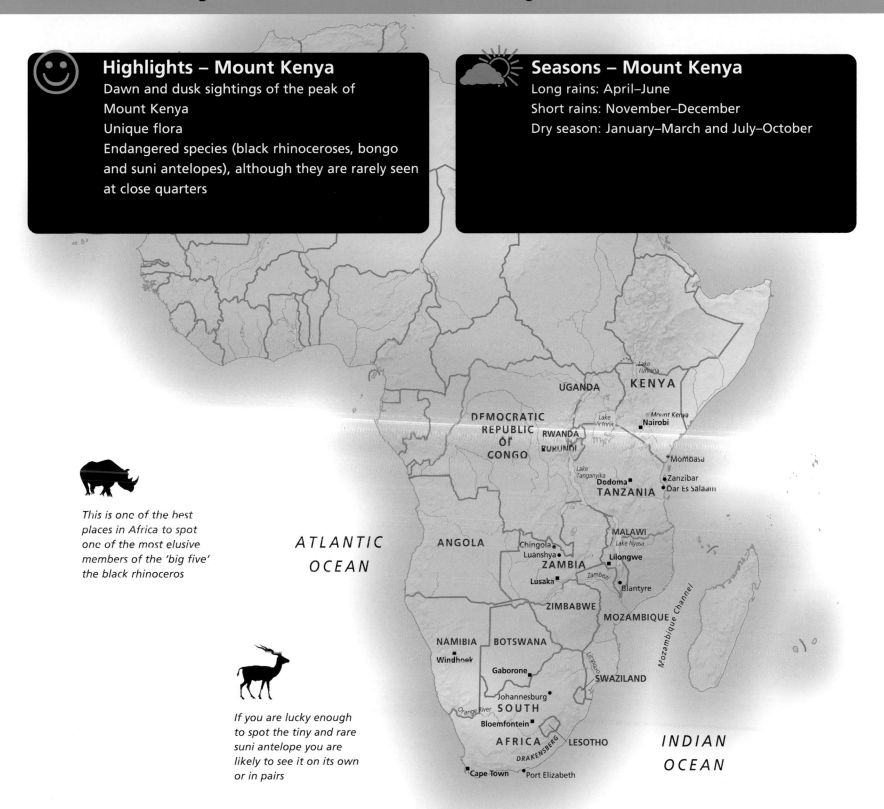

☺ **Highlights – Mount Kenya**
Dawn and dusk sightings of the peak of
Mount Kenya
Unique flora
Endangered species (black rhinoceroses, bongo
and suni antelopes), although they are rarely seen
at close quarters

Seasons – Mount Kenya
Long rains: April–June
Short rains: November–December
Dry season: January–March and July–October

*This is one of the best
places in Africa to spot
one of the most elusive
members of the 'big five'
the black rhinoceros*

*If you are lucky enough
to spot the tiny and rare
suni antelope you are
likely to see it on its own
or in pairs*

UGANDA
KENYA
Lake
Turkana
DEMOCRATIC
REPUBLIC
OF
CONGO
RWANDA
BURUNDI
Lake
Victoria
Mount Kenya
Nairobi
Mombasa
Lake
Tanganyika
Dodoma
Zanzibar
Dar Es Salaam
TANZANIA

ATLANTIC
OCEAN

ANGOLA
MALAWI
Lake Nyasa
Chingola
Luanshya
Lilongwe
ZAMBIA
Zambezi
Lusaka
Blantyre
ZIMBABWE
MOZAMBIQUE
Mozambique Channel

NAMIBIA
BOTSWANA
Windhoek
Gaborone
SWAZILAND
Johannesburg
Limpopo
Orange River
SOUTH
Bloemfontein
AFRICA
LESOTHO
DRAKENSBERG
Cape Town
Port Elizabeth

INDIAN
OCEAN

Highlights – Samburu, Buffalo Springs & Shaba

Gerenuk 'giraffe-necked' antelopes (endemic to the area)

Reticulated giraffes

Grevy's zebras

Leopards (unusually, commonly seen in daylight)

Samburu indigenous people

Seasons – Samburu, Buffalo Springs & Shaba

Long rains: April–June

Short rains: November–December

Dry season: January–March and July–October

Look out for the native gerenuk 'giraffe-necked' antelopes

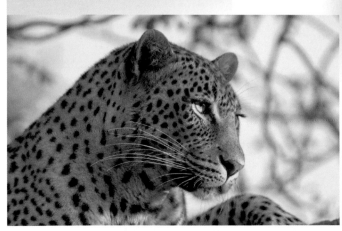

▼ *Leopards can be seen during daylight hours, an unusual sight in Africa.*

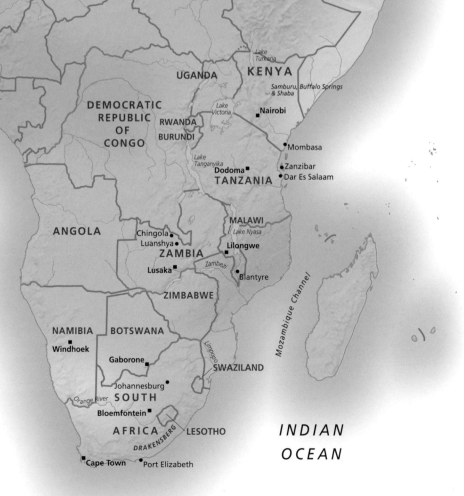

Tsavo & Chyulu Hills National Park, Kenya

Highlights – Tsavo & Chyulu Hills

500 species of birds in Tsavo West

100-strong herds of elephants (often reddish-brown from the richly coloured dust) in Tsavo East

Underwater hippopotamus-viewing hide (Tsavo West)

Mzima Springs attracts large numbers of game (Tsavo West)

Longest lava tube in the world (Chyulu Hills)

Seasons – Tsavo & Chyulu Hills

Long rains: March–May

Short rains: October–December

Dry season: January–March and July–October

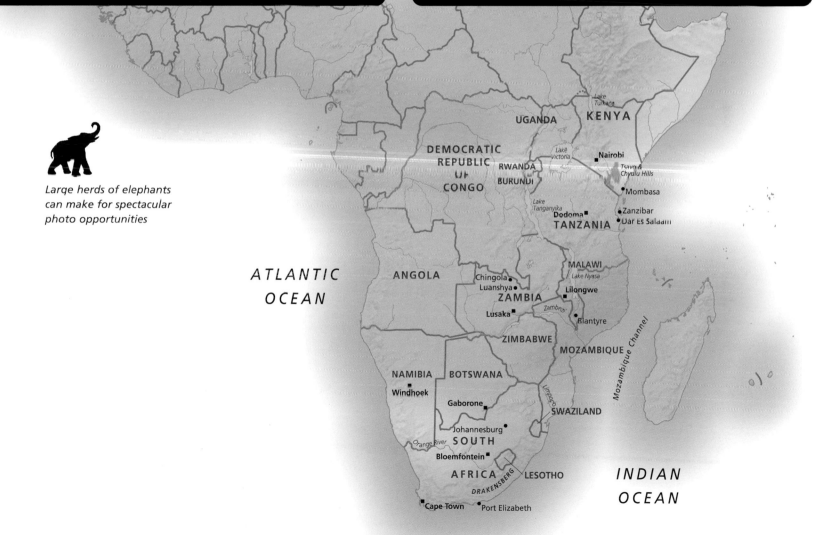

Large herds of elephants can make for spectacular photo opportunities

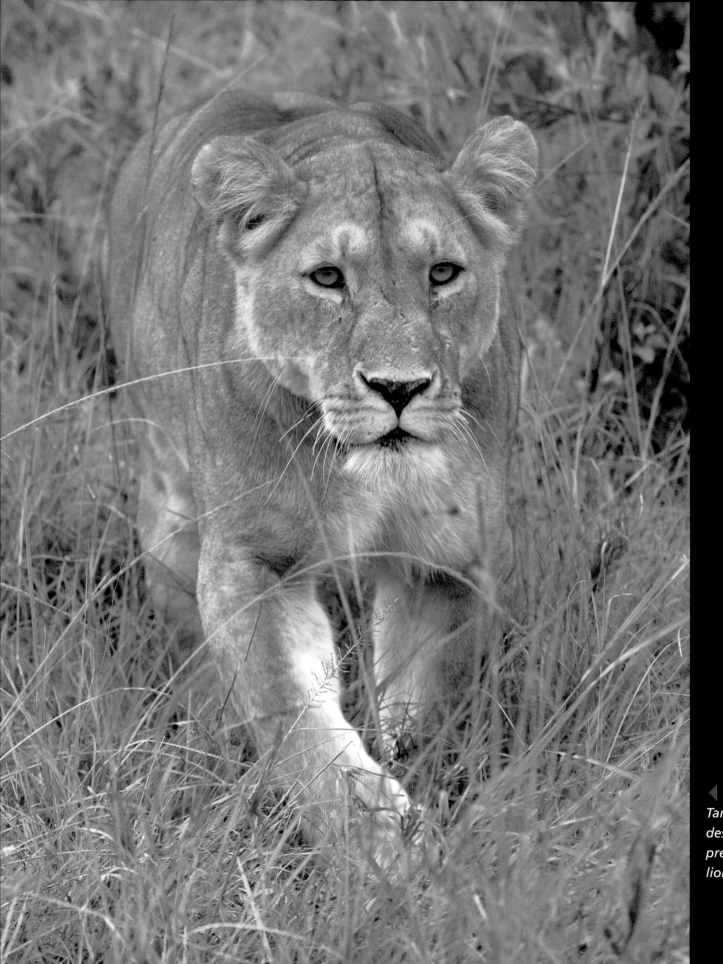

◀ *Katavi National Park* *Tanzania is a reliable* *destination for sightings* *predators, in particular* *lions.*

Arusha and Gombe Stream National Parks, Tanzania

Highlights – Arusha
Black and white colobus monkeys
Views of Mount Meru and Mount Kilimanjaro

Seasons – Arusha
Long rains: March–June
Short rains: November–December (avoid if wanting to climb Mount Meru)
Dry season: July–October (best for game viewing)

Highlights – Gombe Stream
Chimpanzees (many habituated to humans as a result of ongoing research made famous by Dr Jane Goodall)
On-foot safaris
Lake Tanganyika (and submerging baboons)

Seasons – Gombe Stream
Long rains: March–May
Short rains: October–November
Dry season: May–October (best for forest walks)

Highlights – Katavi

Isolated wilderness

Largest of Tanzania's populations of crocodiles and hippopotamuses in Lake Chada

World's largest buffalo herds (around 3,000 individuals)

Good predator sightings, particularly lions

400 species of birds, including large numbers of pelicans

Seasons – Katavi

Long rains: March–May (visits inadvisable)

Dry season: May–October and mid-December–February

Highlights – Mount Kilimanjaro

Africa's highest mountain and the world's highest freestanding mountain

Unique flora and fauna

Seasons – Mount Kilimanjaro

Long rains: April–June

Short rains: November–early December

Dry season: late June–early October (best months for climbing) and late December–early March

Also expect heavy snowfalls. Temperatures above 13,200ft (4,000m) can fall to below 41°F (5°C) and drop well below freezing at the summit.

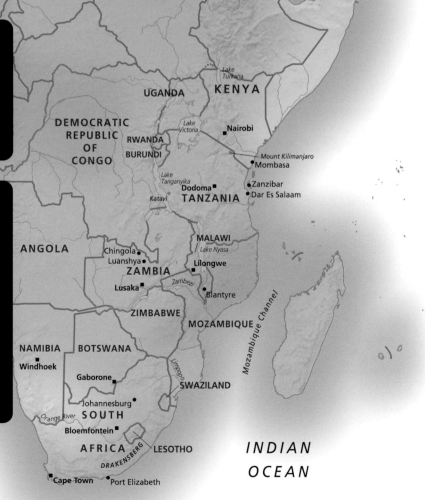

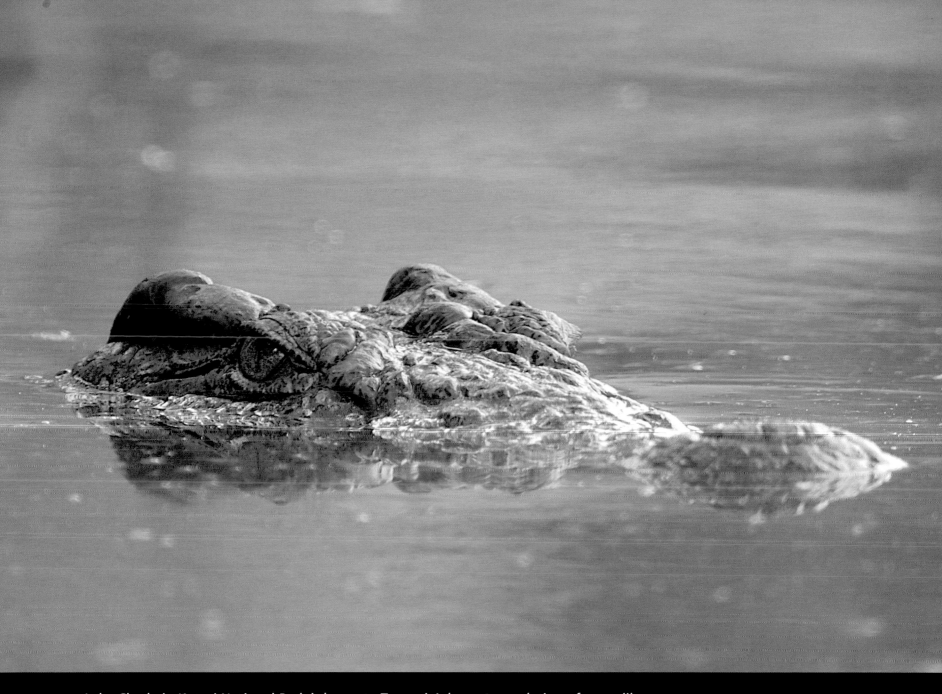

Lake Chada in Katavi National Park is home to Tanzania's largest population of crocodiles.

Highlights – Lake Manyara

Famous tree-climbing lions

Large population of elephants

Flamingos

Giant flocks of red-billed queleas

Seasons – Lake Manyara

Long rains: March–June (best for bird watching)

Short rains: November–December

Dry season: July–October (best for game viewing)

Elegant flocks of flamingos grace Lake Manyara

▼ *One of only two groups of tree-climbing lions in the world can be seen at Lake Manyara.*

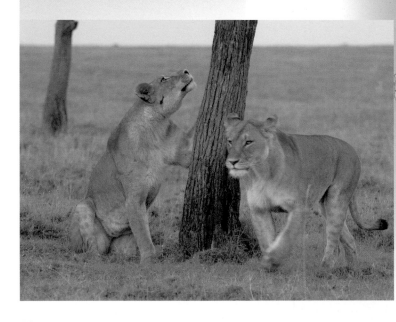

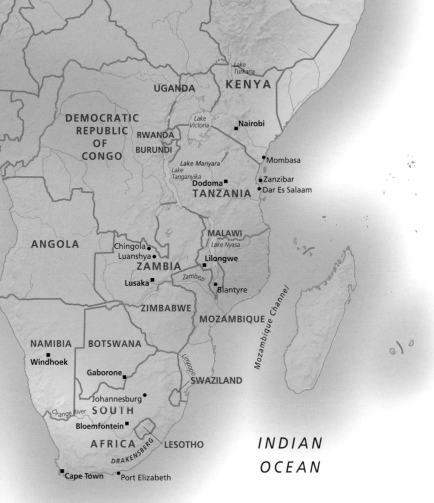

Mahale Mountains National Park, Tanzania

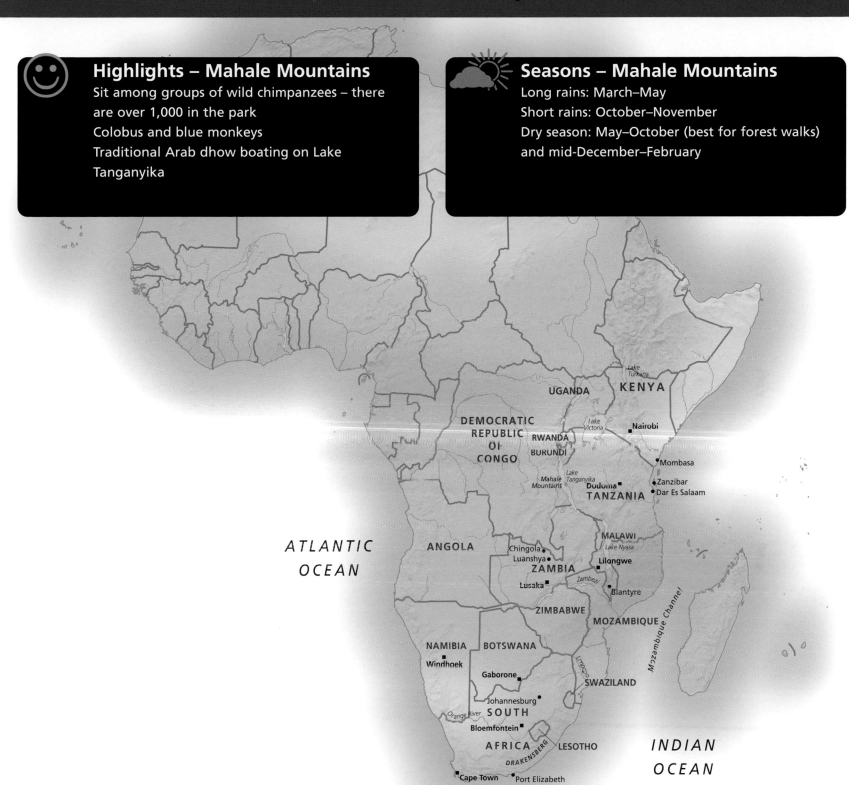

Highlights – Mahale Mountains
Sit among groups of wild chimpanzees – there are over 1,000 in the park
Colobus and blue monkeys
Traditional Arab dhow boating on Lake Tanganyika

Seasons – Mahale Mountains
Long rains: March–May
Short rains: October–November
Dry season: May–October (best for forest walks) and mid-December–February

Lake Turkana

UGANDA KENYA

DEMOCRATIC
REPUBLIC
OF
CONGO RWANDA
Lake Victoria Nairobi
BURUNDI

Mombasa

Mahale
Mountains
Lake Tanganyika
Dodoma Zanzibar
Dar Es Salaam
TANZANIA

MALAWI
Lake Nyasa

ATLANTIC
OCEAN

ANGOLA Chingola
Luanshya Lilongwe

ZAMBIA Zambezi
Lusaka Blantyre

ZIMBABWE
MOZAMBIQUE

Mozambique Channel

NAMIBIA BOTSWANA
Windhoek

Gaborone SWAZILAND

Johannesburg
Orange River SOUTH
Bloemfontein
AFRICA LESOTHO INDIAN
DRAKENSBERG OCEAN
Cape Town Port Elizabeth

Limpopo

Highlights

Black rhinoceroses

Plains teeming with grazing animals

Black-maned lions

Clans of spotted hyenas

Seasons

Long rains: March–May

Short rains: November–December

Dry season: June–October

Accessibility

The Crater Conservation Area is open throughout the year but movement is often restricted during the wet season, which runs from November to May. This is the time to see the crater at its greenest and is also when most animals give birth to young, increasing the likelihood of seeing the big predators. Migrating birds also arrive during the rainy season. In the dry season (June to October) wildlife remains bountiful within the crater itself and the grasses have turned brown–yellow in colour. Restrictions are placed on how long each vehicle can spend in the park. At the time of writing there is a maximum of six hours per day per vehicle allowed, longer stays can be applied for, but are not guaranteed.

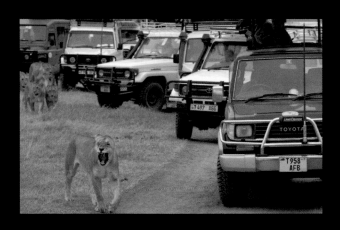

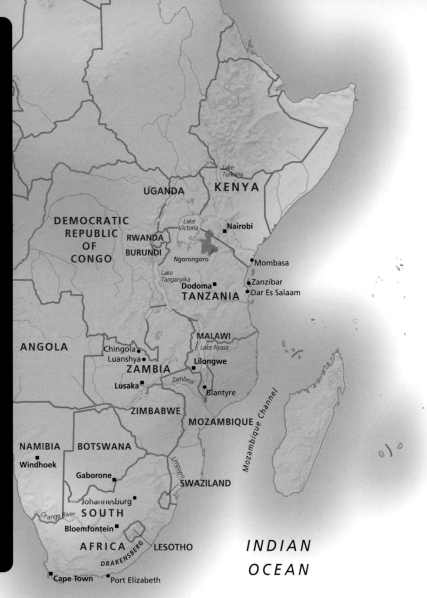

Game viewing

The Ngorongoro Crater is a natural amphitheatre containing the largest concentration of wildlife on Earth, with around 30,000 animals – half of which are zebras and wildebeeste – inhabiting the 100 sq. mile (259km$^2$) caldera. It is a mini-ecosystem within itself, having everything necessary for wildlife to exist and thrive to the extent that many never leave the crater floor.

With such a large population of ungulates it is a perfect habitat for large predators, most of which exist here. Lions and spotted hyenas are the principal hunters, but there are also cheetahs and three species of jackals. On the slopes and along the rim are the elusive leopards, which occasionally venture into the crater. Noteworthy too are Tanzania's few remaining black rhinoceroses, which are often seen.

A major attraction of the crater is Lake Magadi with its salt-whitened shores that turn a shade of pastel pink with the arrival of thousands of lesser and greater flamingos. These majestic birds parade in the hostile waters, sifting for algae and shrimps. Every so often they will scatter in a flurry of feathers, completing a flying circuit of the soda lake before settling again in a slightly different area to the one they left. Other wading birds join them, including avocets, plovers and black-winged stilts.

All of them compete for space with the large pods of hippopotamuses that lounge partially submerged during the heat of the day. It is worth spending some time at the edge of Magadi as, along with the flamingo displays, throughout the day various other animals come to drink.

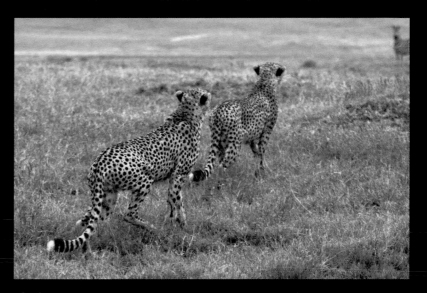

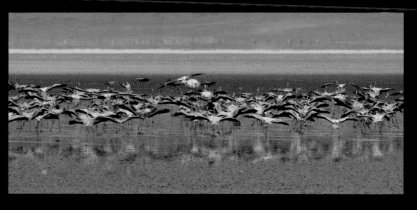

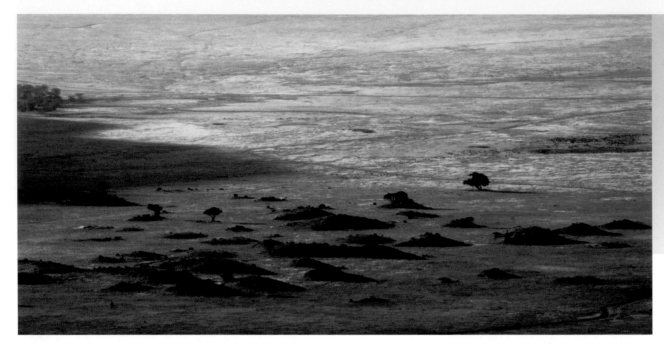

◀ Before it collapsed, the Ngorongoro volcano once rivalled Mount Kilimanjaro in size. Today, Ngorongoro is a giant caldera supporting the largest concentration of animals on Earth.

The Ngorongoro Conservation Area is situated within the crater highlands of northern Tanzania and forms part of what is referred to as the Serengeti-Ngorongoro-Masai Mara ecosystem. Its boundaries are formed by the Great Rift Valley to the east and Serengeti National Park to the west. The landscape is a juxtaposition of ancient and (relatively) new geological events. The granite outcrops scattered throughout the Serengeti Plains are several hundred million years old.

History and background

Around 20 million years ago, eastern Africa began to crack and rift causing the land in between to sink and the earth's crust to thin and soften. In turn, molten materials were pushed to the surface and lava beds and, later, volcanoes followed. Within the Ngorongoro region eight major volcanoes were formed along the Eyasi Rift – Lemagrut, Sadiman, Oldeani, Ngorongoro, Olmoti, Sirua, Lolmalasin and Empakaai.

Ngorongoro itself once rivalled Mount Kilimanjaro in size before the lava that filled the volcano and formed a solid lid collapsed, creating the giant caldera that is now the Ngorongoro Crater. Close by, Olmoti and Empakaai also collapsed but without quite the same effect. The huge quantities of ash produced by the volcanoes had a lasting effect on the environment.

Outside the conservation area crop production is enriched by the fertile soils, while inside it the lush savannah grasslands support one of the world's greatest concentrations of ungulate herds. In nearby Olduvai (Oldupai) Gorge archaeologists and palaeontologists have had access to a fossil treasure trove, preserved by the volcanic ash, which has led to a much greater understanding of origins of modern man – hence the area's common title, 'The Cradle of Mankind'.

Ecology and conservation

In total the Ngorongoro Conservation Area covers an area of 5,175 sq. miles (8,280km²). Habitat ranges from swamps to lakes, rivers, forests and savannah woodlands, grassy plains, mountains and volcanic craters – the most famous of which is the Ngorongoro Crater. Being in the shadow of the mountains, the western plains are prone to elongated dry spells but the slopes to the south and east receive high precipitation. The area is approached from Arusha – the tourist centre of Tanzania – via the agricultural regions of Karatu and Oldeani.

From the Lodware entrance gate the scenery and habitat changes to beautiful montane forest before the road emerges at the edge of the Ngorongoro Crater. The floor of the crater is predominantly grassy plains and home to one of the largest concentrations of wildlife on earth. Managing the crater is a complex process of balancing the needs of the wildlife and vegetation with those of the Masai pastoralists and their cattle, as well as tourists. It is no simple task.

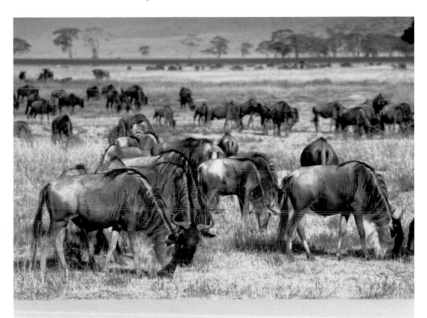

▲ Of the 30,000 animals ever-present in the Ngorongoro Crater, over half are wildebeeste and zebras. With such a large population of ungulates, the Crater is a perfect habitat for large predators and lions, cheetahs, leopards and spotted hyenas can all be seen on the crater floor.

▼ The habitat of the Ngorongoro Conservation Area ranges from swamps, rivers and lakes to forest and savannah woodlands, grassy plains, mountains and volcanic craters – the most famous of which is the Ngorongoro Crater.

Olduvai Gorge – the cradle of mankind

Lying between Ngorongoro Crater and Serengeti National Park, Olduvai (or, more correctly Oldupai) Gorge is one of the world's most important archaeological sites. About 3.5 million years ago our ancestors walked upright across rain-dampened volcanic ash deposit in an area we know as Laetoli. Shortly thereafter, a fresh layer of ash covered their tracks, preserving them until they were revealed in 1978. Their discovery has given us a far greater understanding of our ancestry than we have ever enjoyed before.

At the site there is a small museum in the visitors' centre and rangers give short talks explaining the importance of the site and its ecology. Guides are also available to take visitors into the Gorge itself. Early morning and late afternoon are the best times for photography of the landscape from the viewpoints at the visitor centre but the floor of the Gorge is in shadow until the sun rises to illuminate it later in the day. A polarizing filter will help to saturate the colours of the rocks and a graduated neutral density filter will help to even out the tones between the Gorge floor and the sky.

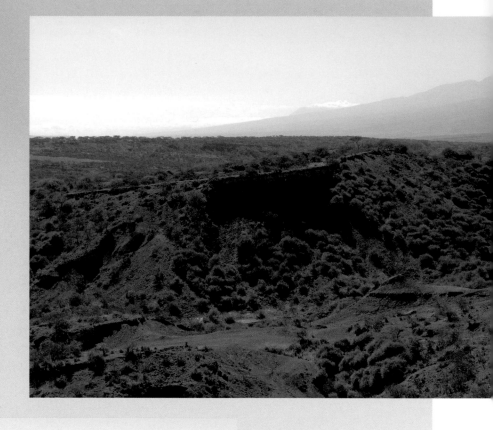

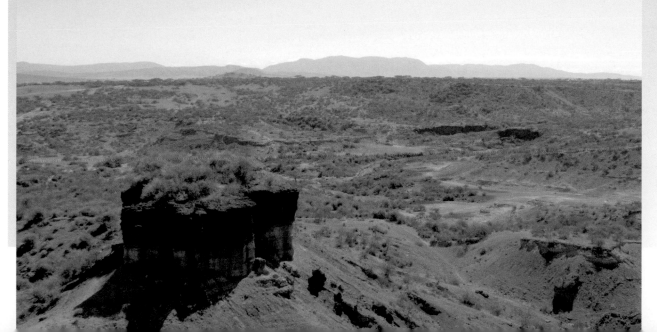

◀ ▲ *Oldupai Gorge, lying between the Ngorongoro Crater and Serengeti National Park, is one of the world's most important archaeological sites and is referred to locally as the 'cradle of mankind'.*

Photographic tips

It is worth taking a variety of focal length lenses from wideangles for scenic shots to long telephotos for frame-filling images of shyer creatures, such as cheetahs, and distant birds on Lake Magadi. Visitors must remain in vehicles while in the crater and so a beanbag will be necessary for supporting long, heavy lenses.

In winter the crater floor is dry and dusty and the heavy concentration of vehicles will raise a lot of dust so be careful to protect your equipment. Exciting animal sightings are often accompanied by a jam of vehicles so prepare yourself for a long wait.

▼ *In much of Africa dust can play havoc with photographic equipment, particularly digital cameras, which are more prone to dust than their film counterparts.*

Ruaha National Park, Tanzania

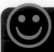

Highlights – Ruaha

Eurasian migrating birds (March–April and October–December)

Large populations of elephants and buffalos

Wild dogs

Roan and sable antelopes

Seasons – Ruaha

Long rains: January–April (best for bird watching)

Dry season: May–December (best for game viewing and predator sightings)

A number of antelope species can be seen in Ruaha including roan and sable antelopes

▼ *Large herds of buffalos can be seen in Tanzania's Ruaha National Park.*

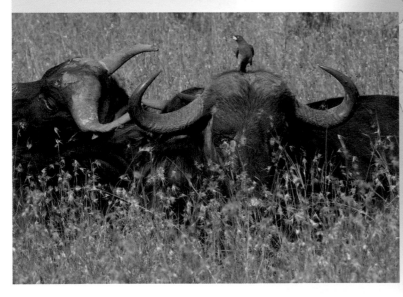

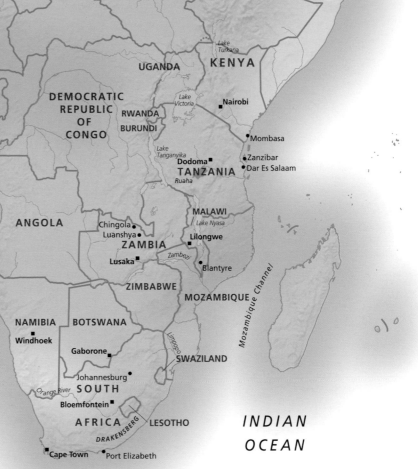

60

Selous Game Reserve, Tanzania

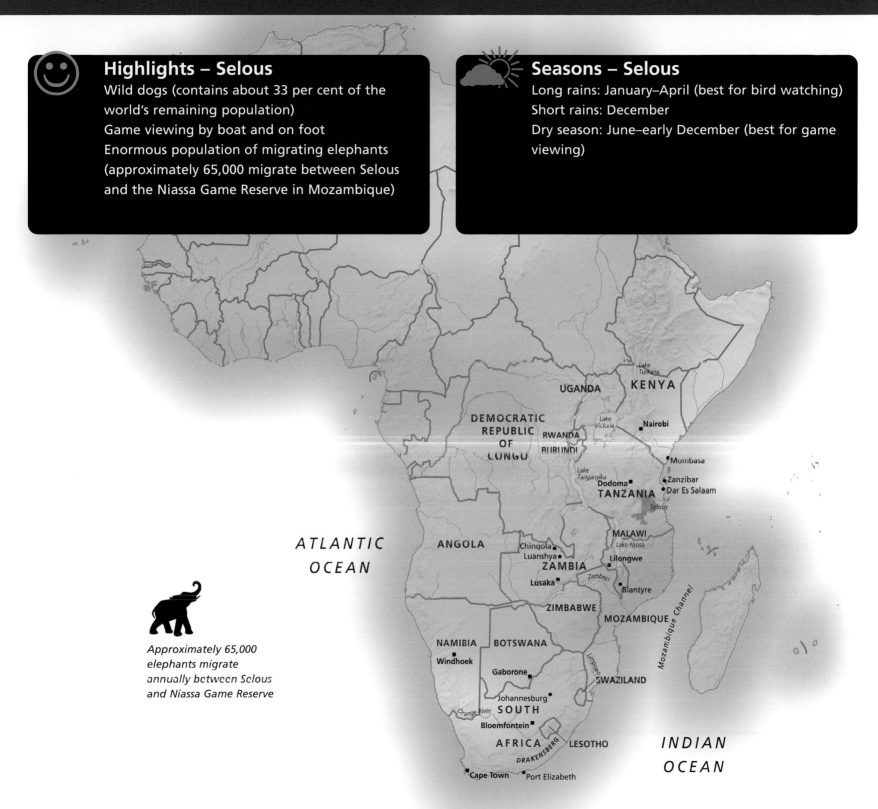

Highlights – Selous
Wild dogs (contains about 33 per cent of the world's remaining population)
Game viewing by boat and on foot
Enormous population of migrating elephants (approximately 65,000 migrate between Selous and the Niassa Game Reserve in Mozambique)

Seasons – Selous
Long rains: January–April (best for bird watching)
Short rains: December
Dry season: June–early December (best for game viewing)

Approximately 65,000 elephants migrate annually between Selous and Niassa Game Reserve

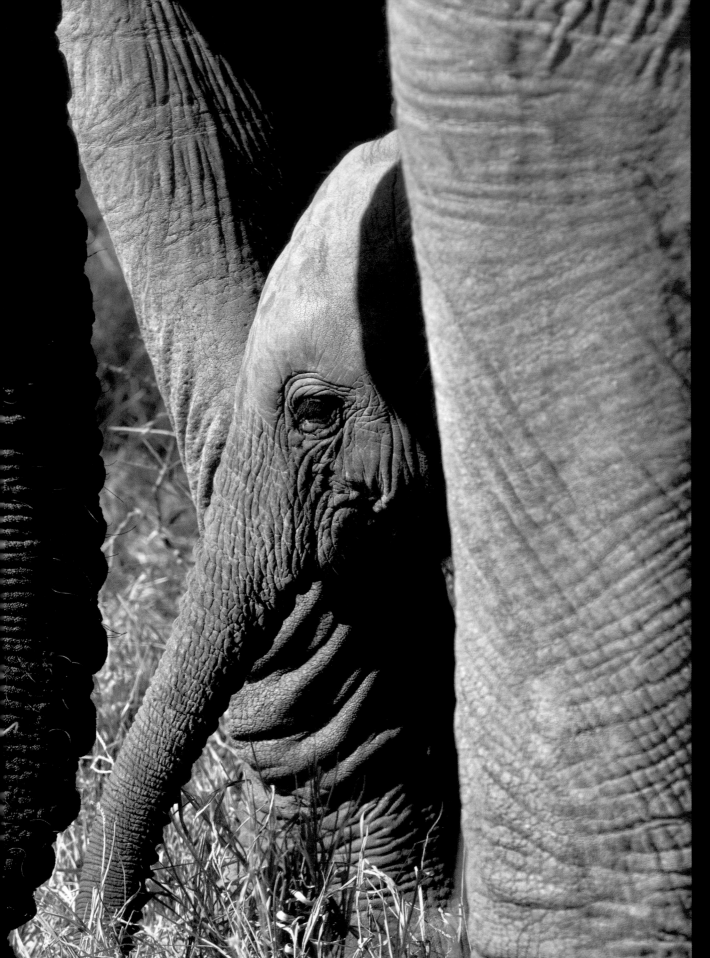

A young elephant, just a few days old, discovers the world from within the protective circle of its family's legs.

Serengeti National Park, Tanzania

Highlights – Serengeti
Annual wildebeeste migration
Large numbers of lion prides
Hunting cheetahs

Seasons – Serengeti
Long rains: March–May
Short rains: November–December
Dry season: June–October and January–February
(best for sightings of hunting cheetahs)

Of the Serengeti, a Masai name that translates as 'Endless Plain', George Schaller, one of the world's greatest naturalists, wrote: 'To witness that calm rhythm of life revives our worn souls and recaptures a feeling of belonging to the natural world. No-one can return from the Serengeti unchanged, for tawny lions will forever prowl our memory and the great herds throng our imagination.'

History and ecology

Serengeti National Park is perhaps Africa's most famous wildlife destination. Vast plains stretch beyond a horizon dotted with woodlands and vast herds of migratory and resident grazers and browsers, along with their entourage of predators and scavengers. It is an extraordinary example of biodiversity and a wonder to behold.

The beginnings of the Serengeti ecosystem formed around 10–12 million years ago when the prevailing winds that collected moisture from the Indian Ocean and crossed Africa were obstructed by the uplift affiliated with the Great Rift Valley. This first caused the climate to become drier and subsequent volcanic eruptions from the volcanoes of the Ngorongoro highlands spewed vast quantities of dust that blanketed the plains below with fertile ash.

In the last 3.5 million years little has changed and the Serengeti remains one of the most intact savannah ecosystems left in the world. It is the setting for one of only three remaining large-scale game migrations on Earth – the white-bearded wildebeeste migration (the other two being the tiang and white-eared knob migrations of southern Sudan).

Hunter-gatherers were the first people to inhabit the Serengeti followed more recently by Masai pastoralists. Agriculturalists avoided the area because of the significant presence of tsetse flies that inflicted sleeping sickness on their livestock. Colonialists arriving in the early twentieth century found an unspoiled land and exploited its game, in particular lion, leopard and buffalo, for hunting purposes.

In recognition for the need to preserve the wildlife and habitat of the area, the central Serengeti was declared a Game Reserve in 1929. In 1951 the Reserve became Tanganyika's (the former name of the country of Tanzania) first national park. The extended, current boundaries were set in 1959 when a section of the plains and the highlands were transferred to the Ngorongoro Conservation Area.

◀ *The Serengeti is the world's most famous wildlife sanctuary and a magnet for tourists wanting to see and photograph wildlife. This posse of vehicles was waiting to catch a glimpse of a leopard.*

Geography and animal dispersal

The Serengeti covers an area of 9,225 sq. miles (14,763km$^2$), roughly the size of Northern Ireland (or Connecticut). It lies at the heart of the Serengeti-Ngorongoro-Masai Mara ecosystem, an extended preserved habitat that includes the Masai Mara National Reserve and the Ngorongoro Conservation Area, which protects the single largest movement of animals on Earth – the great migration.

▼ *The Serengeti is synonymous with the world's largest mass dispersal of animals, the great wildebeeste migration. Every year up to 1.5 million gnus pass through the Serengeti on their annual migration following the lush grass that results from the seasonal rains.*

Kopjes rocks

The intriguing rounded shapes of the rock outcrops called kopjes (pronounced 'copies' from the Flemish meaning 'little head') and more technically known as inselbergs are formed of ancient granite and were created by cracking and exposure caused by the weather. They provide shelter for wildlife during spells of intense heat and are a good source of water. Without them, wildlife such as lions would be incapable of surviving the long dry season on the plains.

▼ *Kopjes provide an ideal platform for resting lions, with an unsurpassed view of the surrounding environment. In sweltering heat they also provide shade and water, without which they and other wildlife would struggle to survive.*

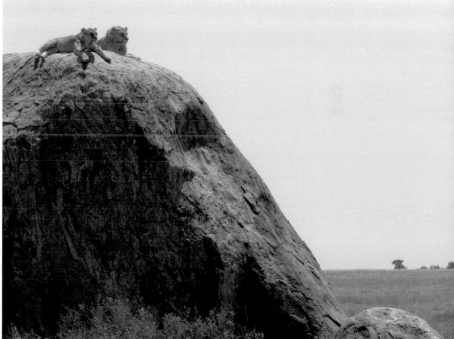

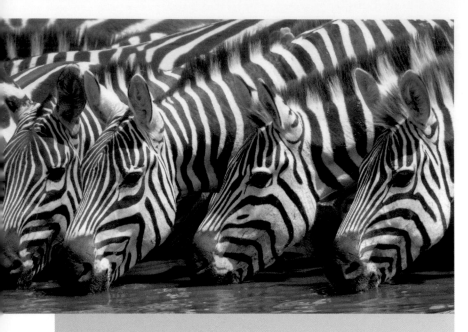

▲ Up to half a million zebras migrate through the Serengeti along with wildebeeste and Thomson's gazelles. All three species are important to the migration process and seemingly co-exist in harmony.

Southern short-grass plains

The southern short-grass plains are some of the most productive and nutritious natural grasslands in existence. In November, during the short rains, the wildebeeste tramp south from the Northern woodlands to exploit the plains, which are rich in the minerals needed for healthy breeding. It is here, from around late January through to early March, that 90 per cent of females give birth and the plains are teeming with wildebeest calves. This is the most likely time for witnessing a big cat kill as lions and cheetahs, in particular, prowl the grasses for easy pickings.

The wildebeeste can remain on the plains for several weeks, sharing the copious food supply with zebras, elands and Thomson's gazelles, as well as resident grazers such as Grant's gazelles, topis and hartebeeste. The area is also used at this time by migratory birds including white storks, pallid harriers and peregrine falcons. When the rains cease, however, the plain quickly dries prompting the herds to head west in miles-long meandering lines and bunched herds towards the western corridor in scenes that typify the migration, before continuing north towards the Mara.

Seronera

The Seronera Valley is a transition zone between the plains and northern woodlands. It is a rich mosaic of habitats crossed by numerous rivers, foremost of which is the Seronera River. With year-round water, this is one of the most reliable areas for observing wildlife, and has many resident species. Giraffes, buffalos, topis, hartebeeste, waterbucks, impalas, reedbucks and dik-diks, as well as hippopotamuses and crocodiles all inhabit this region. There are also large prides of lions and clans of spotted hyenas throughout the Seronera. Leopards are also plentiful although sightings are as elusive as anywhere else, the river tracks being the most fruitful places. Cheetahs, servals and caracals are also present.

The main groups of kopjes are Barafu, Gol, Masai, Loliondo, Simba and Moru and each collection is unique. Moru kopjes are outstanding for their size and lions are often seen around here, along with a profusion of other wildlife, including leopards, servals and caracals. Early Masai paintings are also found at Moru, as well as a special rock used for making music. Gol and Barafu kopjes provide important habitat for cheetahs and are used by wildebeeste during the wet season. Masai and Loliondo kopjes are predominant lookout posts for lions that avoid the large cobras that can regularly be seen basking on the hot surface of the rock. Simba kopjes are the easiest to see – along the main route to Seronera – and are another haunt of lions (simba) after which they are named.

Grumeti western corridor

Bordering Lake Victoria the western corridor is an important feature of ancient migratory routes. Depending on the rains, in a typical year the migration reaches this region of the Serengeti in June and July having departed the now-dry southern plains.

Cutting across the corridor, the Grumeti River supports a lush riverine of forest that contrasts starkly with the surrounding plains and hosts some of the Serengeti's more unusual residents, such as the black and white Colobus monkey. Here too, at Kirawira, you will find Tanzania's fiercest predator – the giant Nile crocodile. Sustained by the annual flow of prey these enormous reptiles can grow to around 20ft (6m) and move with a speed and dexterity belied by their cumbersome appearance. Their existence is inextricably linked to the migration and lucky visitors will witness attacks on thirsty wildebeeste that approach the river nervously to drink. For visits to the Park outside of the main

crossing season in September the Grumeti River provides an opportunity to see a less impressive but equally enthralling event around the time of June. Indeed the period between June and October is the best time to visit the western corridor for photography.

Lobo northern woodlands

Although the northern woodlands have a resident population of wildlife, including elephants, they come to life between June and December when the migrants begin to appear. The area is typified by long, succulent grass, rocky hills, rivers and woodlands and extends into the Masai Mara. Photography can be difficult here as trees and bushes often obscure sightings.

▶ *Around the time of June, the migrating wildebeeste are in the western corridor in Serengeti National Park. On their journey north they cross the Grumeti River, a less spectacular event than the Mara crossing, but equally photogenic.*

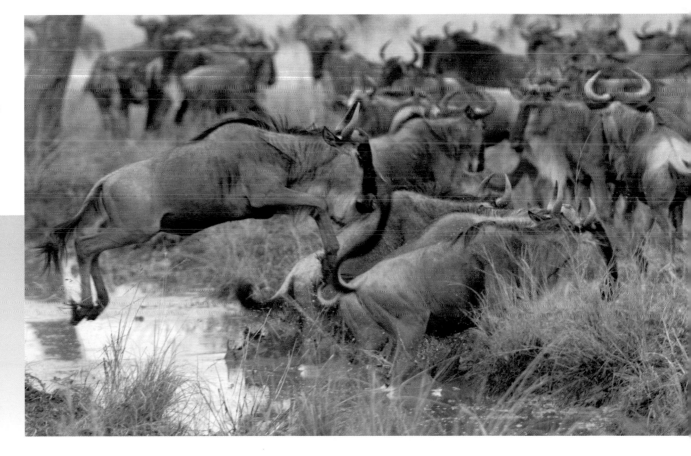

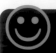

Highlights – Tarangire

A high density of game, second only to the
Ngorongoro Crater
A plethora of game along the Tarangire River
550 species of birds
Tree-climbing pythons

Seasons – Tarangire

Long rains: March–May (visits best avoided during
this period)
Short rains: November–December
Dry season: June–September (best for game
viewing) and January–February

*The density of game in
Tarangire National Park is
second only to that in the
Ngorongoro Crater*

▼ *Approximately 550 species
of bird can be seen in the
Tarangire National Park.*

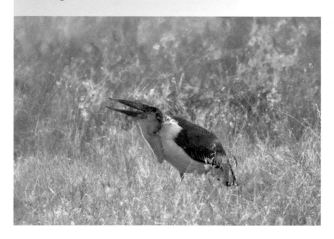

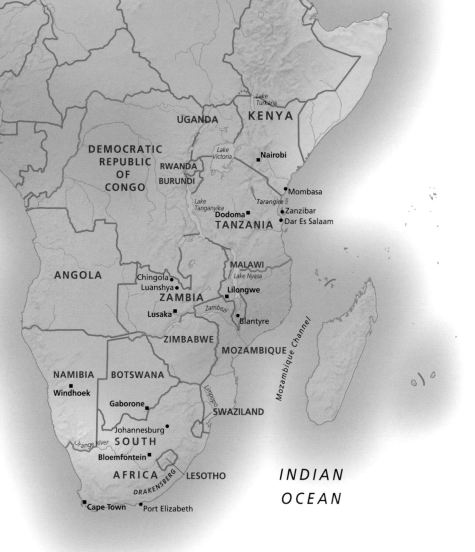

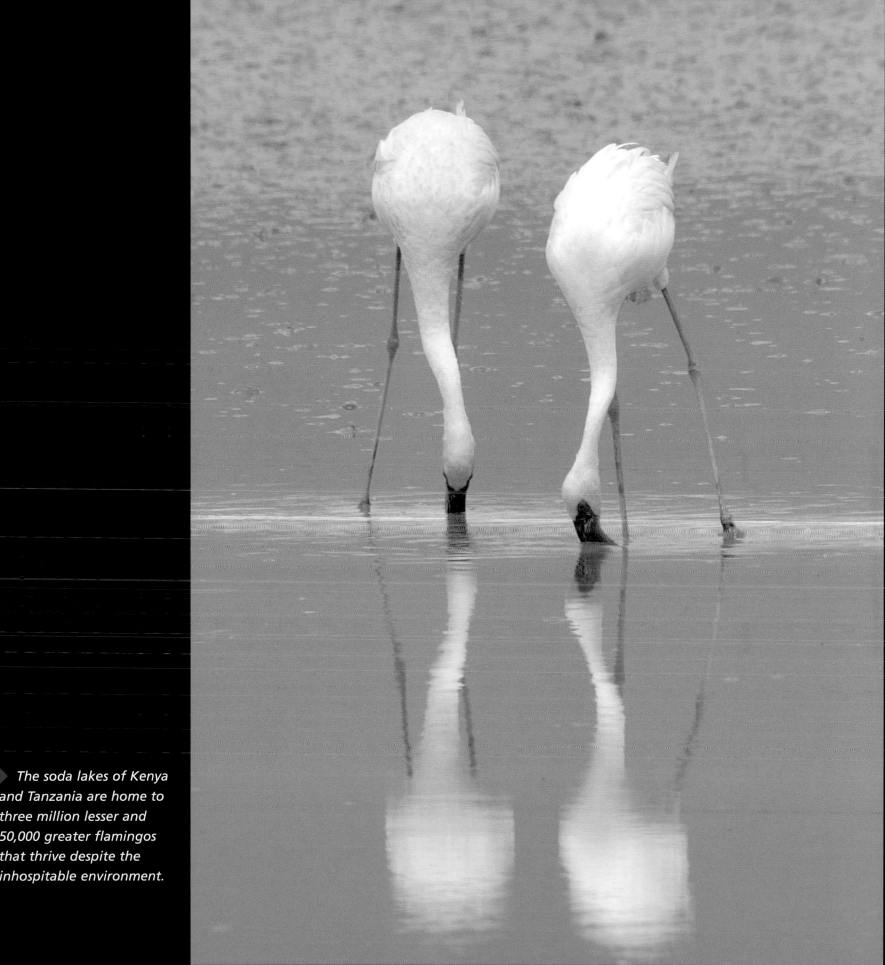

The soda lakes of Kenya and Tanzania are home to three million lesser and 50,000 greater flamingos that thrive despite the inhospitable environment.

Lake Malawi (Lake Nyasa), Malawi

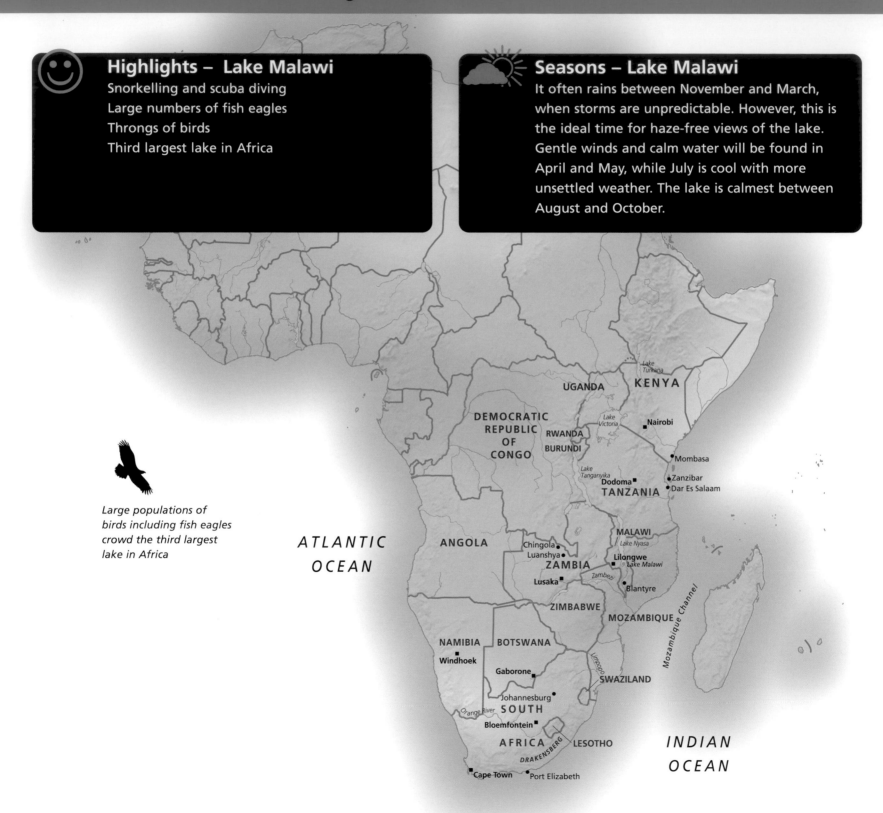

Highlights – Lake Malawi
Snorkelling and scuba diving
Large numbers of fish eagles
Throngs of birds
Third largest lake in Africa

Seasons – Lake Malawi
It often rains between November and March, when storms are unpredictable. However, this is the ideal time for haze-free views of the lake. Gentle winds and calm water will be found in April and May, while July is cool with more unsettled weather. The lake is calmest between August and October.

Large populations of birds including fish eagles crowd the third largest lake in Africa

ATLANTIC OCEAN

INDIAN OCEAN

UGANDA
KENYA
Lake Turkana
DEMOCRATIC REPUBLIC OF CONGO
RWANDA
BURUNDI
Lake Victoria
■Nairobi
•Mombasa
Lake Tanganyika
Dodoma■ •Zanzibar
•Dar Es Salaam
TANZANIA
MALAWI
Lake Nyasa
ANGOLA
Chingola•
Luanshya•
ZAMBIA
Lilongwe■
Lake Malawi
Lusaka■
Zambezi
•Blantyre
ZIMBABWE
MOZAMBIQUE
Mozambique Channel
NAMIBIA
BOTSWANA
■Windhoek
Gaborone■
SWAZILAND
Johannesburg•
Orange River SOUTH
Bloemfontein■
AFRICA LESOTHO
DRAKENSBERG
■Cape Town •Port Elizabeth

Liwonde & Mvuu Wilderness, Malawi

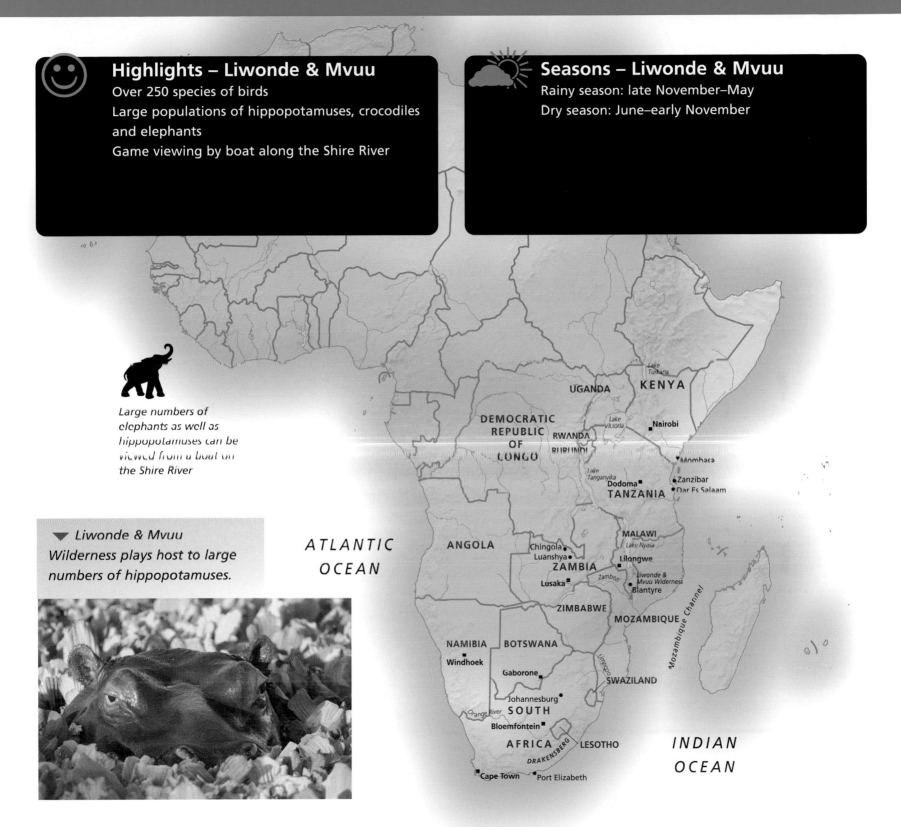

🙂 Highlights – Liwonde & Mvuu
Over 250 species of birds
Large populations of hippopotamuses, crocodiles and elephants
Game viewing by boat along the Shire River

Seasons – Liwonde & Mvuu
Rainy season: late November–May
Dry season: June–early November

Large numbers of elephants as well as hippopotamuses can be viewed from a boat on the Shire River

▼ Liwonde & Mvuu Wilderness plays host to large numbers of hippopotamuses.

UGANDA
KENYA
Lake Turkana
DEMOCRATIC REPUBLIC OF CONGO
RWANDA
BURUNDI
Lake Victoria
Nairobi
Mombasa
Lake Tanganyika
Dodoma
Zanzibar
Dar Es Salaam
TANZANIA

ATLANTIC OCEAN

ANGOLA
MALAWI
Lake Nyasa
Chingola
Luanshya
Lilongwe
ZAMBIA
Zambezi
Liwonde & Mvuu Wilderness
Blantyre
Lusaka
ZIMBABWE
MOZAMBIQUE
Mozambique Channel
NAMIBIA
BOTSWANA
Windhoek
Gaborone
Limpopo
SWAZILAND
Johannesburg
Orange River
SOUTH
Bloemfontein
AFRICA
LESOTHO
DRAKENSBERG
INDIAN OCEAN
Cape Town
Port Elizabeth

Kafue and Lower Zambezi National Parks, Zambia

 Highlights – Kafue
Large variety of antelopes, including roans, sables, hartebeeste, elands, sitatungas and oribis
Numerous predator species, including wild dogs, lions and cheetahs
400 species of birds

 Seasons – Kafue
Hot rainy season: December–April (many lodges are closed during this period)
Cool dry season: May–September
Hot dry season: October–November

 Highlights – Lower Zambezi
Large populations of elephants, crocodiles and hippopotamuses
Swimming elephants
Game viewing by boat
Night drives
Bush walks

 Seasons – Lower Zambezi
Hot rainy season: December–April (many lodges are closed during this period)
Cool dry season: May–September
Hot dry season: October–November

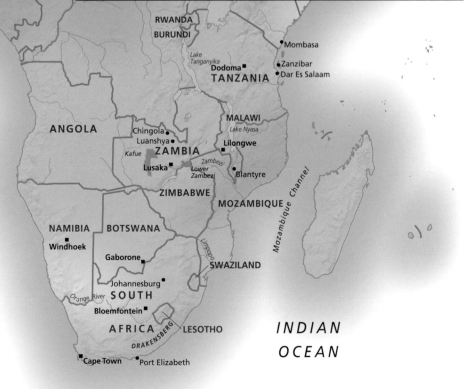

▼ *One of the many predator species in abundance at Kafue is the cheetah.*

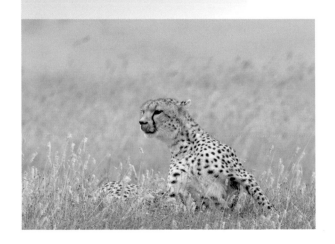

North and South Luangwa National Parks, Zambia

Highlights – North Luangwa

Large herds of buffalos (over 1,000 head per herd)

Numerous bird species

Oribis, hartebeeste and elands

Seasons – North Luangwa

Rainy season: November–March

Dry season: April–October (July–October best for visits)

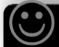

Highlights – South Luangwa

Night sightings of lions and leopards

Honey badgers and civets

Large packs of wild dogs

400 species of birds

Indigenous sub-species of giraffes and zebras

Large pods of hippopotamuses

Night drives and bush walks

Seasons – South Luangwa

Rainy season: December–April

Dry season: May–November (September–October best for game viewing)

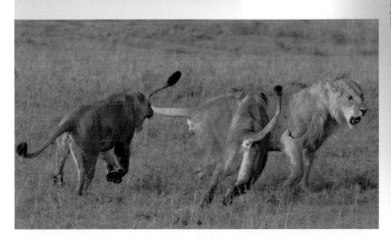

▼ Lions can be frequently seen during both day and night in South Luangwa National Park.

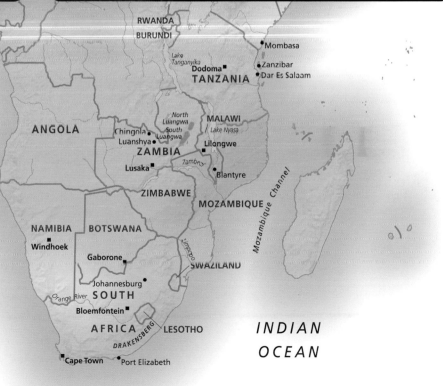

Accessibility

It is possible to explore the falls on foot or from the air. Several well-laid paths provide spectacular views at numerous vantage points that cut through the forest clinging to the edge of the sheer basalt rock. The Knife Edge Bridge is particularly staggering giving anyone who dares to arrest their march onward with a heart-pounding view of the eastern cataract and the main falls towards the 'Boiling Pot'.

Between Zambia and Zimbabwe the Victoria Falls Bridge spans the mighty gorge and forms a no-man's-land between the border posts of the two countries. From the middle of the bridge there is an inspiring view of the tumultuous water and of the lush green mist-soaked forest. For an even more exciting view of the falls you may want to make the terrifying 360ft (111m) bungee leap available here!

Another viewpoint is sometimes open during the dry season when the water level is low. Walking along the lip of the falls it is sometimes possible to reach Livingstone Island, where David Livingstone first glimpsed the Falls, and from which there is perhaps the most impressive view from the ground of all.

The most alluring view of the falls, however, is from the air. There are four main options available, including helicopter, micro-light, light aircraft or Tiger Moth biplane. Which you choose, if any, will depend on what you hope to achieve from the flight. For pure sightseeing helicopter is perhaps the best option. For an adrenaline rush, take the micro-light.

However, for anyone serious about taking photographs, the only viable option is the Tiger Moth, being the only aircraft from which you can photograph without the obstruction of a Perspex window (cameras are not permitted on the micro-lights). That said, if you have plenty of money speak to one of the helicopter operators, they may be willing to fly without the doors attached for a suitable fee – that's how the BBC and *National Geographic* do it!

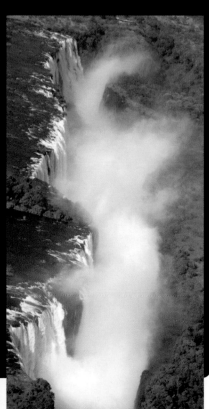

Seasons

Rainy season: peaks in March and April
Dry season: peaks in November and December

Peak flood season is around March to April and the full power of the falls can be experienced during this time. The heavy spray, however, frequently obscures views and it is not an ideal time for photography on foot. However, aerial views can be breathtaking, with mist rising high into the air.

From April onwards the views improve as the water level decreases until November and December when it is at its lowest and in some places the falls are dry. This is the time to photograph the magnitude of the great abyss and the sheer cliffs that form the walls of the chasm.

An ideal time for photographing the falls for a balance between the two extremes is between June and August.

Highlights

Walks along and views of Victoria Falls
Flights over the falls
Lunar rainbow during full moon

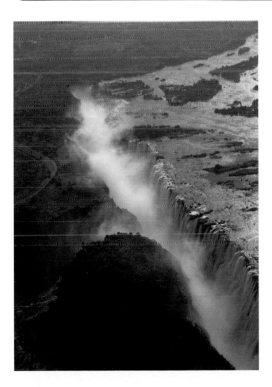

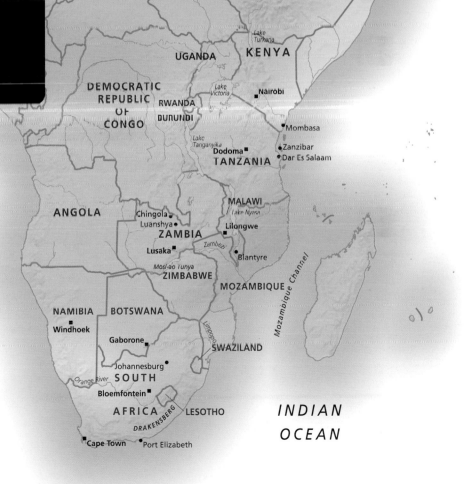

Mosi-ao-Tunya is the Kololo name for Victoria Falls – the Smoke that Thunders. It is an apt title as visitors will hear the falls and see the giant plumes of spray that waft heavenward like billowing smoke long before they ever set eyes on the falls itself. The park is divided into two sections with separate entrances: a game park along the Zambezi riverbank and Victoria Falls. The following information concentrates solely on the latter.

History and background

In 1855 David Livingstone was the first to bring Victoria Falls to the public's attention and it was he that named them after his Queen. The sight that greeted Livingstone and, indeed, greets all visitors is a mile-wide (1.6km) sheer basalt fault line over which the Zambezi River cascades to a depth of 300ft (90m) creating a blossoming cloud of spray that can be seen for twenty miles on a good day and often obscures the falls completely.

The creation of the falls is open to a certain amount of conjecture. It is believed that earth movement during an earlier geological period caused the upper Zambezi to divert from its south-easterly course to an easterly one, thus initiating the development of a waterfall. The basalt in the Livingstone area is characterized by prominent cracks that may have developed as the molten lava cooled. A series of joints running in an east to west direction is associated with areas of soft material within the basalt which, because the course of the Zambezi in this area runs due south, are easily eroded to form the great east–west gorges.

Upstream retreat of the falls is caused by a second series of joints running north to south. Steady erosion caused the Zambezi to be concentrated into a long, narrow cleft and the broad fall line was abandoned. This prompted the narrow gorges to cut back into another

◀ *Although Victoria Falls lends itself to photography using a wideangle lens, here I have used a telephoto lens in order to isolate specific elements of the greater whole.*

transverse fracture zone of soft material creating a broad fall. The process has been repeated over many years and the zigzag nature of the gorges represent seven previous lines of falls. The Devil's Cataract on the Zimbabwean side of the falls, which is between 68 and 120ft (21–37m) lower than the rest of the falls, reveals how the water is starting to cut back along a similar line of weakness.

Photography tips

Photographing at Victoria Falls is like taking pictures during a rainstorm. For photographers the main concern is the camera and keeping the spray away from the front element of the lens. Frequently, the only option is to keep a UV filter in place over the lens and either change or dry it when it becomes too wet for taking quality images. I usually carry several UV filters for this purpose and simply change them over when I reach a dry place.

Cover the camera body with a strong plastic bag or a purpose-made rain protector and a wide-ranging zoom lens (28–200mm is a good range) will negate the need to switch lenses anywhere near the spray. It is also useful to keep a dry towel handy.

A polarizing filter will help to intensify the colours of the multiple rainbows that form in the mist and a tripod will keep the camera steady for long exposures that blur the motion of the falling water for an ethereal effect. Keep your mind open to some of the less obvious shots, such as long telephoto shots of rocks and water droplets.

If you plan to take pictures from the air a zoom lens is recommended as changing lenses in mid-flight can be precarious. Turbulence is likely to be a factor so optically stabilized lenses are useful, and a relatively fast film or ISO rating will help keep shutter speeds high as will setting a wide aperture (depth of field isn't an issue at such a height). Keep the camera strap wrapped around your arm or wrist to avoid dropping the camera.

▲ Victoria Falls is famous for the nearly ever-present double rainbow that can be seen clearly from the Zambian side. A polarizing filter will help to saturate the colours, making them more vivid.

A note about Zimbabwe

Although some visitors naturally prefer the Zambian side of Victoria Falls as the least commercial of the two, some people emphasize that the view from the Zimbabwean side is better. And, if you are willing to cope with the ordeal of customs it is possible to visit both by crossing the Victoria Falls Bridge. However, given the political unrest in Zimbabwe (at the time of writing) I would advise against making the trip.

Hlane Game Reserve, Swaziland

Highlights – Hlane

Numerous species of eagles and other raptors

Guided bush walks

Seasons – Hlane

Rainy season: October–May

Dry season: June–September

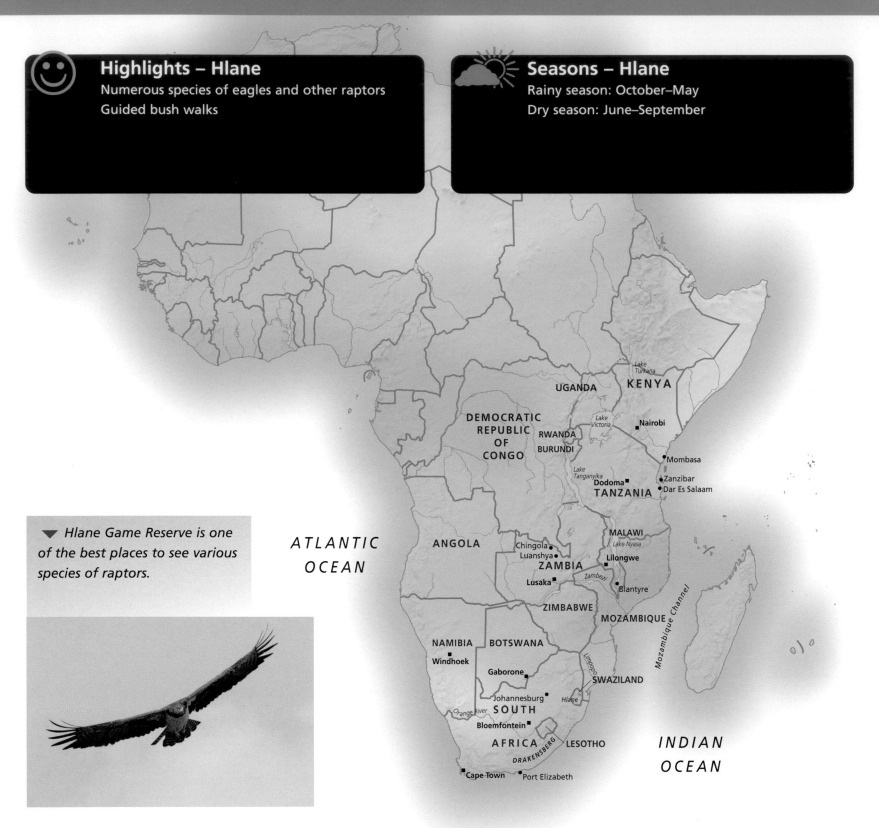

▼ Hlane Game Reserve is one of the best places to see various species of raptors.

KENYA

UGANDA

DEMOCRATIC REPUBLIC OF CONGO

RWANDA

BURUNDI

Lake Turkana

Lake Victoria

Nairobi

Mombasa

Lake Tanganyika

Dodoma

Zanzibar

Dar Es Salaam

TANZANIA

ATLANTIC OCEAN

ANGOLA

Chingola

Luanshya

ZAMBIA

Lusaka

Zambezi

MALAWI

Lake Nyasa

Lilongwe

Blantyre

ZIMBABWE

MOZAMBIQUE

Mozambique Channel

NAMIBIA

BOTSWANA

Windhoek

Gaborone

Limpopo

SWAZILAND

Johannesburg

Hlane

Orange River

SOUTH

Bloemfontein

AFRICA

DRAKENSBERG

LESOTHO

Cape Town

Port Elizabeth

INDIAN OCEAN

Malolotja Nature Reserve, Swaziland

ATLANTIC
OCEAN

INDIAN
OCEAN

UGANDA
KENYA
Lake
Turkana
DEMOCRATIC
REPUBLIC
OF
CONGO
RWANDA
BURUNDI
Lake
Victoria
•Nairobi
•Mombasa
Lake
Tanganyika
Dodoma■
•Zanzibar
•Dar Es Salaam
TANZANIA
MALAWI
Lake Nyasa
ANGOLA
Chingola•
Luanshya•
•Lilongwe
ZAMBIA
Zambezi
Lusaka■
•Blantyre
ZIMBABWE
MOZAMBIQUE
Mozambique Channel
NAMIBIA
BOTSWANA
Windhoek■
Gaborone■
Limpopo
SWAZILAND
Malolotja
Johannesburg•
SOUTH
Orange River
Bloemfontein■
AFRICA
DRAKENSBERG
LESOTHO
■Cape Town
•Port Elizabeth

Addo Elephant Park and Blyde River Canyon, South Africa

 Highlights – Addo Elephant Park
Elephants
Flightless dung beetles

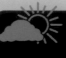 **Seasons – Addo Elephant Park**
Spring: September–November
Summer: December–February
Autumn: March–May
Winter: June–August

 Highlights – Blyde River Canyon
Spectacular views of the Canyon
Hiking trails
Bourke's Luck potholes
Rich and varied flora

 Seasons – Blyde River Canyon
Rainy season: October–March (expect summer haze)
Dry season: April–September

Addo Elephant Park – as the name suggests – is one of the best places for viewing elephants in Africa

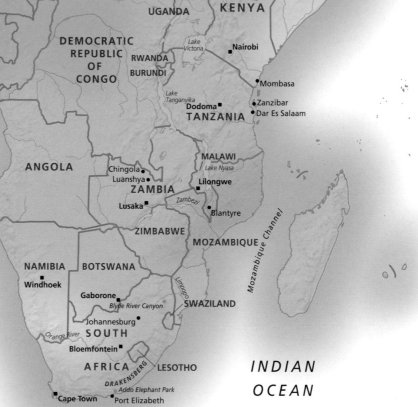

Cape Peninsula and Drakensberg Mountains, South Africa

 Highlights – Cape Peninsula
Table Mountain
Breathtaking scenery and coastline
Whale watching
Boulders Beach penguin colony
Fynbos – the world's sixth floral kingdom – with around 2,250 plant species

 Seasons – Cape Peninsula
Rainy season: May–September
Dry season: October–February

 Highlights – Drakensberg Mountains
Spectacular scenery
Hiking trails
Black eagles and vultures

 Seasons – Drakensberg Mountains
Rainy season: October–April
Dry season: May–September

▼ *Eagles and vultures are a common sight in the Drakensberg Mountains.*

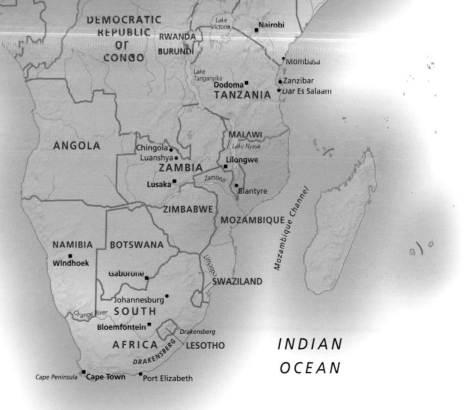

Hluhluwe & Umfolozi Game Reserves, South Africa

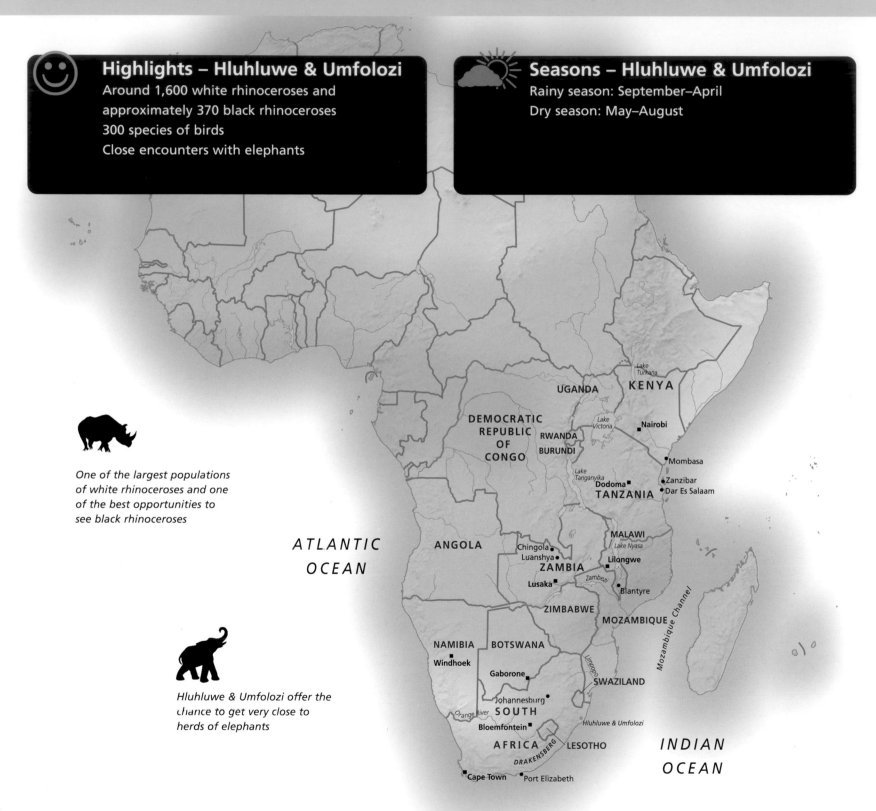

☺ **Highlights – Hluhluwe & Umfolozi**
Around 1,600 white rhinoceroses and
approximately 370 black rhinoceroses
300 species of birds
Close encounters with elephants

Seasons – Hluhluwe & Umfolozi
Rainy season: September–April
Dry season: May–August

*One of the largest populations
of white rhinoceroses and one
of the best opportunities to
see black rhinoceroses*

*Hluhluwe & Umfolozi offer the
chance to get very close to
herds of elephants*

ATLANTIC
OCEAN

UGANDA
KENYA
DEMOCRATIC
REPUBLIC
OF
CONGO
RWANDA
BURUNDI
Lake
Victoria
Nairobi
Lake
Turkana
Mombasa
Lake
Tanganyika
Dodoma
Zanzibar
Dar Es Salaam
TANZANIA

ANGOLA
MALAWI
Lake Nyasa
Chingola
Luanshya
Lilongwe
ZAMBIA
Zambezi
Blantyre
Lusaka
ZIMBABWE
MOZAMBIQUE
Mozambique Channel

NAMIBIA
BOTSWANA
Windhoek
Gaborone
Limpopo
SWAZILAND
Johannesburg
Orange River
SOUTH
Hluhluwe & Umfolozi
Bloemfontein
AFRICA
LESOTHO
DRAKENSBERG
INDIAN
OCEAN
Cape Town
Port Elizabeth

Kalahari Gemsbok, South Africa

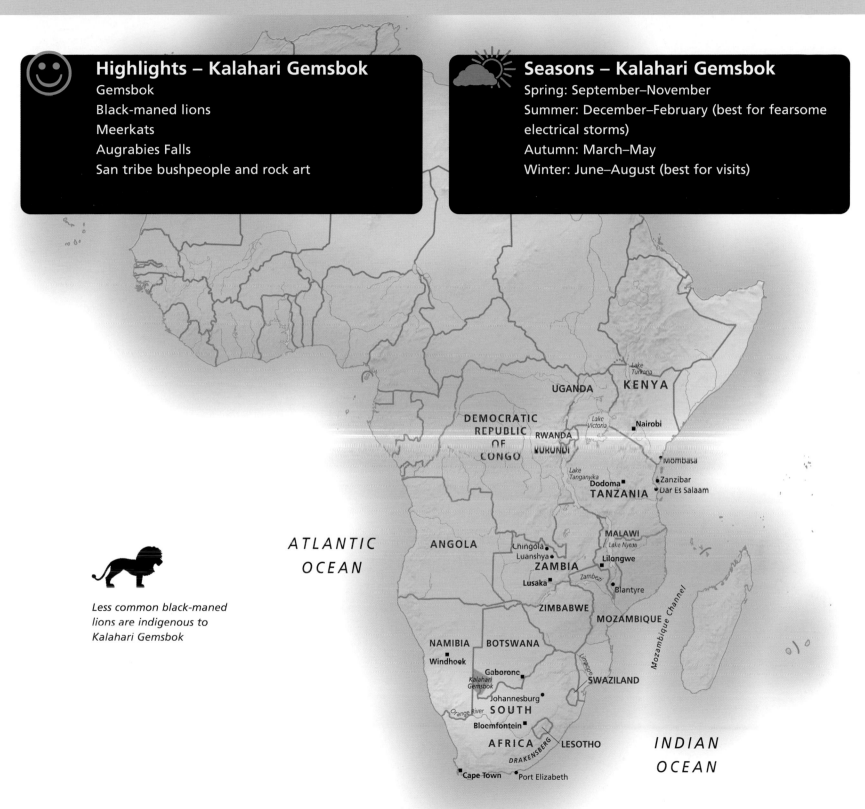

Highlights – Kalahari Gemsbok

Gemsbok

Black-maned lions

Meerkats

Augrabies Falls

San tribe bushpeople and rock art

Seasons – Kalahari Gemsbok

Spring: September–November

Summer: December–February (best for fearsome electrical storms)

Autumn: March–May

Winter: June–August (best for visits)

Less common black-maned lions are indigenous to Kalahari Gemsbok

ATLANTIC OCEAN

INDIAN OCEAN

UGANDA

KENYA

Lake Turkana

DEMOCRATIC REPUBLIC OF CONGO

RWANDA

BURUNDI

Lake Victoria

Nairobi

Mombasa

Lake Tanganyika

Dodoma

Zanzibar

Dar Es Salaam

TANZANIA

MALAWI

Lake Nyasa

ANGOLA

Chingola

Luanshya

Lilongwe

ZAMBIA

Zambezi

Lusaka

Blantyre

ZIMBABWE

MOZAMBIQUE

Mozambique Channel

NAMIBIA

BOTSWANA

Windhoek

Gaborone

Kalahari Gemsbok

SWAZILAND

Limpopo

Johannesburg

Orange River

SOUTH

Bloemfontein

AFRICA

DRAKENSBERG

LESOTHO

Cape Town

Port Elizabeth

Kruger National Park, South Africa

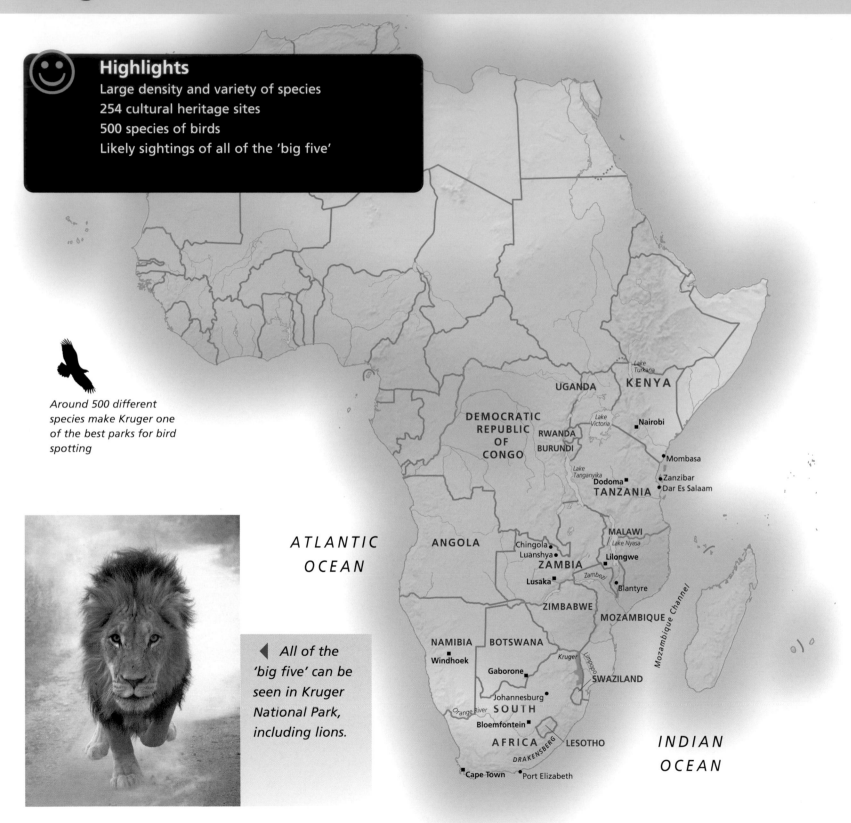

Highlights

Large density and variety of species

254 cultural heritage sites

500 species of birds

Likely sightings of all of the 'big five'

Around 500 different species make Kruger one of the best parks for bird spotting

◀ *All of the 'big five' can be seen in Kruger National Park, including lions.*

ATLANTIC OCEAN

INDIAN OCEAN

Mozambique Channel

Lake Turkana

KENYA

UGANDA

Nairobi

DEMOCRATIC REPUBLIC OF CONGO

RWANDA

BURUNDI

Lake Victoria

Mombasa

Lake Tanganyika

Dodoma

Zanzibar

Dar Es Salaam

TANZANIA

ANGOLA

MALAWI

Lake Nyasa

Chingola

Luanshya

Lilongwe

ZAMBIA

Lusaka

Zambezi

Blantyre

ZIMBABWE

MOZAMBIQUE

NAMIBIA

BOTSWANA

Windhoek

Kruger

Limpopo

Gaborone

SWAZILAND

Johannesburg

SOUTH

Orange River

Bloemfontein

AFRICA

DRAKENSBERG

LESOTHO

Cape Town

Port Elizabeth

Seasons

Rainy season: October–March

Dry season: April–September (best for game viewing)

December–February (Summer)

The summer months of December to January see the height of the wet season. December is the peak of the breeding season for impalas and zebras. January, when rainfall reaches its heaviest, yields blooming summer flowers and large groups of primates among the flowering trees. Waterbucks breed in February and game are often in peak condition. However, during this period the amount of rain means that wildlife is greatly dispersed and vegetation is high and dense, making game viewing difficult and sporadic.

March–May (Autumn)

March sees the last of the main rains and buffalos and kudus breeding at their peak. In April there is a noticeable drop in temperature although late rains are possible. The vivid colour of the red bushwillows is particularly striking at this time and impalas, wildebeeste and warthogs begin rutting, with displays of courtship and aggression. In May animals begin migrating to the warmer areas, with elephants heading north. Game viewing is still difficult at the onset of autumn but improves towards the end of the season.

June–August (Winter)

The onset of winter sees the animals heading for the nutrient-rich eastern grasslands. Rain is rare and vegetation begins to thin. In July the mopaneveld turns from green to yellow and animals' conditions worsen due to the scarcity of water. August is one of the most productive times for predators as the weaker animals suffer due to the lack of food and water brought about by the dry season. Winter is the best season for game viewing as wildlife congregate around the permanent waterholes and vegetation is at its most sparse.

September–November (Spring)

August winds herald the onset of spring and September sees the first of the itinerant rains. Trees begin to flower. Animals are still prevalent around the waterholes. The wet season begins in earnest in October, which also heralds the start of the new breeding season for many smaller mammals. In November rainfall is typically double that of October and vegetation takes on a new lushness. Giraffes, elands, nyalas, impalas and wildebeeste begin to calf and the onset of tiny hooves attracts many predators keen to pick on the easy prey. Game-viewing opportunities diminish as the vegetation thickens towards the end of the season.

 # Game viewing

Parfuri

Although less accessible to tourists, the extreme north of Kruger Park is richer in wildlife than the mopaneveld to the south. However, the remoteness and the lack of an extensive road network makes game viewing more difficult. The Luvuvhu River is especially good for antelopes around the forest fringes, while huge Nile crocodiles and large pods of hippopotamuses inhabit the murky water.

Punda Maria

The complex ecology of the area around Punda Maria ensures a diversity of wildlife, from commonly seen zebras, kudus and elephants to the less visible lions and leopards.

▼ Hippopotamuses are ever present at Sunset Dam, which is a one-minute drive from the camp gate at Lower Sabie in South Africa's Kruger National Park.

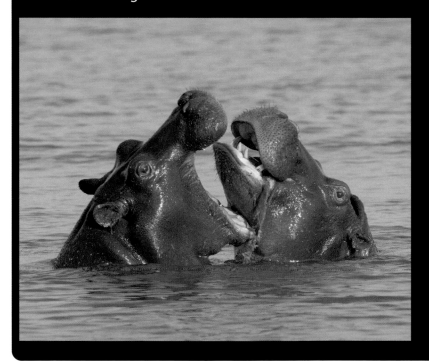

Shingwedzi

The mopaneveld habitat of the region around Shingwedzi attracts large herds of elephants, while the proximity of the Lebombo River provides the greatest diversity of wildlife anywhere in the mopaneveld. The most rewarding game drives are those that follow the course of the river.

Mopani Camp

The area around Mopani traditionally is less productive for game viewing. Sightings are erratic although the Tsendzi River has the potential to conjure elephants, buffalos and rhinoceroses. However, there are better, more likely areas for viewing these creatures.

Olifants and Letaba

Several different ecosystems converge in this area making wildlife viewing rich and rewarding with a great diversity of game. Elephants are a common visitor to the area as are leopards. Hippopotamuses can be seen in the rivers.

Satara

The central grasslands around Satara attract large numbers of grazers, such as wildebeeste, impalas, zebras, waterbucks, warthogs and, the lions' favourite, buffalos. With such large numbers of grazing animals present the big cats will never be far and lions, cheetahs and leopards are all present in the area.

Lower Sabie to Tshokwane

The return loop between Lower Sabie and Tshokwane, which traverses the sweetveld plains, proffers one of Kruger Park's best game-driving areas. Here you will find large herds of grazers and the predators that accompany them. About half a mile (1km) from Lower Sabie camp there is a large waterhole (Sunset Dam).

◀ *The dining hall at Lower Sabie camp in Kruger National Park overlooking the Sabie River.*

▼ *A herd of impalas remain alert to the danger posed by predators. Despite their numbers in certain parts of Africa – and they are likely to be the first animal you see in the Kruger – they are listed on the IUCN's endangered species list.*

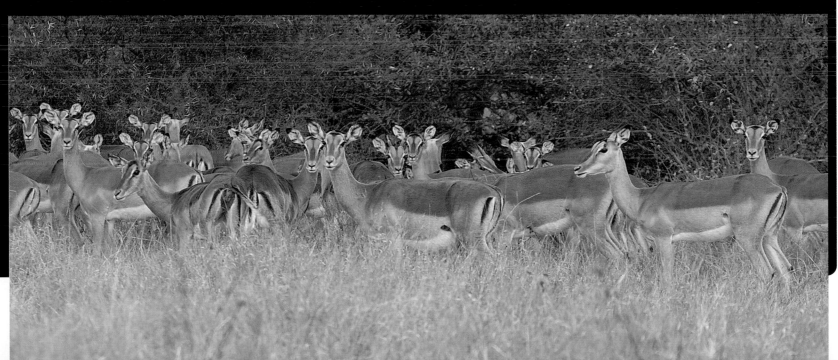

Game viewing

Skukuza to Lower Sabie
Almost as productive is the drive between Skukuza and Lower Sabie. The riverine bush attracts leopards, which prey on the many grazers and browsers in the area. The eternal enemies, lions and hyenas, are also prevalent, as are large hippopotamuses and crocodiles in the Sabie River.

Skukuza
The loop around the Mathekanyane kopjes often yields sightings of rhinoceros, while klipspringers can be seen precariously perched on the kopje outcrops. Transport Dam is

▼ *Aptly named for the presence of crocodiles, the area around Crocodile Bridge is also a likely place to see cheetahs. At the tip of the park in an area known as Hippo Pools, a ranger will escort you on a guided walk to view large numbers of hippopotamuses.*

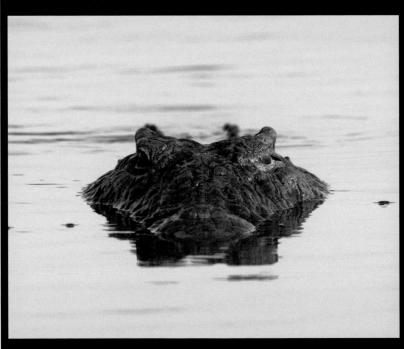

good for sightings of lions, waterbucks and buffalos and also check Maroela and Sand River loops for lions.

Skukuza to Tshokwane
The waterholes around Orpen rocks attract many elephants and lions and leopards can sometimes be seen along the Sabie River.

Pretoriuskop to Afsaal
Several different eco-zones converge around Afsaal increasing the diversity of species in the area. Rare sightings of sable antelopes and elands are possible, along with rhinoceroses and (on very rare occasions) Lichtenstein's hartebeeste and caracals.

Berg en Dal
The southern biome around Berg en Dal is notable for sightings of the beautifully marked and elusive wild dog. A great diversity of wildlife exists here including lions, rhinoceroses, buffalos, elephants, giraffes and the rare southern reedbucks.

Crocodile Bridge to Lower Sabie
Cheetahs in particular thrive in the open grasslands of the region between Crocodile Bridge and Lower Sabie. In a single day on the road between Duke and Nhlanganzwani Dam (around 4 miles/7km) I once witnessed two cheetah kills – one before lunch and one immediately after. Lions and hyenas also share the habitat, which is also excellent for rhinoceros sightings. About 3.5 miles (6km) from Crocodile Bridge camp you will come to Hippo Pool where a ranger will escort you on a guided walk, one of the few areas in the Kruger Park where it's possible to alight from your vehicle.

▷ *A purpose-built hide near Tshokwane is an ideal place to sit and watch the Kruger's wildlife. I hadn't been there long before seeing this beautifully coloured malachite kingfisher.*

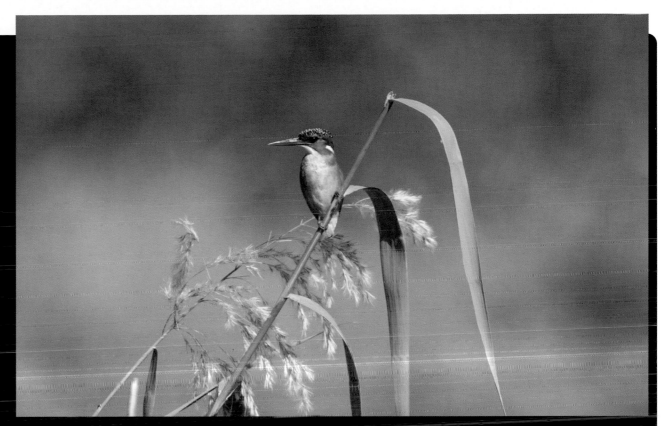

▷ *This cheetah was one of two brothers that I watched stalk and chase a large herd of zebras near Duke Dam between Crocodile Bridge and Lower Sabie. On this occasion they missed their prey but the whole event was reminiscent of a spectacular wildlife documentary.*

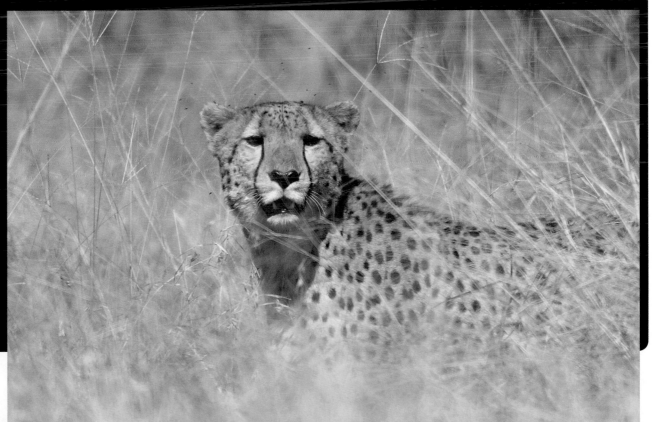

Kruger National Park is one of the greatest wildlife and cultural destinations in Africa. Evidence of human existence from prehistoric man to San bushpeople, in the form of artefacts, rock art and over 300 archaeological sites, has been well documented along with additional evidence of the presence of Nguni people.

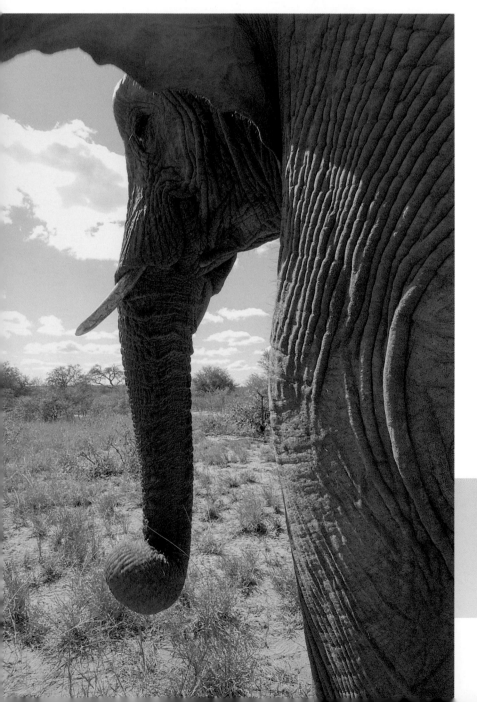

History and background

The first known white settler in the area was the Italian-born João Albasini, around 1845. At a similar time, an Afrikaner by the name of Paul Kruger moved into the old Transvaal to farm. After the first Anglo-Boer war in 1883 Paul Kruger became President and committed to instigate legislation that would conserve the wildlife of the region. Five years later, the area between the Sabie and Crocodile rivers was proclaimed the Sabie Game Reserve.

The Park's first warden was a Scotsman named Major James Stevenson-Hamilton, who was appointed in 1902. Stevenson-Hamilton was an officer of the 6th (Inniskilling) Dragoon Guards and Laird of Fairholm in Lanarkshire. With his rangers, great efforts were made in difficult and trying circumstances to consolidate areas to the north and to enlarge the boundaries of the reserve. In 1926 the Government passed the National Parks Act and the Sabie and Shingwedzi Game Reserves were merged to form the Kruger National Park.

The modern aims of the Park reflect the original vision of Kruger and Stevenson-Hamilton – namely the wise conservation of the heritage and wildlife of the region, the protection of the interests of local people and the discreet and unobtrusive development of Park facilities for visitors to the Park.

◀ *Due to effective anti-poaching measures, Kruger's population of elephants has soared. Their impact on the Park, which is entirely fenced, is now concerning the park authorities and there is a debate on how to best deal with the problem of over-population.*

Ecology and eco-zones

The Kruger Park covers an enormous area (approximately 12,500 sq. miles/20,000km$^2$), equivalent to the size of Wales. It stretches north to south a distance of 240 miles (380km) – the same as travelling between York and Portsmouth. A varied geological substructure, ranging from old coastal deposits of very deep sand to undulating plains of granite, supports a rich diversity of life. In total, there are around 147 mammal, 507 bird, 148 reptile and amphibian, 49 fish and 336 tree species in the park.

In search of hunters

Kruger Park is best known for its predators – lions, hyenas, leopards, cheetahs and wild dogs – which between them are thought to be responsible for around 75,000 kills every year. Given their numbers (approximately 2,000 lions, 2,000 hyena, 1,000 leopards, 200 cheetahs and 400 wild dogs) that equates to roughly 13 kills per animal per year.

Lions
Generally sighted south of Oliphants River. Between Orpen and Satara, the eastern grasslands in the vicinity of Tshokwane and the mixed woodlands around Skukuza, Lower Sabie and Crocodile Bridge are often the most productive areas for sightings.

Hyenas
Most likely sightings are in the south in the mixed woodlands around Skukuza, west towards Pretoriuskop and south of Afsaal. The Orpen, Satara and Tshokwane regions are also likely to produce sightings.

▶ *Africa is renowned for its sunsets. Here an adult giraffe is isolated in silhouette against a vivid orange sky.*

Leopards
Of the 'big five' the leopard is the one most want to see and the one most will leave the park having missed. Your best chances for sightings are the riverine bush and kopjes throughout Kruger and along the Sabie River between Skukuza and Lower Sabie. Also along the Luvuvhu River in the north.

Cheetahs
Open savannah is ideal for cheetahs and sightings are most likely between Satara and Tshokwane, around Skukuza and Pretoriuskop and the loop between Lower Sabie and Crocodile Bridge.

Wild dogs

Wild dogs are non-territorial and their home range can stretch for hundreds of miles, which makes spotting them all the more difficult. The areas around Malelane and Berg en Dal and Pretoriuskop in the south and in the north-western mopaneveld between Letaba and Olifants in the north are often best for sightings.

▼ *There are thought to be around 1,000 leopards in Kruger National Park but their propensity for solitary living, highly effective camouflage, preference for a nocturnal existence and natural shyness make them one of the more difficult to sight of Africa's 'big five'.*

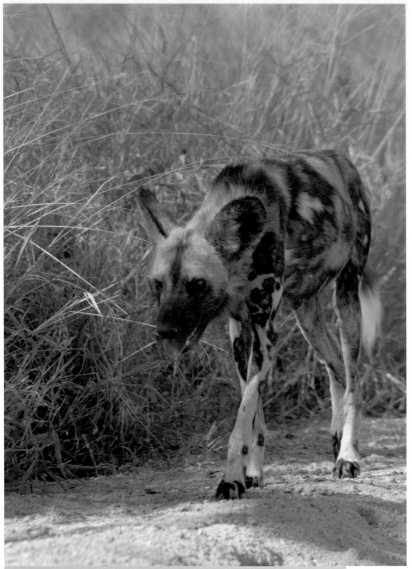

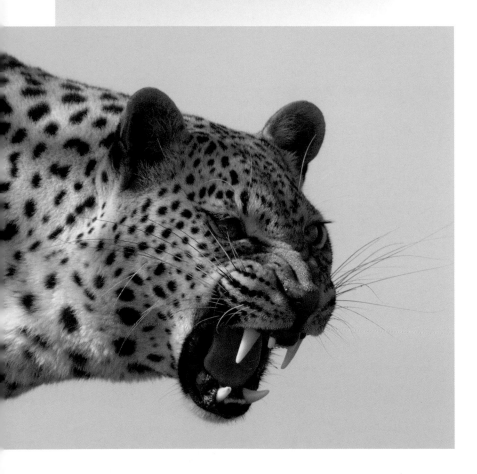

▲ *Of all of Africa's prominent pack hunters – wild dogs, hyenas and jackals – the wild dog is the most endangered and scarce. There are around 400 animals in the whole of Kruger National Park, which is considered one of the best places to see them.*

Maputaland Coastal Forest and Mkuze, South Africa

Highlights – Maputaland
Whales, dolphins and sharks
Egg-laying turtles
Great snorkelling and diving

Seasons – Maputaland
Rainy season: October–March
Dry season: April–September

Highlights – Mkuze
Large pods of hippopotamuses
Crocodiles
Great bird life

Seasons – Mkuze
Rainy season: October–March
Dry season: April–September

Mkuze is renowned for its abundance of fantastic bird life

▼ *Crocodile-infested waters are one of Mkuze's main attractions.*

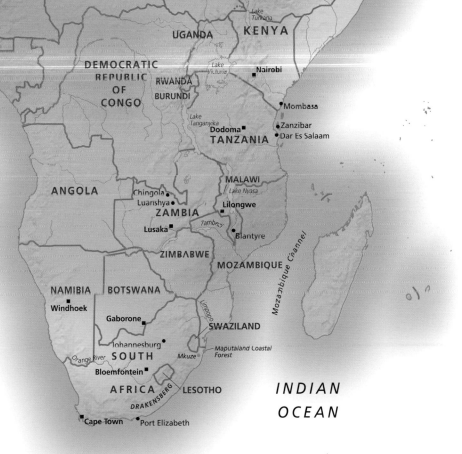

UGANDA
KENYA
DEMOCRATIC REPUBLIC OF CONGO
RWANDA
BURUNDI
Lake Turkana
Lake Victoria
Nairobi
Mombasa
Lake Tanganyika
Dodoma
Zanzibar
Dar Es Salaam
TANZANIA
ATLANTIC OCEAN
ANGOLA
Chingola
Luanshya
ZAMBIA
Lusaka
MALAWI
Lake Nyasa
Lilongwe
Zambezi
Blantyre
ZIMBABWE
MOZAMBIQUE
Mozambique Channel
NAMIBIA
Windhoek
BOTSWANA
Gaborone
Johannesburg
SWAZILAND
Limpopo
Orange River
SOUTH AFRICA
Bloemfontein
Mkuze
Maputaland Coastal Forest
DRAKENSBERG
LESOTHO
Cape Town
Port Elizabeth
INDIAN OCEAN

Ndumo & Tembe Elephant Park, South Africa

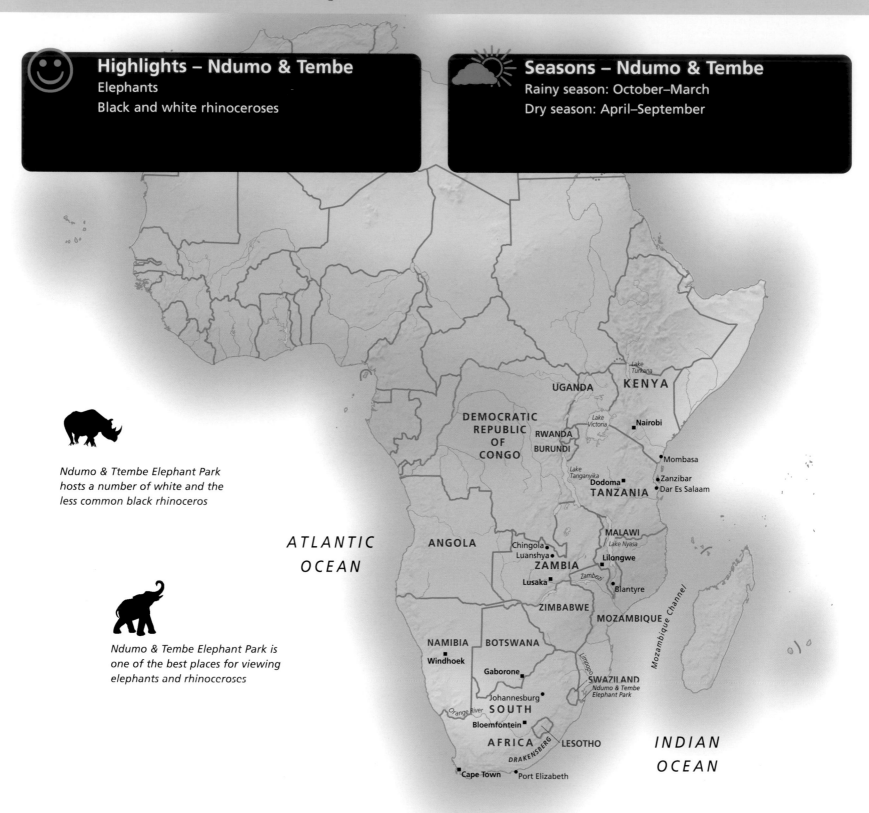

Ndumo & Ttembe Elephant Park hosts a number of white and the less common black rhinoceros

Ndumo & Tembe Elephant Park is one of the best places for viewing elephants and rhinocceroses

ATLANTIC
OCEAN

INDIAN
OCEAN

UGANDA
KENYA

DEMOCRATIC
REPUBLIC
OF
CONGO
RWANDA
BURUNDI

Lake
Turkana

Lake
Victoria
Nairobi

Mombasa

Lake
Tanganyika
Dodoma
TANZANIA
Zanzibar
Dar Es Salaam

ANGOLA
MALAWI
Lake Nyasa

Chingola
Luanshya
ZAMBIA
Lilongwe

Lusaka
Zambezi
Blantyre

ZIMBABWE
MOZAMBIQUE
Mozambique Channel

NAMIBIA
BOTSWANA
Windhoek

Gaborone

Limpopo
SWAZILAND
Ndumo & Tembe
Elephant Park

Johannesburg

Orange River
SOUTH

Bloemfontein

AFRICA
LESOTHO

DRAKENSBERG

Cape Town
Port Elizabeth

Pilanesberg and Saint Lucia Wetland Park, South Africa

Highlights – Pilanesberg
'Big five' within a small area (212 miles/550km)
300 species of birds
Vast stroll-through aviary and vulture 'restaurant'

Seasons – Pilanesberg
Rainy season: October–March
Dry season: April–September

Highlights – Saint Lucia
Hippopotamuses and crocodiles on the
Saint Lucia estuary
Prolific bird life
Whales and dolphins
Egg-laying turtles
Coral reefs

Seasons – Saint Lucia
Rainy season: October–March
Dry season: April–September

All of the 'big five' can be viewed within a relatively small area

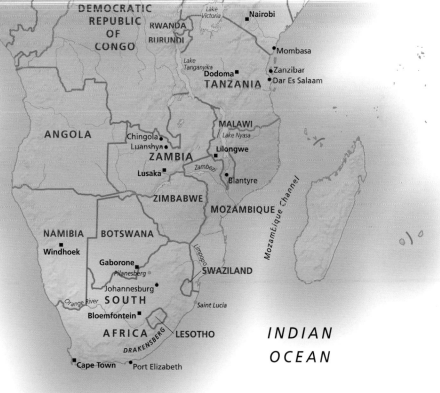

Tsitsikama National Park, South Africa

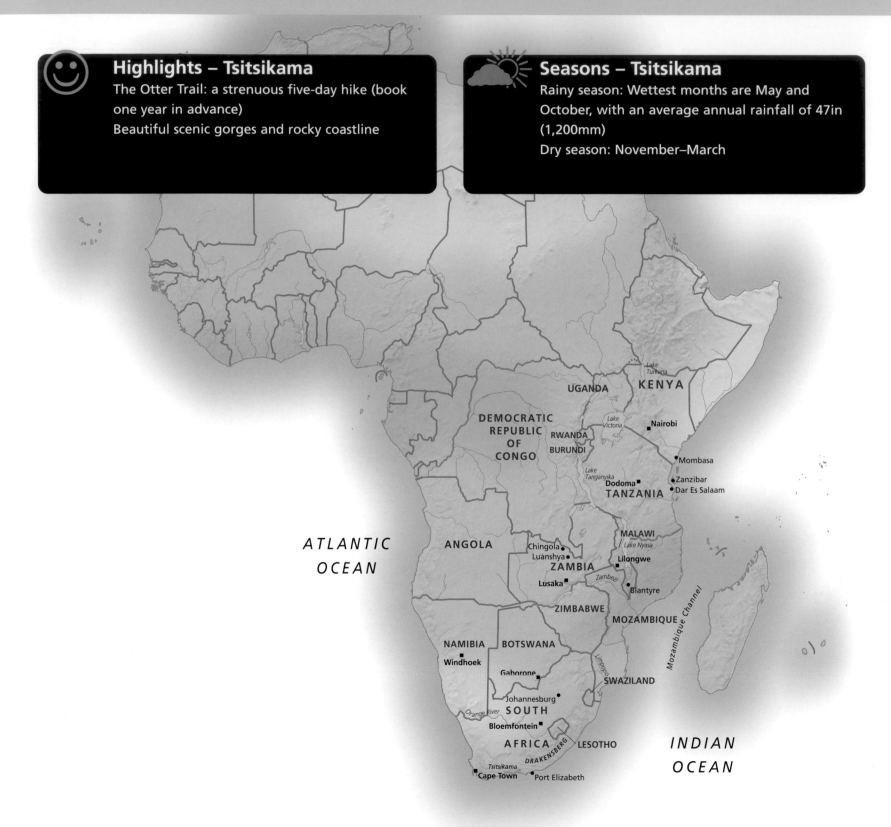

Highlights – Tsitsikama
The Otter Trail: a strenuous five-day hike (book one year in advance)
Beautiful scenic gorges and rocky coastline

Seasons – Tsitsikama
Rainy season: Wettest months are May and October, with an average annual rainfall of 47in (1,200mm)
Dry season: November–March

UGANDA

KENYA

DEMOCRATIC
REPUBLIC
OF
CONGO

RWANDA

BURUNDI

Lake
Turkana

Lake
Victoria

Nairobi

Mombasa

Zanzibar
Dar Es Salaam

Lake
Tanganyika

Dodoma

TANZANIA

MALAWI

Lake Nyasa

ATLANTIC
OCEAN

ANGOLA

Chingola
Luanshya

ZAMBIA

Lilongwe

Lusaka

Zambezi

Blantyre

ZIMBABWE

MOZAMBIQUE

Mozambique Channel

NAMIBIA

BOTSWANA

Windhoek

Gaborone

Limpopo

SWAZILAND

Johannesburg

Orange River

SOUTH

Bloemfontein

AFRICA

LESOTHO

DRAKENSBERG

INDIAN
OCEAN

Tsitsikama
Cape Town

Port Elizabeth

West Coast National Park, South Africa

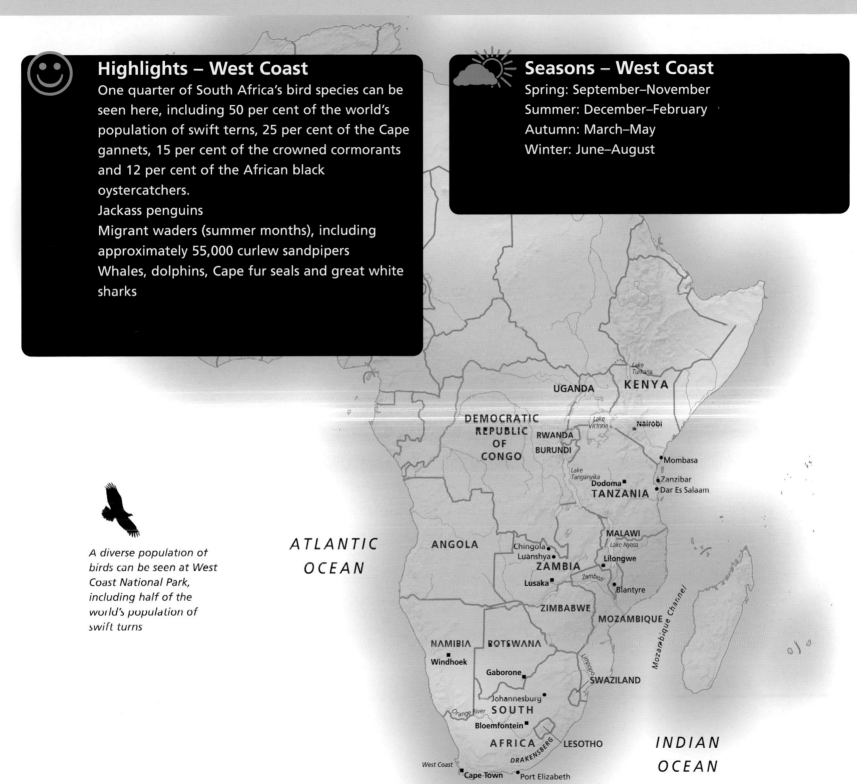

Highlights – West Coast

One quarter of South Africa's bird species can be seen here, including 50 per cent of the world's population of swift terns, 25 per cent of the Cape gannets, 15 per cent of the crowned cormorants and 12 per cent of the African black oystercatchers.

Jackass penguins

Migrant waders (summer months), including approximately 55,000 curlew sandpipers

Whales, dolphins, Cape fur seals and great white sharks

Seasons – West Coast

Spring: September–November
Summer: December–February
Autumn: March–May
Winter: June–August

A diverse population of birds can be seen at West Coast National Park, including half of the world's population of swift turns

ATLANTIC OCEAN

UGANDA

KENYA

DEMOCRATIC REPUBLIC OF CONGO

RWANDA

BURUNDI

Lake Turkana

Lake Victoria

Nairobi

Mombasa

Lake Tanganyika

Dodoma

Zanzibar

Dar Es Salaam

TANZANIA

MALAWI

Lake Nyasa

ANGOLA

Chingola

Luanshya

ZAMBIA

Lilongwe

Lusaka

Zambezi

Blantyre

ZIMBABWE

MOZAMBIQUE

Mozambique Channel

NAMIBIA

BOTSWANA

Windhoek

Gaborone

SWAZILAND

Johannesburg

Orange River

SOUTH

Bloemfontein

AFRICA

DRAKENSBERG

LESOTHO

Limpopo

INDIAN OCEAN

West Coast

Cape Town

Port Elizabeth

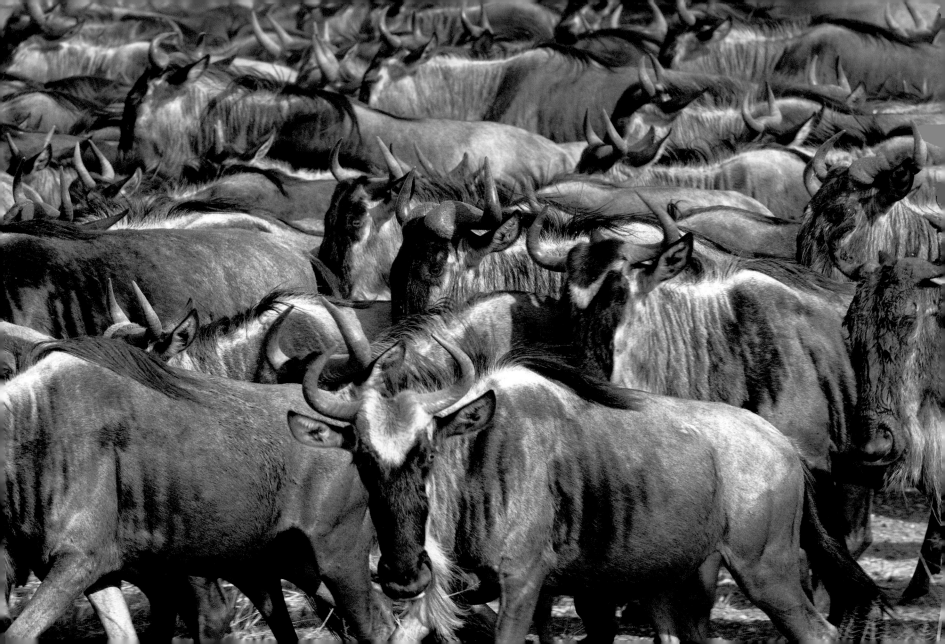

Central Kalahari Game Reserve, Botswana

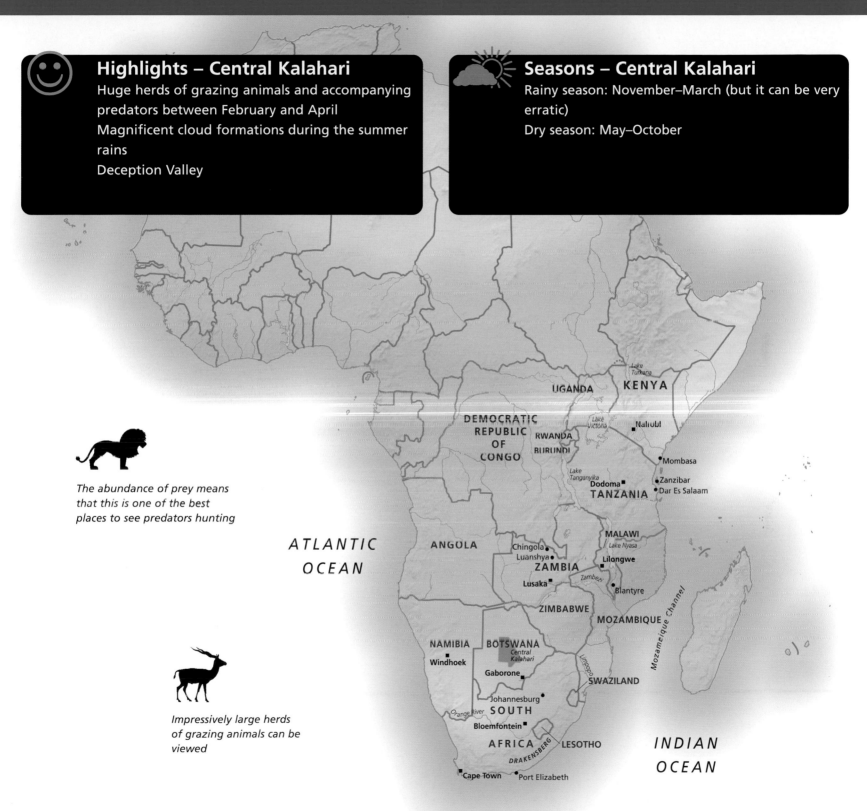

😊 **Highlights – Central Kalahari**
Huge herds of grazing animals and accompanying predators between February and April
Magnificent cloud formations during the summer rains
Deception Valley

Seasons – Central Kalahari
Rainy season: November–March (but it can be very erratic)
Dry season: May–October

The abundance of prey means that this is one of the best places to see predators hunting

Impressively large herds of grazing animals can be viewed

ATLANTIC OCEAN

INDIAN OCEAN

UGANDA
KENYA
Lake Turkana
DEMOCRATIC REPUBLIC OF CONGO
Lake Victoria
Nairobi
RWANDA
BURUNDI
Mombasa
Lake Tanganyika
Dodoma
Zanzibar
Dar Es Salaam
TANZANIA
MALAWI
Lake Nyasa
ANGOLA
Chingola
Luanshya
Lilongwe
ZAMBIA
Zambezi
Lusaka
Blantyre
ZIMBABWE
MOZAMBIQUE
Mozambique Channel
NAMIBIA
BOTSWANA
Central Kalahari
Windhoek
Gaborone
SWAZILAND
Limpopo
Johannesburg
Orange River
SOUTH
Bloemfontein
AFRICA
LESOTHO
DRAKENSBERG
Cape Town
Port Elizabeth

Chobe National Park, Botswana

 Highlights
Large populations of elephants along (and in) the Chobe River during the dry season
440 species of birds
Boating safaris
Pel's fishing owls

 Seasons
Rainy season: November–March
Dry season: May–October (best for elephant viewing)

Among the 440 species of birds is the Pel's fishing owl, which, if you are lucky, you can watch hunt in rivers and lakes

Large numbers of elephants can be seen wading and bathing in the Chobe River

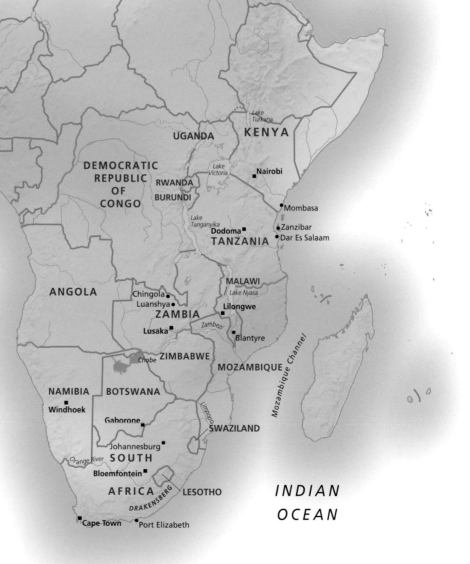

ATLANTIC OCEAN

INDIAN OCEAN

UGANDA
KENYA
DEMOCRATIC REPUBLIC OF CONGO
RWANDA
BURUNDI
Lake Turkana
Lake Victoria
Nairobi
Mombasa
Lake Tanganyika
Dodoma
Zanzibar
Dar Es Salaam
TANZANIA
MALAWI
Lake Nyasa
ANGOLA
Chingola
Luanshya
Lilongwe
ZAMBIA
Lusaka
Zambezi
Blantyre
Chobe
ZIMBABWE
MOZAMBIQUE
Mozambique Channel
NAMIBIA
BOTSWANA
Windhoek
Gaborone
Limpopo
SWAZILAND
Johannesburg
Orange River
SOUTH
Bloemfontein
AFRICA
LESOTHO
DRAKENSBERG
Cape Town
Port Elizabeth

Game viewing

Chobe has the highest concentration of elephants anywhere on Earth and they are the main attraction of the Park. Chobe Riverfront is the best location to see them, during the dry season (October is the best month but also the hottest) when outlying water is scarce and the elephants head to the river to drink, to bathe and to play. Large breeding herds and lone males are present all along both sides of the bank and perfect sunsets create an ideal backdrop for photographs. Here you will also find large herds of buffalos that similarly use the Chobe River, as well as zebras, lechwes, the Chobe bushbucks and Puku antelopes – the southernmost point where they can be found. In the air, African fish eagles are common, their distinctive cry an evocative reminder of your location – if one were needed – and the Pel's fishing owl is another of the birders' favourites.

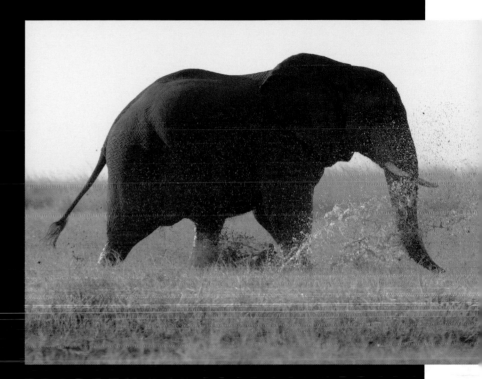

Linyanti is less appealing, with only 4 miles (7km) of riverfront that can be used for game drives and a long and arduous journey to reach the area. Adventurous travellers may enjoy the challenge and a quite cacophonous dawn chorus is a sound to behold for those that do. In stark comparison to Chobe Riverfront Savute has a desert-like landscape that provides a unique wildlife experience. The scorching sun and loose, hot sand causes wildlife to pack tightly in any available area of shade and elephants impatiently wait their turn at the dwindling water supplies. Nogatsaa is different again. The landscape is quite unappealing, consisting predominantly of mopane and mixed combretum veld and pockmarked with numerous pans. But what it lacks in natural beauty it compensates for with exciting game viewing at the waterholes, many of which have hides.

▶ *Chobe National Park is home to Africa's largest concentration of elephants. They can be seen regularly in and around the Chobe River, particularly during the dry season, which runs from May to October. As well as elephants, Chobe River is teeming with hippopotamuses and crocodiles.*

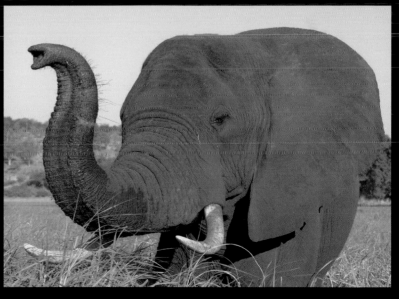

▲ *A water lily emerges from the Chobe River to bask in the hot afternoon sun.*

History and background

During the middle decades of the twentieth century ivory poaching in this region of Botswana was rife and a timber concession in the Serondella area was quickly changing the habitat. The idea of creating a wildlife reserve was first muted in the 1930s by the then commissioner, Colonel Charles Rey.

It took until the early 1960s before his dream became a reality with the passing by the Government of Bechuanaland (as Botswana was then known) of Proclamation 22, which created the Chobe Game Reserve.

The first warden, Mr Pat Hepburn, was appointed in 1962 and at the same time all existing residents were asked to leave the new reserve. Four main tourist areas have been developed in the park. Chobe Riverfront is perhaps the best known, the others being Linyanti, Savute and Nogatsaa.

Ecology and geology

Chobe National Park lies in the north-west corner of Botswana covering an area of 6,686 sq. miles (10,698km²). It is the third largest of Botswana's national parks and game reserves behind the Central Kalahari Game Reserve and Kgalagadi Transfrontier Park. The Chobe River forms its northern boundary and elsewhere wildlife-management areas buffer the entire park, including, in the extreme south-west corner, Moremi Game Reserve. In bygone times this whole area was submerged beneath a mighty inland lake, the ancient shorelines of which (denoted by the Gedikiwe sand ridge in the south and the Magawikhwe in the north) are clearly visible in satellite photographs of the park – and sometimes even to the naked eye.

Unsurprisingly, the Park was named after the Chobe River, which originates in the highlands of Angola. The first section of the river is known as the Kwando and

after entering Botswana its name changes to the Linyanti. Later, at Parakurungu, it changes again to the Itenge and only near Ngoma Gate does it finally assume its more recognized name, Chobe. There is an abrupt bend in the Linyanti and here the Magwegqana links it with the Okavango Delta. Contrary to popular belief, the Chobe flows only one way. Water backing up a considerable distance, however, creates the illusion of it flowing in both directions.

Heading towards Savute, the main road from Maun follows the edge of the Mababe Depression, of which the Savute Marsh forms the deepest part. The dead trees on the marsh were drowned by the flooding of the Savute Channel, which is one of the main water sources of the Mababe Depression. Others include the Ngwezumba River and channels from the delta. However, in recent times, the latter two sources rarely reach the depression.

The Savute Channel has a contrary history of flooding and drying independently of seasonal variations in climate. A possible explanation for the erratic nature of the flow of the Channel is tectonic movements. The Savute runs along one of the fault lines that first caused the Linyanti/Intenge/Chobe River to alter direction so dramatically. Prominent features of this area are the dead camelthorn trees (*Acacia erioloba*) in the channel. It is believed they grew when the river was dry between around 1888 and 1957, enough time for them to reach full maturity. When later floods occurred the trees drowned. The Savute Channel has a history of drying, then flowing again, which has earned it the nickname, the Stolen River.

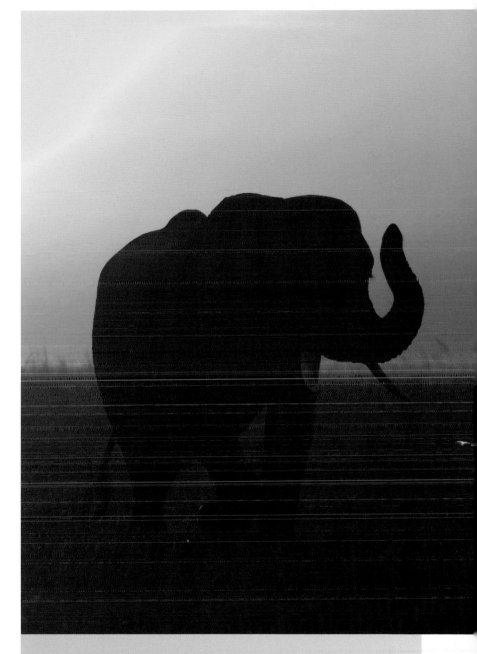

▲ *An adult elephant smells the air, isolated in silhouette against the serene sky lit orange by the setting sun.*

103

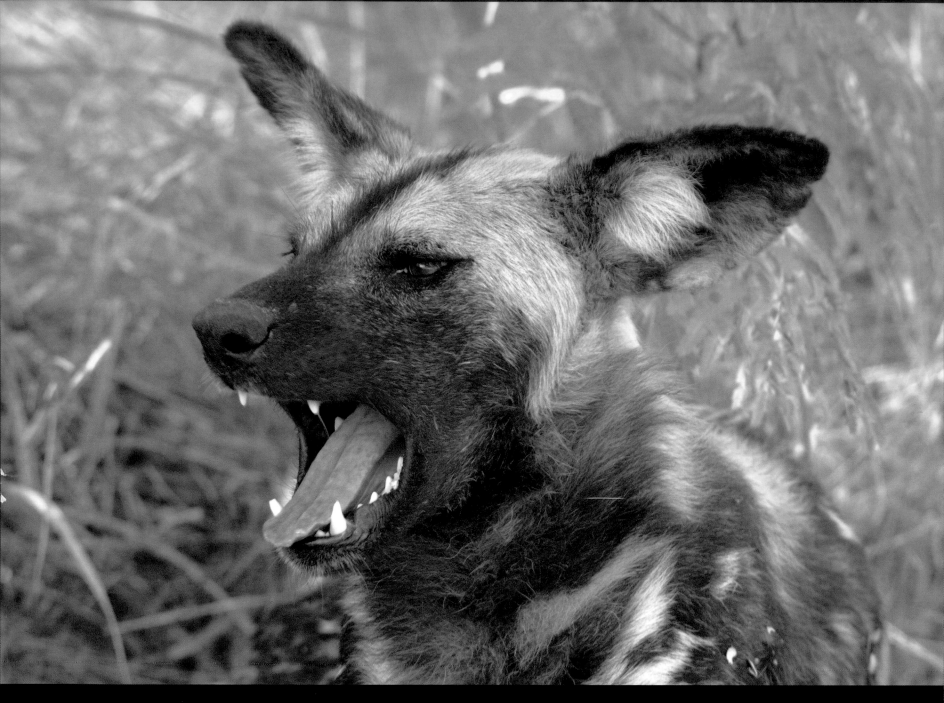

▲ Wild dogs, which are also known by the common names painted dogs or Cape hunting dogs, are one of Africa's most endangered carnivores. They live in sophisticated packs, and are non-territorial, having instead home ranges that cover vast distances. Habitat destruction and human encroachment are the principal causes of their decline.

Makgadikgadi Pan National Park & Salt Pans, Botswana

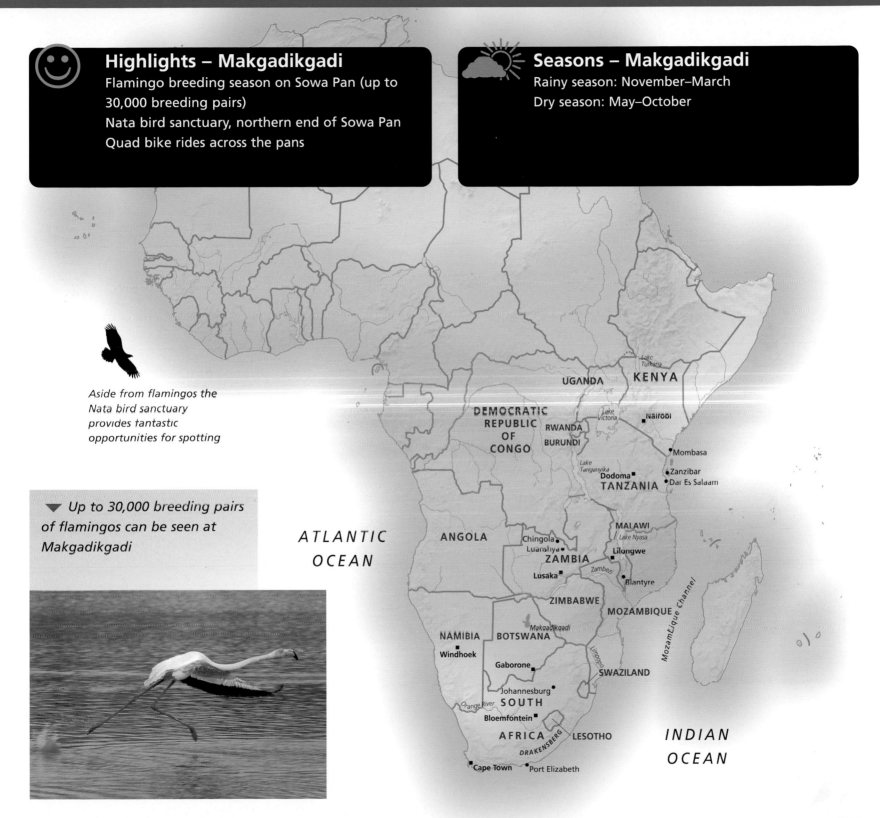

Highlights – Makgadikgadi

Flamingo breeding season on Sowa Pan (up to 30,000 breeding pairs)

Nata bird sanctuary, northern end of Sowa Pan

Quad bike rides across the pans

Seasons – Makgadikgadi

Rainy season: November–March

Dry season: May–October

Aside from flamingos the Nata bird sanctuary provides fantastic opportunities for spotting

▼ Up to 30,000 breeding pairs of flamingos can be seen at Makgadikgadi

ATLANTIC OCEAN

INDIAN OCEAN

UGANDA
KENYA
DEMOCRATIC REPUBLIC OF CONGO
RWANDA
BURUNDI
Lake Turkana
Lake Victoria
Nairobi
Mombasa
Lake Tanganyika
Dodoma
Zanzibar
Dar Es Salaam
TANZANIA
MALAWI
Lake Nyasa
ANGOLA
Chingola
Luanshya
Lilongwe
ZAMBIA
Zambezi
Lusaka
Blantyre
Mozambique Channel
ZIMBABWE
MOZAMBIQUE
Makgadikgadi
NAMIBIA
BOTSWANA
Windhoek
Gaborone
Limpopo
SWAZILAND
Johannesburg
Orange River
SOUTH
Bloemfontein
AFRICA
DRAKENSBERG
LESOTHO
Cape Town
Port Elizabeth

Mashatu & Tuli Game Reserves, Botswana

Highlights – Mashatu & Tuli

Mashatu

Frequent and regular sightings of lions and leopards

The largest population of elephants on privately owned land (around 700 individuals)

Tuli

Large migrant populations of antelopes, zebras and hippopotamuses

Seasons – Mashatu & Tuli

Rainy season: September–May

Dry season: June–August

Mashatu Game Reserve has the largest single population of elephants on privately owned land

▼ *Lions and leopards are relatively easy to spot in Mashatu Game Reserve.*

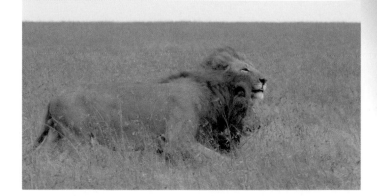

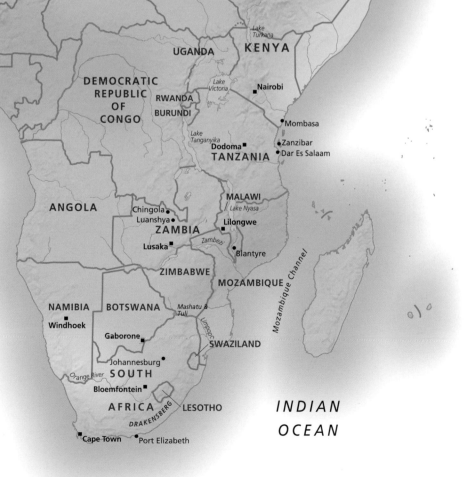

106

Moremi and Nxai Pan National Park, Botswana

 Highlights – Nxai
Large herds of springboks and giraffes
Variety of bird life during the wet season,
including large numbers of raptors

 Seasons – Nxai
Rainy season: November–April (December–April is
best for game viewing)
Dry season: May–September

 Highlights – Moremi
Canoe safaris through the delta
Walking safaris
Abundant bird life
Large herds of antelopes and elephants

 Seasons – Moremi
Rainy season: November–March
Dry season: April–October

*Large herds of elephants
are present in Moremi*

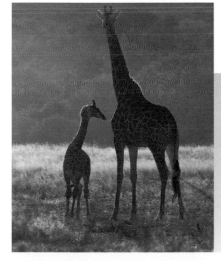

 *Some of the
largest herds of
giraffes grace
Nxai Pan
National Park.*

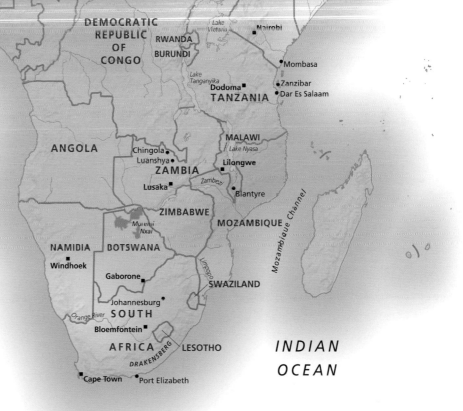

ATLANTIC
OCEAN

DEMOCRATIC
REPUBLIC
OF
CONGO
RWANDA
BURUNDI
Lake Victoria
Nairobi
Mombasa
Lake Tanganyika
Dodoma
Zanzibar
Dar Es Salaam
TANZANIA

ANGOLA
MALAWI
Lake Nyasa
Chingola
Luanshya
Lilongwe
ZAMBIA
Zambezi
Lusaka
Blantyre
ZIMBABWE
MOZAMBIQUE
Moremi
Nxai
Mozambique Channel
NAMIDIA
BOTSWANA
Windhoek
Gaborone
SWAZILAND
Limpopo
Johannesburg
Orange River
SOUTH
Bloemfontein
LESOTHO
AFRICA
DRAKENSBERG
Cape Town
Port Elizabeth
INDIAN
OCEAN

Okavango Delta, Botswana

Highlights – Okavango
Canoe safaris through the delta
Walking safaris
Abundant bird life
Large herds of antelopes and elephants

Seasons – Okavango
Rainy season: November–March
Dry season: April–October

Alongside impressive herds of elephants you can also see massed ranks of antelopes

▼ *Elephants can frequently be seen in water at Botswana's, Okavango Delta.*

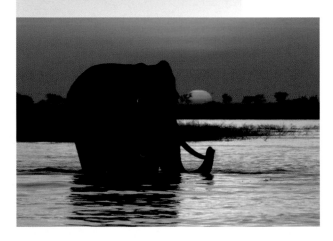

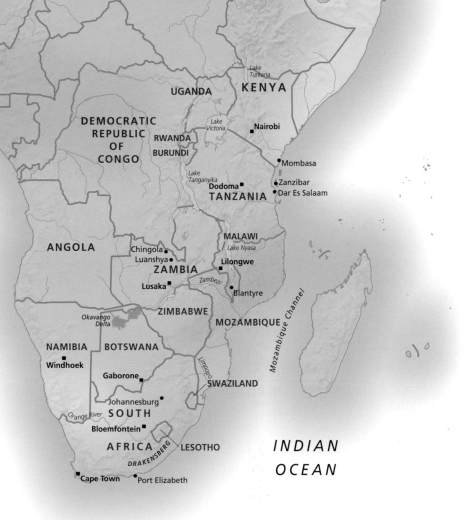

ATLANTIC OCEAN

INDIAN OCEAN

UGANDA
KENYA
Lake Turkana
DEMOCRATIC REPUBLIC OF CONGO
RWANDA
BURUNDI
Lake Victoria
■ Nairobi
• Mombasa
Lake Tanganyika
Dodoma ■
• Zanzibar
• Dar Es Salaam
TANZANIA
MALAWI
Lake Nyasa
ANGOLA
Chingola •
Luanshya •
ZAMBIA
Lilongwe ■
Lusaka ■
Zambezi
• Blantyre
ZIMBABWE
MOZAMBIQUE
Mozambique Channel
Okavango Delta
NAMIBIA
BOTSWANA
• Windhoek
Gaborone •
Limpopo
SWAZILAND
Johannesburg •
Orange River
SOUTH
Bloemfontein •
LESOTHO
AFRICA
DRAKENSBERG
■ Cape Town
• Port Elizabeth

Savuti Channel & Savuti Marsh, Botswana

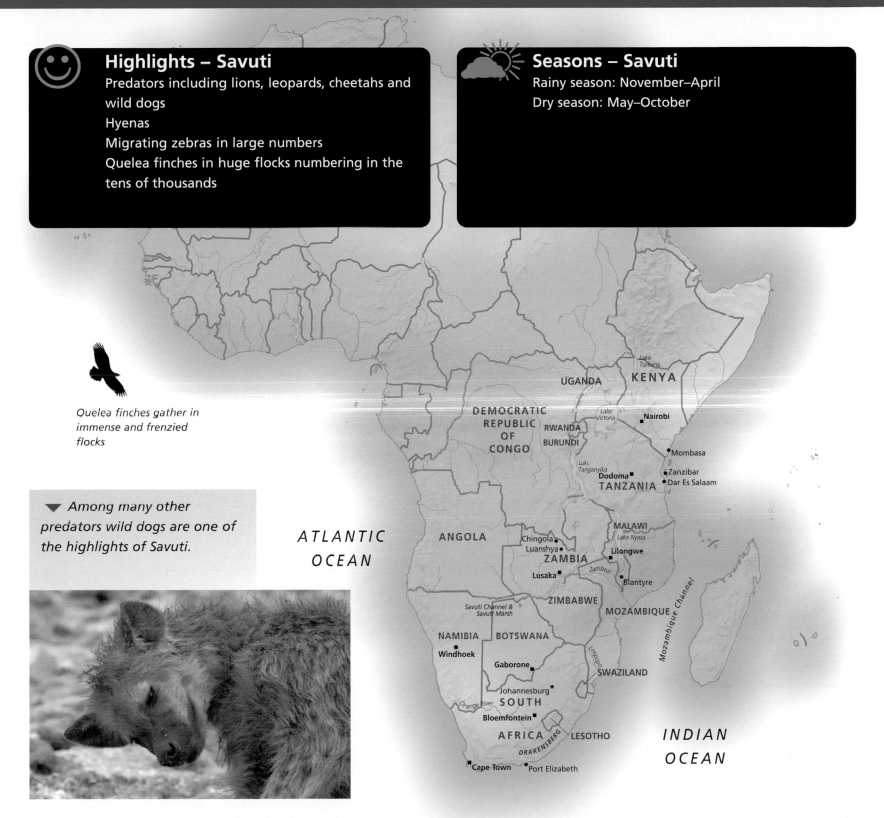

Quelea finches gather in immense and frenzied flocks

▼ *Among many other predators wild dogs are one of the highlights of Savuti.*

Highlights – Damaraland & Brandberg

Possibility of sightings of desert elephants and rare free-ranging black rhinoceroses

Petrified forests

Brandberg Massif Mountains

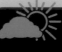

Seasons – Damaraland & Brandberg

Summer: November–April (temperatures average 95°F/35°C)

Winter: May–September

Rainy season: Rainfall is around 4in (100mm) per year and begins in January peaking in March

Highlights – Etosha

Great game viewing at the waterholes during the dry season

Large herds of elephants

Flocks of flamingos in the wet season

Seasons – Etosha

Rainy season: November–March (best for bird watching)

Dry season: July–September (May–September are best for game viewing)

There is the possibility of sighting desert elephants

▼ *Large flocks of flamingos visit Etosha in the wet season.*

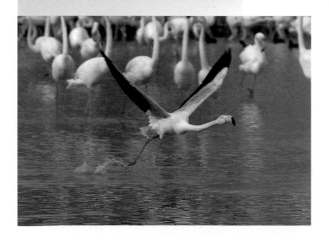

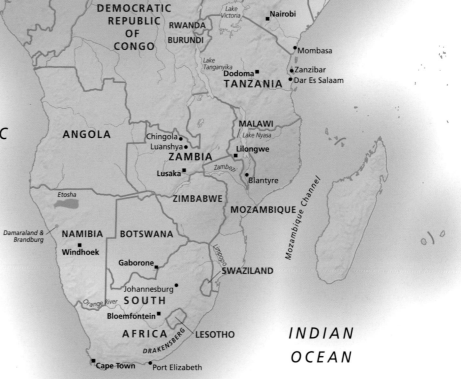

Fish River Canyon & Ai-Ais Hot Springs, Namibia

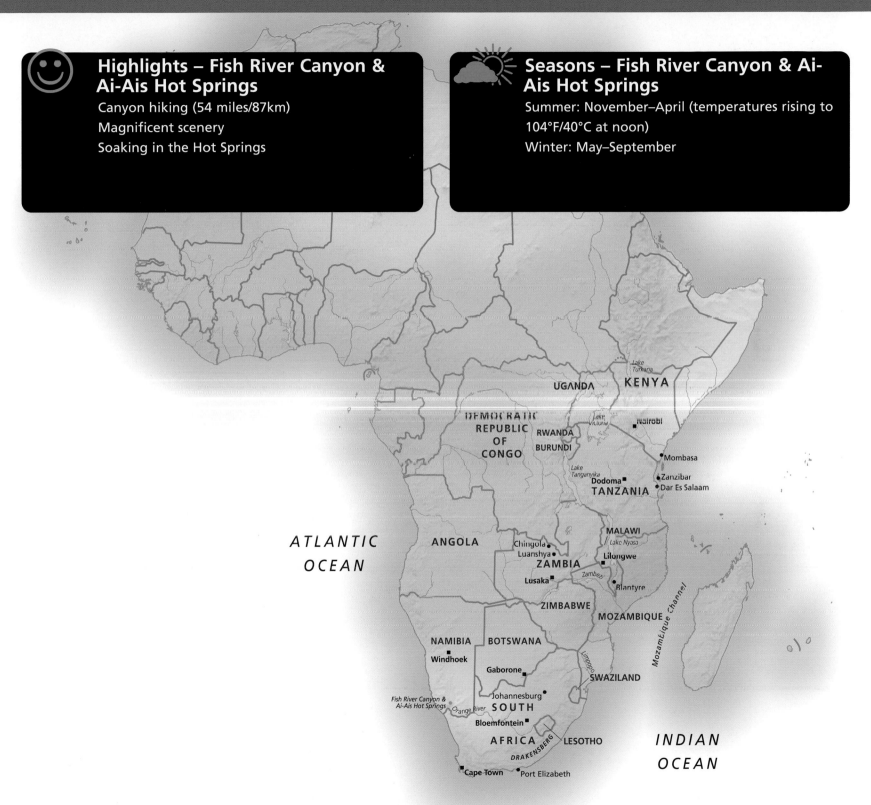

Highlights – Fish River Canyon & Ai-Ais Hot Springs

Canyon hiking (54 miles/87km)

Magnificent scenery

Soaking in the Hot Springs

Seasons – Fish River Canyon & Ai-Ais Hot Springs

Summer: November–April (temperatures rising to 104°F/40°C at noon)

Winter: May–September

UGANDA

KENYA

Lake Turkana

DEMOCRATIC REPUBLIC OF CONGO

RWANDA

BURUNDI

Lake Victoria

Nairobi

Mombasa

Lake Tanganyika

Zanzibar

Dodoma

Dar Es Salaam

TANZANIA

ATLANTIC OCEAN

ANGOLA

MALAWI

Lake Nyasa

Chingola

Luanshya

Lilongwe

ZAMBIA

Zambezi

Lusaka

Blantyre

ZIMBABWE

MOZAMBIQUE

Mozambique Channel

NAMIBIA

BOTSWANA

Windhoek

Gaborone

SWAZILAND

Limpopo

Fish River Canyon & Ai-Ais Hot Springs

Johannesburg

Orange River

SOUTH

Bloemfontein

AFRICA

LESOTHO

DRAKENSBERG

INDIAN OCEAN

Cape Town

Port Elizabeth

Highlights – Namib

Giant, brightly coloured sand dunes
Lone oryxes

Seasons – Namib

Rainfall is rare, averaging 2½in (63mm) per year, but most likely in December, March and April. Temperatures between November and March are around 95°F (35°C) during the day dropping to 59°F (15°C) at night. From April to October, daytime temperatures can be cooler, as low as 77°F (25°C), although they can easily hit the summer peaks.

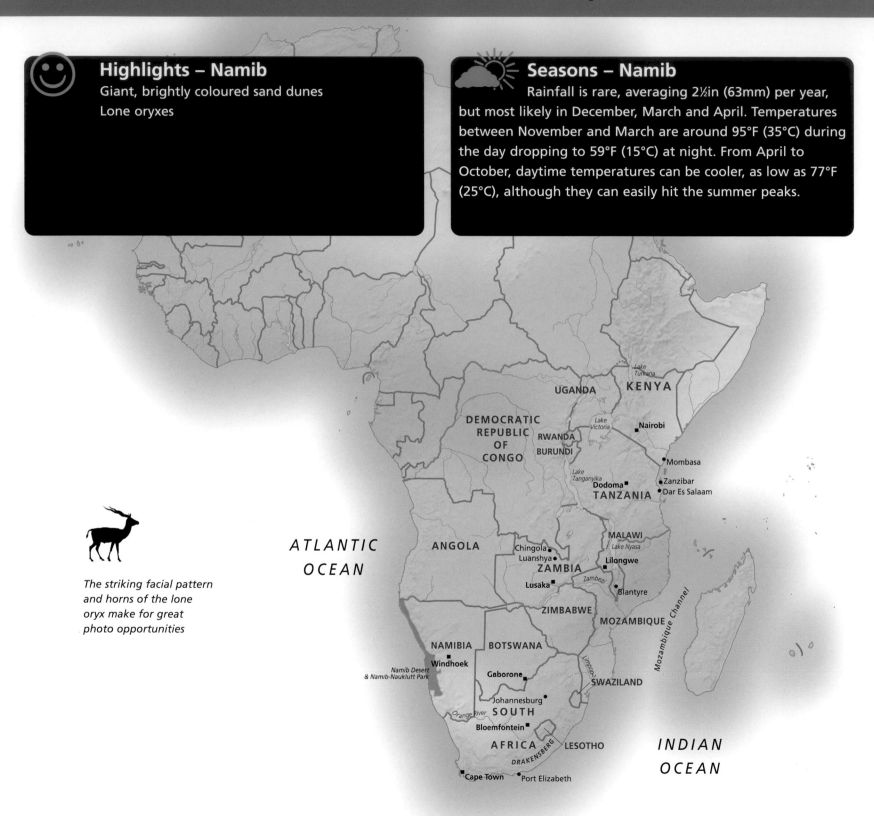

The striking facial pattern and horns of the lone oryx make for great photo opportunities

ATLANTIC
OCEAN

INDIAN
OCEAN

UGANDA KENYA

DEMOCRATIC
REPUBLIC
OF
CONGO

RWANDA
BURUNDI

Lake
Turkana

Lake
Victoria

Nairobi

Mombasa

Zanzibar
Dar Es Salaam

Lake
Tanganyika

Dodoma

TANZANIA

MALAWI
Lake Nyasa

ANGOLA

Chingola
Luanshya

ZAMBIA

Lilongwe

Lusaka

Zambezi

Blantyre

ZIMBABWE

MOZAMBIQUE

Mozambique Channel

NAMIBIA BOTSWANA

Windhoek

Namib Desert
& Namib-Naukluft Park

Gaborone

SWAZILAND

Johannesburg

Orange River

SOUTH

Bloemfontein

AFRICA LESOTHO

DRAKENSBERG

Limpopo

Cape Town Port Elizabeth

Highlights – Skeleton Coast

Cape fur seal colonies

Coastal shipwrecks

Skeletons on the sand

Possible encounters with Himba tribespeople

Seasons – Skeleton Coast

Summer: October–May (best time for visiting)

Winter: May–September

Highlights – Waterberg Plateau

200 bird species, including a rare breeding colony of Cape vultures

White and black rhinoceroses are well protected in this area

Seasons – Waterberg Plateau

Rainy season: November–March

Dry season: April–October

Good protection schemes mean that you have a strong chance of sighting a rhinoceros

▼ *Over 200 species of birds, including various vulture species can be seen.*

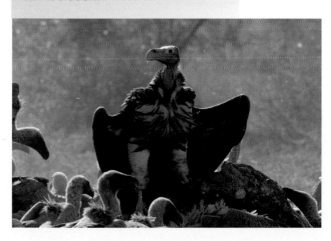

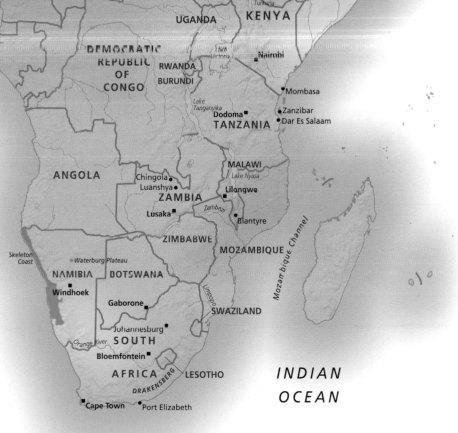

The principal reason for travel to Africa, although by no means the sole one, is to view and photograph wildlife. Nowhere on Earth shares the extent of the combined diversity and density of mammals than the African continent.

Many of the animals here are familiar to us through documentaries and books. No photographic book can cover them all, and here I have attempted to provide an insight into those you are most likely to encounter on a safari holiday or, perhaps, are most eager to see in the wild. Each animal has also had a map included to give an indication of the best places to go if you wish to photograph that species, again this is not exclusive.

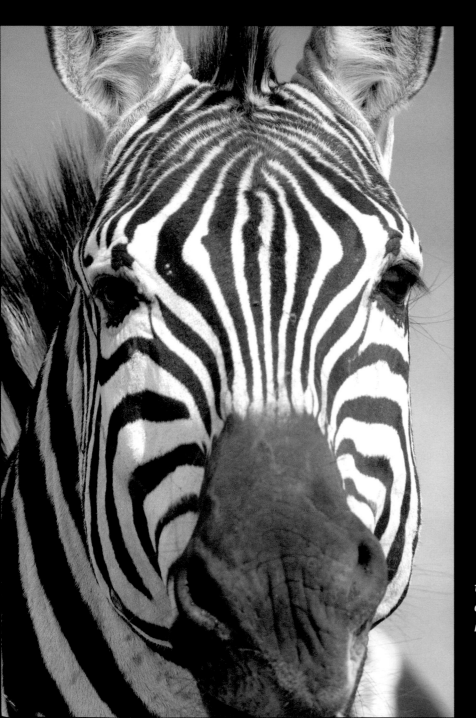

The 'big five'

Any visitor to Africa will soon hear the words 'big five' bandied about. The term has little to do with modern safaris. Instead it refers to the five species of animal that hunters in Africa considered the most dangerous to pursue. These are the lion, leopard, elephant, buffalo and black rhinoceros. In recent times the term has become synonymous with safaris and is often used, rightly or wrongly, as a measure of a successful trip, particularly by those on short safaris. Recently, due to the dramatic decline in black rhinoceroses, this species has become interchangeable with the more common but equally impressive white rhinoceros. For safari purposes another term has been added to the vocabulary of tour guides – the 'magnificent seven'. It refers to the 'big five' plus cheetahs and wild dogs, the seven species together being considered the most sought after and often the most difficult to locate.

◄ *Zebras are one of Africa's most photogenic species. Spending time with a herd will always result in numerous opportunities to capture behavioural traits, action and interaction between individual animals.*

Wildebeeste (Gnus)

Although it is the predators that often get the attention in Africa two of my favourite subjects form the primary constituents of the world's greatest wildlife spectacle, the annual mass migration of the Serengeti-Ngorongoro-Masai Mara ecosystem – wildebeeste and zebras.

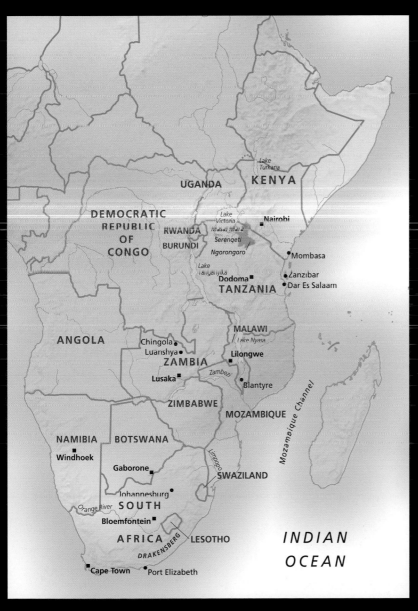

▲ *The name gnu stems from the distinctive and seemingly everlasting grunt-like call of the male. Like many herd species, they are best photographed after spending long periods of time with a single herd, once they have become used to your presence and lost their inhibitions.*

▼ *The main role of the gnu is to mow the grasses of Africa, which it does with incredible efficiency. A zoom technique has been used to create a more artistic interpretation of the scene.*

Like most people I enjoy a good laugh and there are few things in nature more comical than a gnu, as wildebeeste are sometimes known. The most fetching description of this rather odd creature I have ever seen was given as, 'a dumpy, thick-necked, long-faced antelope with horns that flare out sideways and then upwards (rather like a cow's).' After that the descriptions only get worse. The affectionate name gnu derives from the Hottentot word 't-gnu', which describes the grunt-like call made by males all day and all night, over and over for the duration of the migration, which, of course, never ends.

That the gnu is mistaken for a type of cow is hardly surprising given its demeanour, which ranges from the mildly foolish to the totally deranged. I once witnessed an entire herd of wildebeeste run straight past two male lions only to stop mid-point, turn around and charge abruptly back again. Seconds later they turned once more and proceeded to run in the direction from which they had just come. Soon after, another about turn and they were heading towards their original destination only to grind to a confused halt directly in front of the lions, where they remained motionless except to look at each other quizzically. Uncertain of whether to escape to the right of the lions or to their left they had chosen to ponder in the one place that put them in greatest danger.

Another example is the rutting gnu: all four legs are moving but each one totally independently of the other three. Of such events are great pictures made and this is the reason for my delight in spending time in the field with wildebeeste.

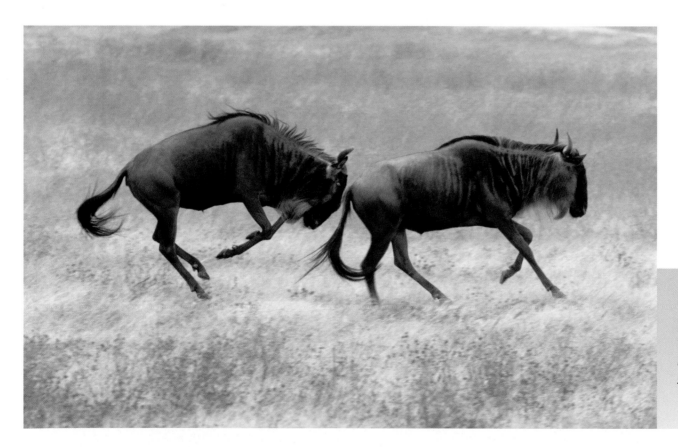

◀ *The demeanour of wildebeeste ranges from the mildly foolish to the totally deranged – which makes them ideal subjects for photography.*

Zebras

Wild horses have all but disappeared from our natural habitats with the exception of zebras, an estimated 300,000 of which live a nomadic life wandering the African plains. They are social animals existing within long-term units of a harem of mares with their offspring and a dominant stallion that protects and herds them. Zebras are also territorial and during the mating season conflicts are common, with males biting, rearing and striking with their front or hind hooves. The loser is driven out and the victor enjoys the spoils of the harem. If you spend enough time with a herd, these fierce battles for supremacy occur regularly and have the makings of exciting and emotive images.

Zebras are a favourite prey of lions and young foals are particularly at risk. To give them a fighting chance zebra foals have to hit the ground running and within a few minutes of birth can stand on wobbly legs. Within a week they are grazing and thereafter, it seems, they never stop.

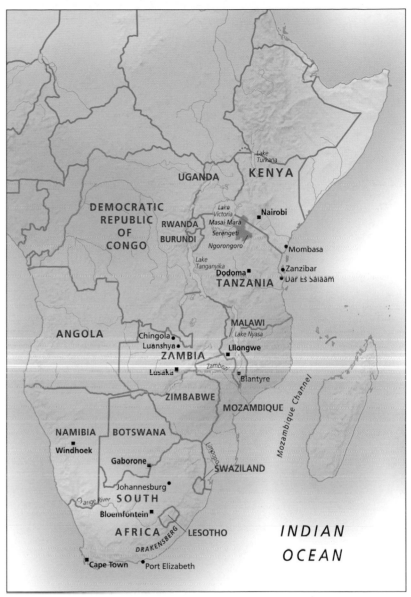

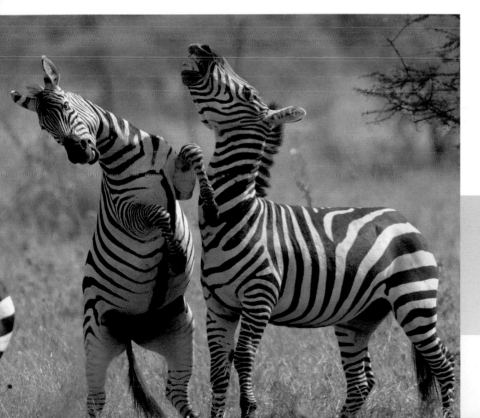

◀ *Zebra stallions will fight to gain dominance over a territory and mating rights over the associated mares. These scraps can turn violent although more often than not both animals come out unscathed.*

Biologists are uncertain as to the exact reason for the distinctive striping. Each zebra's pattern of striping is unique, forming an equine fingerprint that can vary greatly, both between sub-species and individuals. Grevy's zebras, for example, have dense narrow stripes and lacks the grey shadowing of the more common Burchell's zebras. As well as camouflage (see box, opposite) it is thought that the markings help in social identification and maybe even temperature control.

Burchell's zebras are common throughout Africa and for this reason it is easy to ignore them. But a day spent with a large herd of zebras can be photographically rewarding. Their willingness to live in groups, which extends beyond simple predator–prey dynamics, is apparent in the shows of tremendous loyalty and what appears to be genuine affection for members of their family group – grooming, nuzzling, playing, feeding and napping together. All of which make for interesting behavioural studies.

▼ *During territorial disputes it is common for zebras to kick out at a stallion that has questioned another's right to rule.*

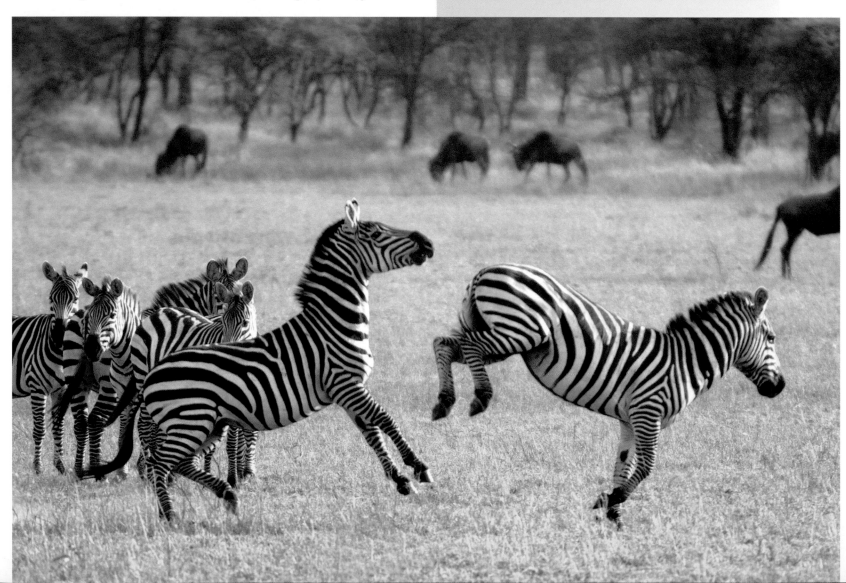

Earning their stripes

Black and white stripes in a golden savannah may seem an odd form of camouflage, yet zebras' stripes are highly effective. When you see a large herd of zebras from a distance, notice how the stripes seem to break the outline of individual animals. Then imagine a lion that, having spotted the herd, picks on a weak or lame target and moves in for the kill. As it gets closer the zebras circle around until, in a swirl of stripes, the lion loses sight of the individual and rather than expend energy on a risky attack backs away.

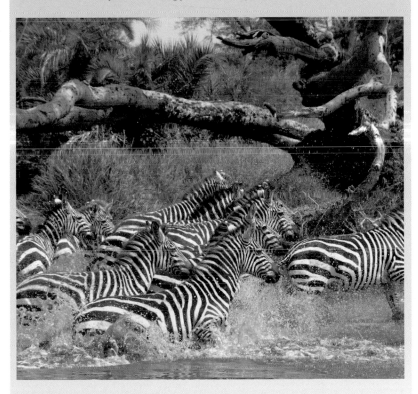

▲ *Despite outward appearances zebras' stripes are a highly effective form of camouflage. In tightly packed herds, it becomes almost impossible for a predator to pick out a single animal, making any attempted attack a risky proposition.*

Flehmen response

In order to heighten his sense of smell a zebra stallion curls his top lip in a display often referred to as a 'horse's laugh'. The term for this behaviour is the Flehmen response, and it is typically seen when a male assesses the readiness of a female for breeding by detecting certain scents in the mare's urine.

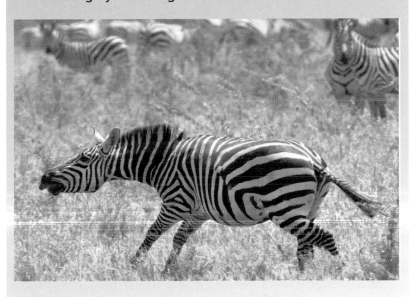

▲ *The Flehmen response is a typical sign of a stallion assessing a mare's readiness to mate.*

Photographic tip

When photographing large herds, such as those of wildebeeste and zebras, don't be impatient to get away. These animals will be wary of your presence initially and will remain so for several minutes. Only when they are settled and convinced you are of no threat will they revert to normal behavioural traits, and only then will you get good photographs. Be prepared to spend several hours or even a whole day with a herd to get compelling pictures.

Every year the Serengeti and the Masai Mara host one of the great wildlife spectacles – the wildebeeste migration. This entails the movement of around two million animals (one and a half million wildebeeste and half a million zebras and Thomson's gazelles) on a circular route of 1,875 miles (3,000km) – equivalent to circumnavigating Britain and Ireland combined.

Following their movements are lions, leopards and cheetahs, who lie hidden in the grass. But the most dramatic moment is the crossing of the Mara River.

Migration diary

Wet season

December – Heading south from the Masai Mara the migration speeds towards the southern plains of the Serengeti, following the Loliondo boundary, desperate for the new grasses regenerated by the rains heading north from the south. Zebras begin to calf.

January – The migration reaches the short grasses of the Serengeti Plains.

February – The migration congregates on the Plains to feed on the plentiful grasses. Numbers have been known to reach two million wildebeeste and up to half a million zebras, gazelles and other antelopes. Predators are all around and the wildebeeste are calving.

March – Heavy rains keep the animals close to the Plains.

April – The migration begins to shift away from the Serengeti Plains to the new grasses around Seronera.

May – The animals continue north along the Mbalageti River towards the Western Corridor of the Serengeti, between the Naabi Hills and the Grumeti River. As they cross the wooded lands columns several kilometres long can be seen.

Dry season

June – The migration is now in the wet, black-cotton soil plains of the Western Corridor. It crosses the Grumeti River running the gauntlet of the resident crocodiles.

July – A split in the migration sees the largest proportion of animals heading north of the Grumeti River into the Grumeti Controlled Area. A smaller number of animals proceed east of the Grumeti River towards the Lobo Area.

August – Repatriated the migration reaches the Ikorongo Controlled Area. Winter is setting in and mornings are cold.

September – The dramatic crossing of the Mara River as the whole population of wildebeeste, zebras and gazelles pass into the Masai Mara in Kenya. The main crossing point is around Paradise Crossing.

October – The migration has left behind the now dry Serengeti National Park and is ensconced in the Masai Mara Game Reserve, where water is always available.

November – As the flame trees begin to blossom the migration heads back into the Serengeti, towards the new rains coming north from the south.

In their desperation to reach the northern bank thousands fall victim to trampling, suffocation or predators. The best time to photograph the crossing is in mid-September when tens of thousands of animals reach Paradise Crossing, close to Governors Camp, made famous by the BBC's *Big Cat Diary*. Unfortunately the timing of the river crossing varies and is dependant on the rains; the later the rains in the Serengeti, the later the crossing into the Mara. For the best viewpoint you will need to rise early. The crossing is a magnet for photographers and tourists alike. Professional photographers and dedicated enthusiasts will park early for the best viewpoints, while numerous tourist vehicles jostle for position throughout the day. Other opportunities to photograph the migration include mid-January to mid-February on the Serengeti Plains, close to Ndutu Lodge and Kusini Camp, when the calving season attracts predators, providing chances to see cheetahs and lions hunting. In June the wildebeeste move to the Western Corridor and, though more dispersed than later in the year, large numbers can be seen together. There is also the possibility of witnessing the less dramatic but still enthralling crossing of the Grumeti River.

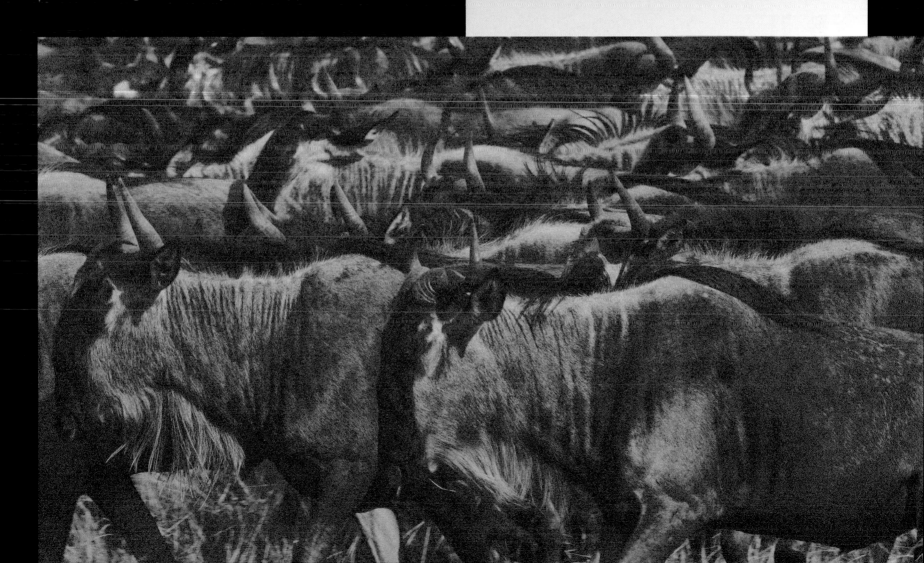

▼ *Zooming in on the herds of the migration and applying a grain effect in Photoshop emphasizes the chaos of the scene, where each individual is hard to distinguish.*

Lions

Of Africa's top predators it is the cats that dominate. They are specialist hunters with muscular bodies, keen senses of sight and smell, powerful limbs, lightning reflexes, super-efficient camouflage and highly evolved teeth and claws. Vision is their predominant sense and all cats have flexible eyesight that allows them to see equally well in daylight and at night. Hearing is also important, however, and their ears are large and mobile and shaped like funnels to draw sound.

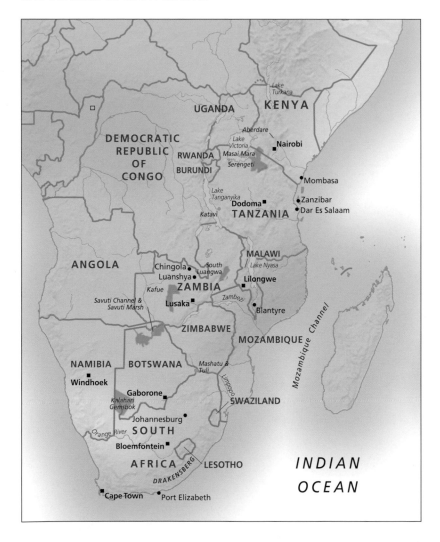

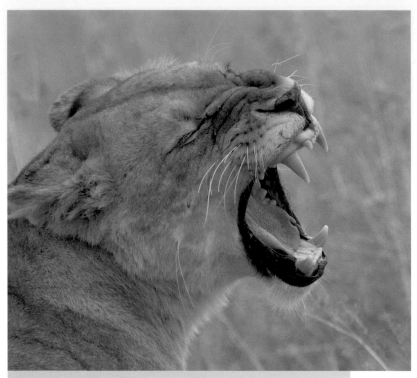

▲ *Lions are notoriously lethargic animals, sleeping for up to twenty hours a day. They tend to restrict their activity to the cooler hours of early morning and evening.*

Hunting techniques vary depending on both the species and the situation. Some cats seek prey and stalk it while others rely on stealth to ambush unwitting victims. Typically, however, most cats use a combination of the two techniques, depending on the situation. Cats are unfussy eaters and prey is chosen indiscriminately, although different species have their favourites. The big cats (lions, leopards and cheetahs) all specialize in catching prey larger than them, which they then drag into a safe feeding spot away from competitive predators and scavengers.

Unlike any other species of large cat, lions live in close-knit social groups (prides) that can sometimes span several generations. These prides are essential to survival, as lions depend on each other to catch prey and to raise healthy offspring. Each pride consists of an average of four to six females with cubs, with lionesses giving birth at around the same time and often sharing suckling duties. Within the pride young lions will often be seen play fighting, a kind of role-play that is used to develop hunting skills. From these tussles social status is established and an individual's role during a hunt will be determined, in other words whether she is part of the chasing group or one who carries out the actual kill.

Lions are territorial, occupying a home range. Within their territory members of the pride co-operate to stalk and kill large prey, such as zebras, impalas, giraffes, wildebeeste and even buffalos. If hunting alone, a lion is likely to prey on much smaller game, such as rodents, small deer, hares and reptiles.

▼ *A lion grabs the scruff of the neck of a lioness to avoid being attacked during mating. The male's penis is barbed, which is painful for the female, sometimes causing her to react in a violent manner.*

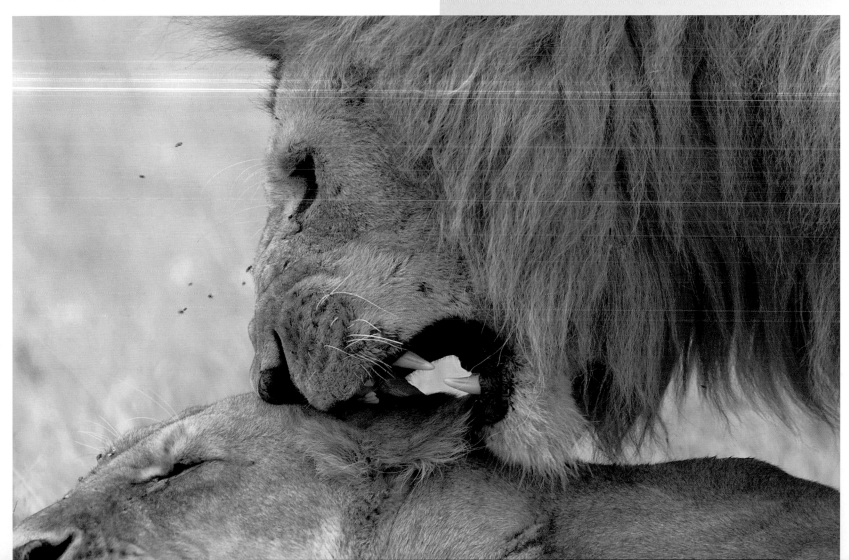

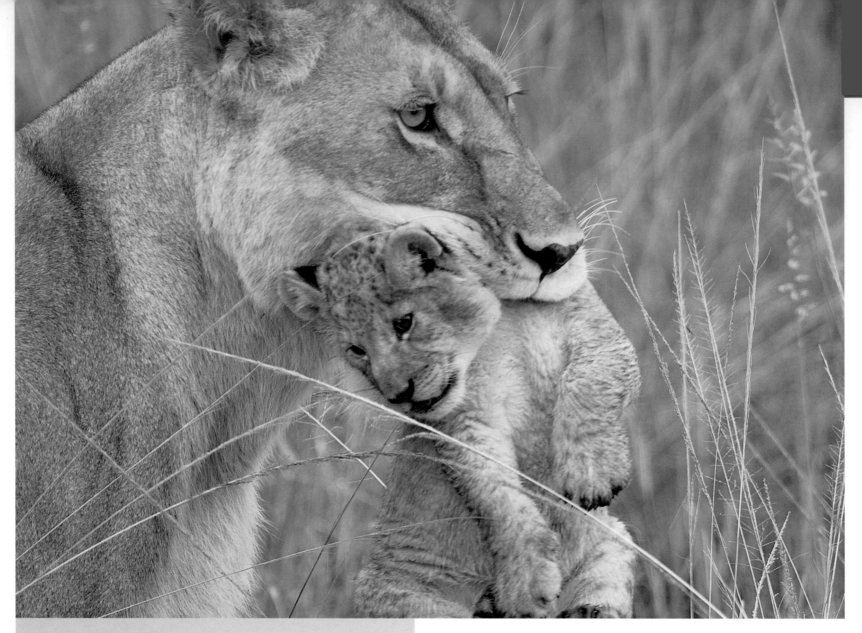

▲ *A lioness carries a cub gently in her mouth. Despite their necessary ferocity towards prey and their lethal canine teeth, lionesses are devoted mothers capable of showing the utmost delicacy when moving their young.*

Outside of the pride adult males will live alone or in a coalition with one or maybe two other unrelated male lions. Coalitions of related males can be larger but usually won't exceed five animals. These coalitions are short-lived, typically lasting no more than two to three years.

However, while they exist, the lions will defend their territory from other adult male coalitions and hold mating rights over prides within their territory.

Lions are difficult to photograph well as they spend most of the daylight hours asleep. Early mornings are the ideal time to photograph them when they are still active. Look out for behavioural traits such as greetings (rubbing of heads), aggression (often seen between females and young or nomadic males) and mating, which can occur every few minutes and last several days. If you are lucky enough to encounter a pride with several young then the antics of the cubs always makes for enthralling photography.

Learning the language of lions

You can determine a lion's mood by its body language. Visible teeth, eyes closed or squinting and the ear openings facing sideways are the sign of a mating grimace. However, if the ear openings are pointing downward, the lion is displaying a defensive threat. When the teeth aren't showing, the eyes are open and the ear openings are forward, the lion is alert, usually either to the presence of danger or prey. When the ear openings are sideways on the lion will be in a playful mood, but ear openings pointed backward and the display is one of an aggressive threat.

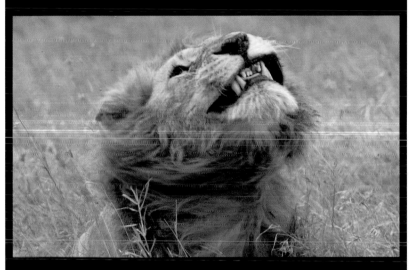

Lions greet each other by rubbing together their heads and bodies, in much the same way a domestic cat will greet its owner. Other forms of friendly social behaviour are rump swivelling, circling, tail flicking and anal sniffing. During courtship, lions will solicit likely mates with a display of mating grimaces. A chase may then ensue.

Scent marking, claw-raking and scraping are typical signs of conflict behaviour. Direct stares and strutting signify a low-intensity threat, but growling, tail lashing and head twisting indicate a high-intensity threat.

Anatomy of a kill

Lions stalk their prey and, when close enough, initiate a short charge, either pouncing on their target or causing it to fall over. If the prey is caught the lions will attempt to get a vice-like grip on the victim's throat, after which death is swift, either by suffocation or a broken neck.

Entry into the carcass is usually made via the stomach, which is often the softest and easiest point of entry. The stomach area also contains the most nutritious parts of the body, such as the kidneys and liver. After a short initial feed they will rest, lying a short distance from the kill in order to defend it from scavengers should the need arise.

Lions may stay with a carcass for over 24 hours and spectacular fights can erupt between pride members or with any scavengers brave enough to attempt a quick steal.

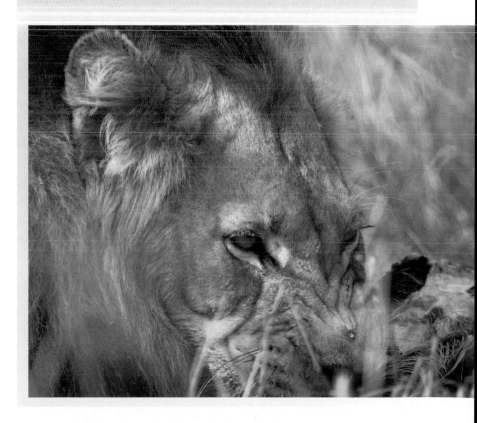

Mating rituals

I followed this pair of lions for an afternoon, during which time they mated on average every seven and a half minutes! After a short nap the female would instigate a new 'session' by nudging the male with her shoulder and then assuming a suitable position. The male, who looked far more in need of sleep than exercise, would then do his duty – an act lasting barely five seconds – before leaping acrobatically away from the female in order to avoid getting bitten. The female, who seemed remarkably satisfied considering the brevity of the moment, would then roll in contented ecstasy, before both lions fell asleep.

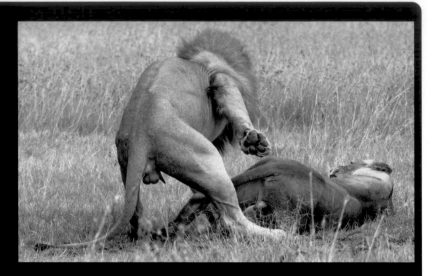

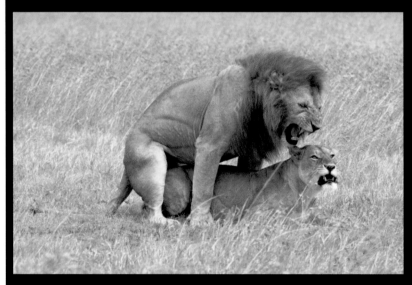

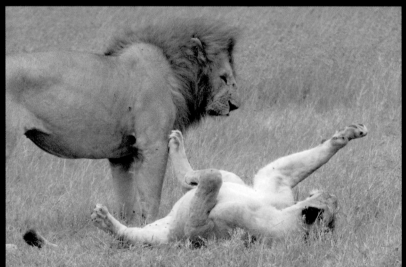

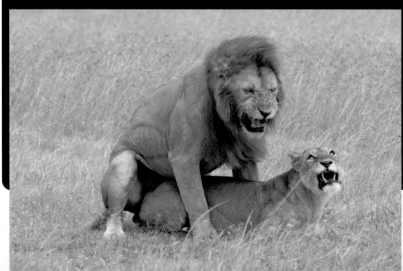

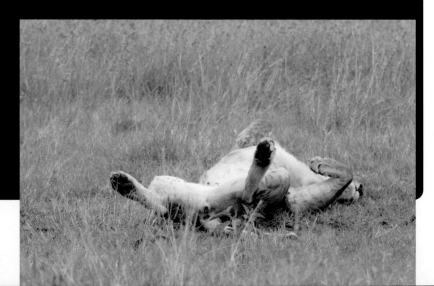

Leopards

Of all the big cats in Africa the leopard is the most elusive. Unlike lions they are solitary creatures that live alone and only come together to mate. Cubs, of which one or two is the typical number, will stay with the female for a year or more. Like lions they are territorial and will defend their territory aggressively, warning enemies with a display of hissing and spitting. A flattening of the ears back against the neck signals a

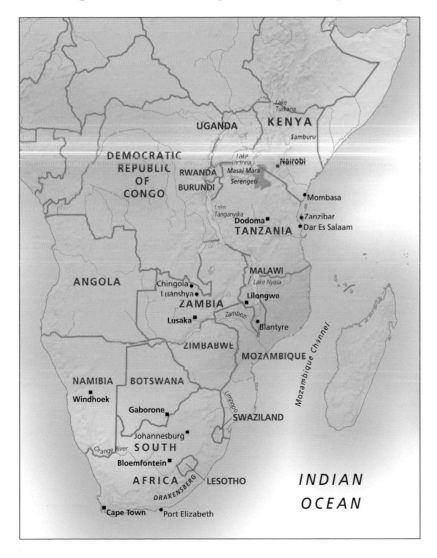

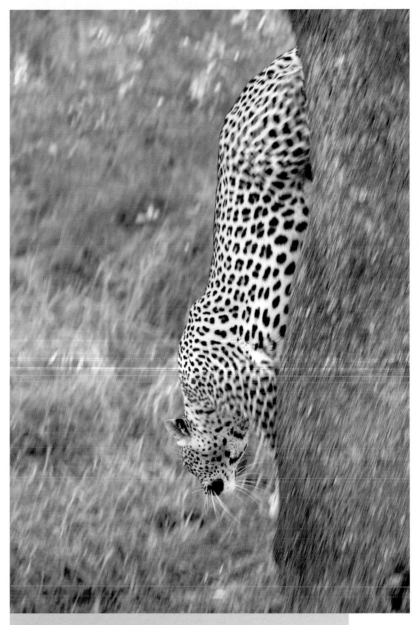

▲ *An adult leopard makes a speedy descent from a tree, where it has been resting during the heat of the afternoon.*

subsequent attack. Leopards are opportunistic hunters and unfussy eaters, feeding on pretty much anything from beetles to large antelopes weighing twice their own bodyweight.

Stealth is the principal weapon in attack and they will remain perfectly hidden until an unwitting victim passes them by when they pounce with immense speed and agility. It is this ability to disappear that makes leopards so hard to spot. I once had a conversation with a ranger in the Kruger Park asking if he had seen any leopards that day. 'Funnily enough,' he replied, 'I saw one this morning with a group I was leading. We had been watching a rhinoceros for 20 minutes when we decided to drive away. As I turned on the jeep's engine, a short way from the vehicle up stood a leopard and wandered off.' Nine tourists and an experienced guide had failed to spot a leopard almost within touching distance that had remained hidden for 20 minutes!

▼ *Like most animals, leopards will take the easiest route from one place to the next. Here a young adult male makes tracks along a well-worn path in Greater Kruger National Park, South Africa.*

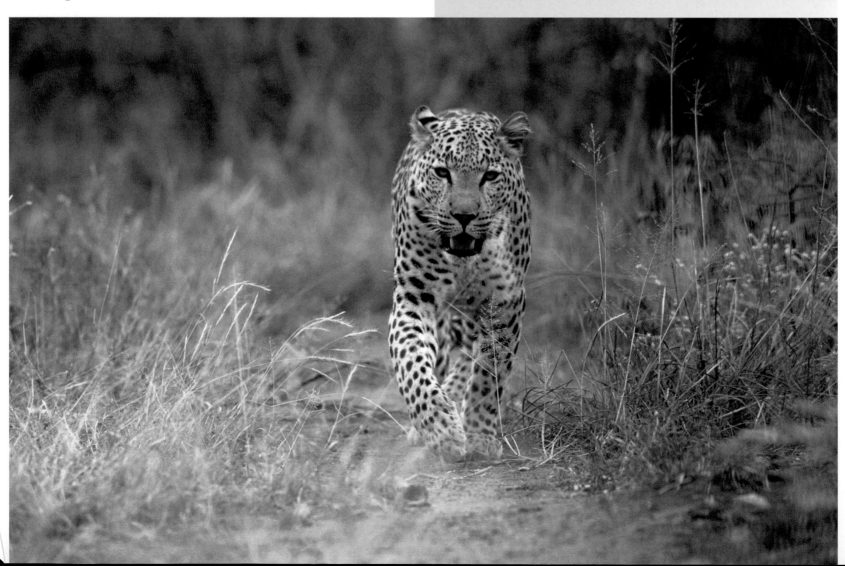

The solitary and elusive nature of leopards also makes it hard to count populations with any degree of accuracy. However, hunting has taken its toll on numbers and they are listed by CITES as Appendix 1. In their favour is the adaptability of the species. However, their ability to adopt new habitats has increased the potential for leopard–human conflicts as, in parts of Africa, they have become tolerant of human presence and have been known to hunt within a few miles of big cities.

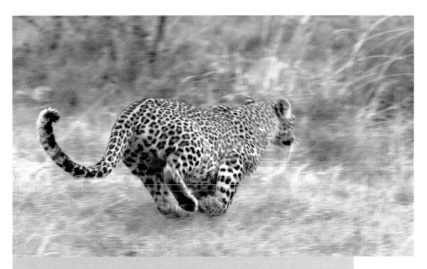

▲ *Leopards will avoid contact with humans if at all possible. This image shows a young male escaping the attentions of several circling tourist vehicles in Masai Mara National Reserve, Kenya.*

Photographic tip

When photographing a leopard resting in a tree the bushy leaves may disrupt the autofocus system of your camera causing it to 'hunt'. Switch to manual focus and focus on the eye for pin-sharp pictures.

Caching food

Leopards are excellent climbers and use their strength to drag carcasses into trees where they may feed immediately or store (cache) the meat until a later time. The reason for caching food in this manner is peace and security. Leopards are the only species of the large carnivores that can climb easily (lions are sometimes found climbing trees but rarely with the skill of the leopard) and caching protects their kill from scavengers.

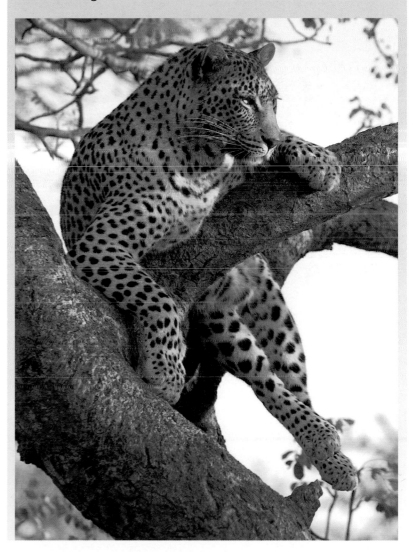

Cheetahs

Often considered the Queens of Africa, cheetahs are the Ferraris of the savannah. They are the fastest of all land mammals, capable of reaching speeds around 70mph (110kmph) over short distances (although the average speed during a chase is less than 40mph/64kmph). After a short burst their bodies begin to overheat and this, combined with oxygen starvation, causes them to stop. Prey that can keep out of reach for long enough will

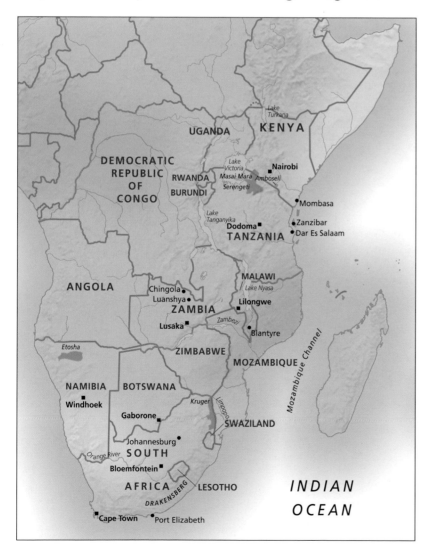

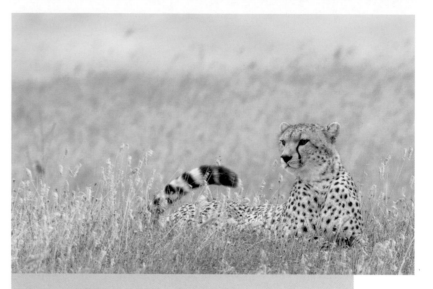

▲ *Cheetahs are the most elegant of all big cats, with a natural poise and demeanour more suited to a catwalk than the savannah. They are the fastest of all land mammals, capable of reaching speeds around 70mph (110kmph).*

usually escape unharmed, if a little shaken. That said, cheetahs are the most successful hunters of the big cats with a kill-to-chase ratio of around one in four – compared with lions, which succeed just one time in 20.

Cheetahs are diurnal, which means they hunt both during the day and at night. Indeed, it is not uncommon for cheetahs to hunt during the middle of the day, when their predator competitors are resting, giving them a greater chance of success and of holding onto the kill once it is made. Without the strength in numbers and muscular power of lions and lacking the tree-climbing ability of leopards, cheetahs will eat swiftly after the kill and, to avoid possible confrontations with other predators and scavengers, will take their fill and leave. Next to lions, cheetahs are the most sociable of the big

cats and although they tend to exist alone it is common for siblings, particularly brothers, to remain together in coalitions lasting several years, although one cat remains dominant over the others and monopolizes mating opportunities. However, for the non-dominant cheetah in the alliance, the advantages of a coalition – longer territory tenure and easier hunting – outweigh the disadvantages. It is only the males that are territorial and females tend to settle within their mother's home range.

▼ *Unlike their feline competitors, lions and leopards, cheetahs are truly diurnal, hunting both at day and night. By hunting during the heat of the day, they avoid conflicts with other predators and are less likely to lose their kill to scavengers.*

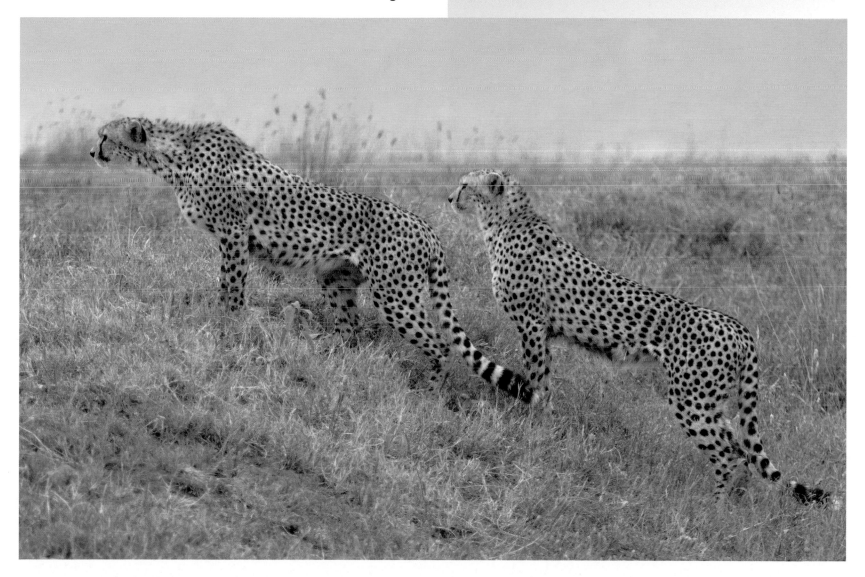

King cheetah

The king cheetah was once considered a separate sub-species but is in fact an African cheetah exhibiting a rare fur pattern mutation consisting of dark stripes along the back and blotches in place of spots on the side and flanks. In order for this mutation to appear a regressive gene must be inherited from both parents. The king cheetah was first discovered in Zimbabwe in 1926 and has been seen in the wild only six times since. It is believed that fewer than 60 such animals exist in the wild, although they can be seen at some cheetah sanctuaries, including the Kapama Cheetah Rehabilitation Centre near Kruger National Park and at the DeWildt Cheetah Research Centre, both in South Africa.

Photographic tip

Photographing a cheetah in chase is not easy. Set a very fast shutter speed, in excess of 1/1000sec and pan the camera to follow the movement of the cat. Depending on the camera-to-subject distance, a powerful flash with an extender may help to freeze the appearance of motion. For artistic blur set a slower shutter speed, in this example 1/250sec.

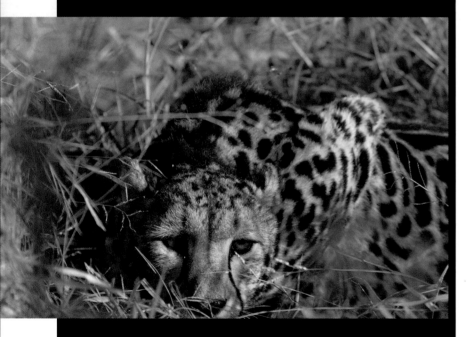

There are thought to be around only 60 king cheetahs in the wild. This photograph of a captive animal shows the distinctive markings that distinguish the king cheetah from a common animal.

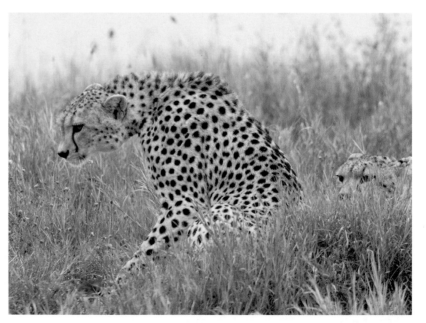

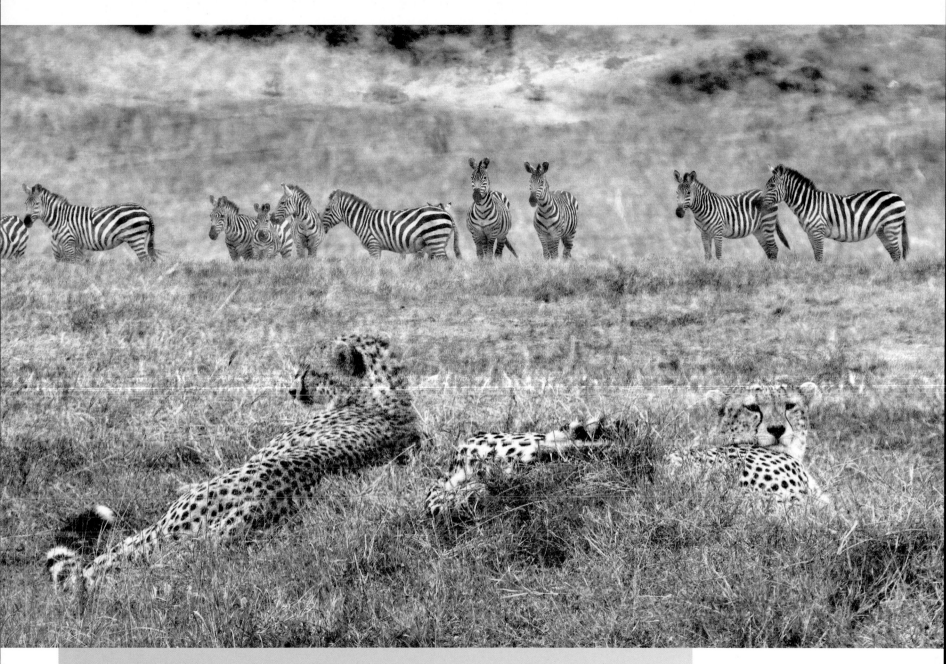

◀ ▲ *Cheetahs show incredible patience when stalking. Often they will lie around seemingly uninterested in nearby prey. But underneath that serene exterior is a calculating mind waiting for the most opportune time to strike. The grainy appearance of this image is a result of it being an in-camera composite of two RAW files.*

Wild dogs

African wild dogs (also known as the painted wolf or Cape hunting dog) live in social groups known as packs. Packs consist of a dominant pair, the alpha male and female, and their offspring within territories that they mark with urine. Older offspring remain with the pack for several years and it is common for a pack to consist of animals of many different ages.

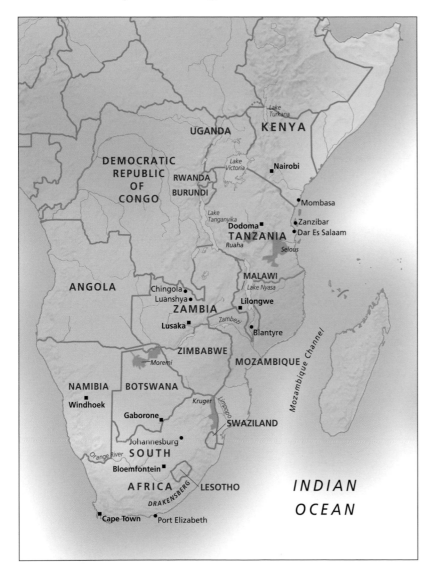

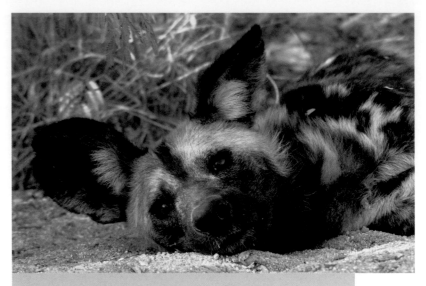

▲ *A wild dog opens its eyes briefly during a long snooze through the heat of the midday sun.*

▼ *Wild dogs possess extreme levels of stamina and will often chase prey for several miles, literally running them to the point of exhaustion, at which stage they move in for an effortless kill.*

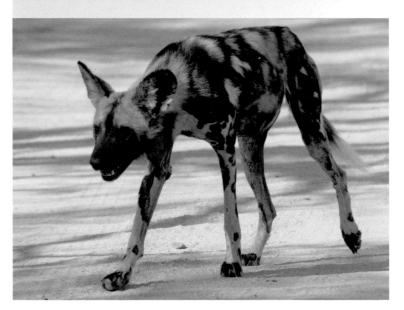

The pack hunts together over a wide home range that can include several types of habitat. In fact, a climber once reported seeing a pack of five wild dogs at 20,000ft (6,345m), near the top of Mount Kilimanjaro. They are diurnal but often hunt by moonlight, tracking a herd of deer or antelopes until scattering them with charges to test for the health and strength of individual animals. The pack leader will then select a single animal that the pack manoeuvres away from the protection of the herd.

Using their immense stamina they will proceed to run their prey to the point of exhaustion before moving in for the kill. At this point a single animal will bite the nose of the prey, immobilizing it by dragging its head downward while the remainder of the pack tear open the stomach and disembowel the victim. By hunting co-operatively wild dogs will kill prey as large as wildebeeste and zebras, enough to sustain the whole pack. At the den food will be regurgitated for pups.

The wild dogs' relations with other predators are nonchalant. They show little fear of other carnivores, although they will avoid lions by 'alarm barking' and moving out of their path. Relations with hyenas are competitive as the latter will regularly attempt to steal

their kills either by piggybacking the pack leader or confronting a feeding pack in a large clan. However, despite the difference in size (hyenas are far larger than wild dogs), the hyenas' lack of inter-clan co-operation means they rarely win a stand off and they are often mobbed and routed.

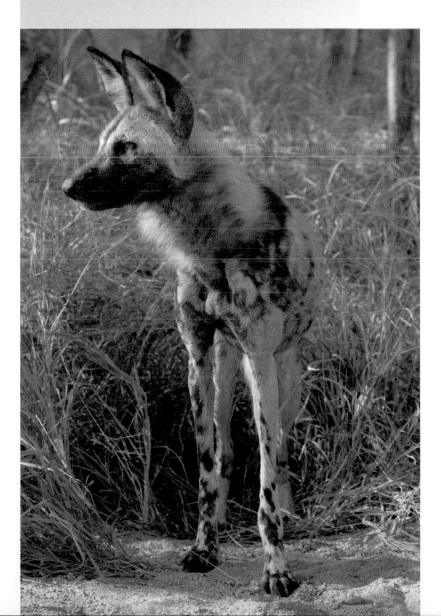

▼ *The over-sized ears of a wild dog are used to detect the quietest of sounds over vast distances.*

Wild dogs and conservation

Wild dogs were once widespread in Africa. However, as with wolves in the northern hemisphere, persecution in the form of shooting, trapping, poisoning and snaring, together with habitat loss and increased human encroachment into their home ranges have taken a toll on their numbers. Diseases such as distemper and rabies can quickly wipe out entire packs, and have led to the wild dog becoming one of Africa's most endangered species; their survival is dependent on active conservation.

Hyenas

The other large predatory pack hunter in Africa is the spotted hyena. Although closely resembling a dog, the hyena is in fact more closely related to cats, civets and genets. They inhabit savannah, such as that found in the Masai Mara and Serengeti; scrubland and semi-arid environments. Like lions they are predominantly nocturnal, which puts the two great predators in conflict on a regular basis.

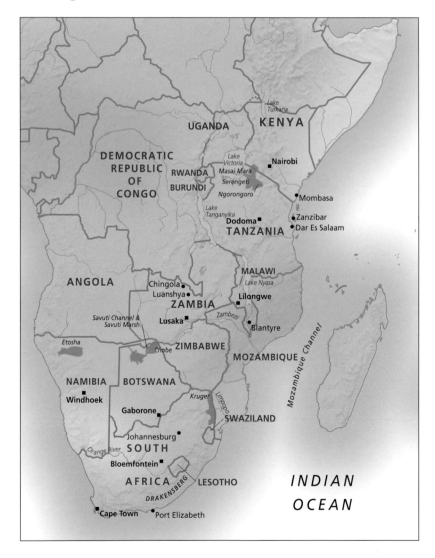

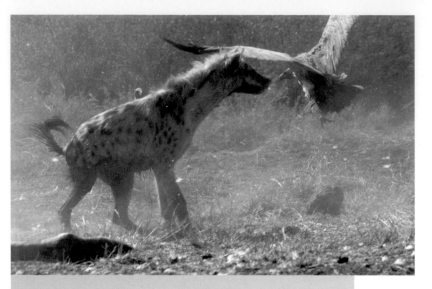

▲ *Hyenas and vultures are often seen together and tolerate each other's presence at a kill. Hyenas have the most powerful bite of any animal in Africa and can easily and quickly demolish the bones of prey.*

Of the three hyena species (the others being the brown and the striped hyenas) the spotted hyena is the largest. Social groups, known as clans, are dominated by females and may include small groups of five or fewer animals in desert areas, or up to 50 or more individuals in prey-rich savannah regions. Territories are defended by the whole clan and can be up to 625 sq. miles (1,000km²), delineated by calls, scent marking and border patrols.

Spotted hyenas are immensely successful hunters and have the most powerful bite of any animal in Africa. Members of the clan will form a hunting pack in order to bring down large prey, such as an adult zebra or wildebeest. Once prey is killed, hyenas will gorge themselves and can consume up to a third of their bodyweight in a single sitting. This makes them one of Africa's most efficient predators.

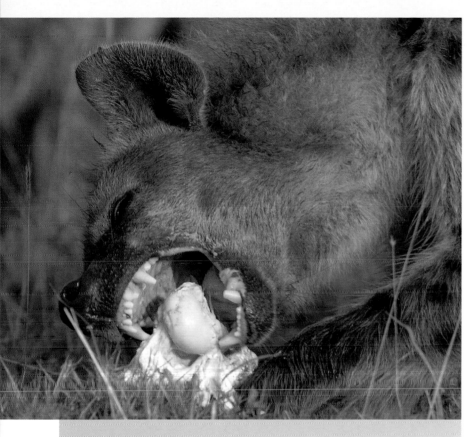

▲ *Hyenas are effective predators as well as scavengers. As you can see from the image above they have an incredibly strong bite, which enables them to crush the bones of their prey and fulfil an important role in the cycle of life.*

Habitat and activity

A radio-collared female in the Ngorongoro Crater was once followed for 12 days. Studies found that she spent little time foraging, simply sharing kills made by other clan members. She travelled less than four miles (6.5km) in 24 hours and spent all but four hours lying down. Conversely, a similar experiment in Kalahari Gemsbok National Park revealed that hyenas there had to work harder for a living, travelling four times the distance foraging for food and twice as long doing it.

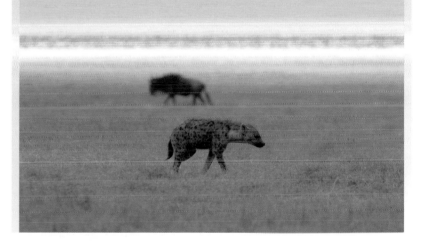

Photographic tip

When photographing pack animals like wild dogs and hyenas I like to include a large amount of the surrounding habitat by using a wideangle lens to create a sense of place and position the subject within the context of its habitat.

The laughing hyena

The so-called laugh for which hyenas are renowned is in fact typically emitted when the animal is being chased and is a sign of intense fear. Happy hyenas are more likely to call using groans and soft squeals. The most common hyena call heard by travellers is a whooping sound that brings clan members together, usually to a kill.

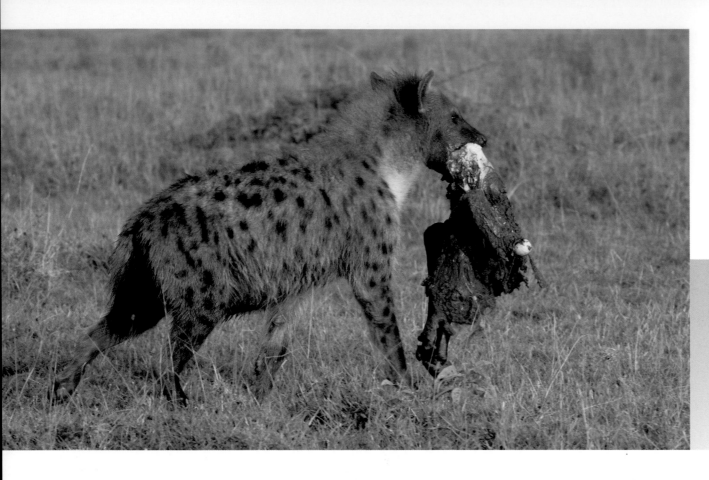

◀ *Hyenas are often labelled as nothing more than scavengers, stealing the prey of predators. In reality, hyenas are successful predators in their own right.*

Brown and striped hyenas

Unlike their cousins, brown hyenas typically live in pairs or small groups. As well as savannah habitat they range further into desert environments than other hyenas and can smell carrion up to 8.5 miles (14km) away. Because they exist in small groups they are more likely to scavenge than spotted hyenas, although they will prey on small mammals such as spring hares. It is not uncommon to find hyenas vying with vultures at a carcass and the two can co-exist. However, when a lion pride is present, the hyenas will back away and wait until they have departed. Single lions and packs of hyenas have been known to challenge each other resulting in a confrontation.

Striped hyenas are found mainly in the north of Africa and beyond into Asia, although they can live as far south as central Tanzania where they inhabit thornbush and scrub woodland. Strictly nocturnal they are rarely seen, spending the daytime in secretive lairs. Subjects tracked in the Serengeti rarely used the same lair on consecutive days, making them even harder to spot.

Vultures

Next in line after the hunters are the scavengers, the animals whose role in life is to clean the killing fields of Africa of the discarded carcasses. In reality, hunting and scavenging are not mutually exclusive. Hyenas, for example, have a long-held reputation for scavenging and even lions are never too proud to steal another predator's kill. Principally, however, responsibility for sweeping away the mess left by the hunters falls on the vultures and jackals.

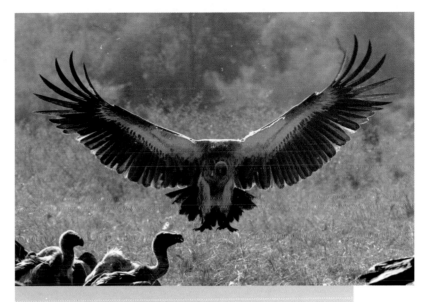

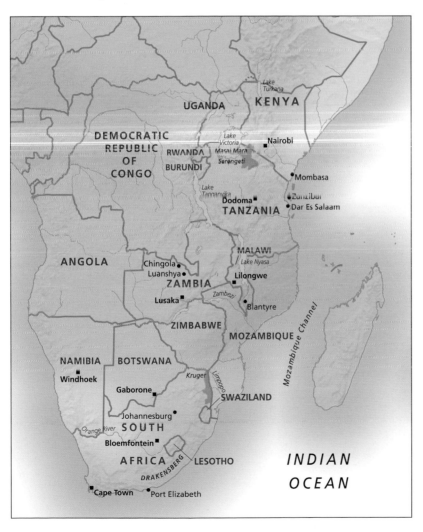

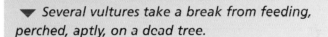

▲ *A lappet-faced vulture, the largest of the vulture species, descends on a kill to take its place among the smaller vulture species.*

▼ *Several vultures take a break from feeding, perched, aptly, on a dead tree.*

Photographic tip

When photographing birds in flight set the camera's autofocus mode to continuous or autotracking, select a fast shutter speed (minimum 1/500sec) and continuous drive mode. Focus the lens on the bird while it is perched. Frame it so that it is in the upper portion of the viewfinder, as birds lose height immediately after take off. Watch for signs of impending flight, such as a ruffling of feathers. When you see these signs press and hold the shutter for a short burst of images.

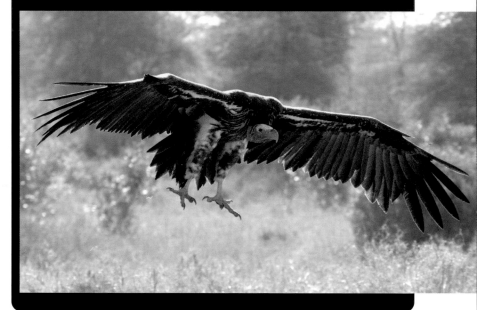

◀ *The large, strong beak of the lappet-faced vulture is designed to tear open the thick skin of dead animals such as elephants, rhinoceroses and hippopotamuses. Without it, none of the smaller vulture species could access the innards, making it essential for their survival.*

Vultures are typically the first to arrive. Once the predators have left they move in and begin the clean-up operation. There are several species of vulture and each one has a different specialism. The lappet-faced vulture is the biggest (and ugliest) of the species, with a strong, hooked beak made for tearing thick hides, in order to reveal innards. White-headed and white-backed vultures have smaller beaks designed for eating flesh off the bone. Finally comes the hooded vulture with a small sharp beak perfectly evolved for removing sinew from the bones, leaving them clean. In all, up to six different species of vultures might be found around a carcass.

Vultures find carrion by circling high in the air, using thermal currents to maintain height. They have amazing eyesight and can pinpoint a carcass from around 45 miles (70km). By keeping a watchful eye on other vultures from up to the same distance, it is possible for all the vultures within a 300 mile (500km) radius to arrive at a kill. The feeding process is both gruesome and at the same time mildly humourous. An entire carcass can be gorged within a matter of hours, but the waddling of the vultures and their constant tumbling as individual birds vie for position makes a good opportunity to take some amusing photographs of the action.

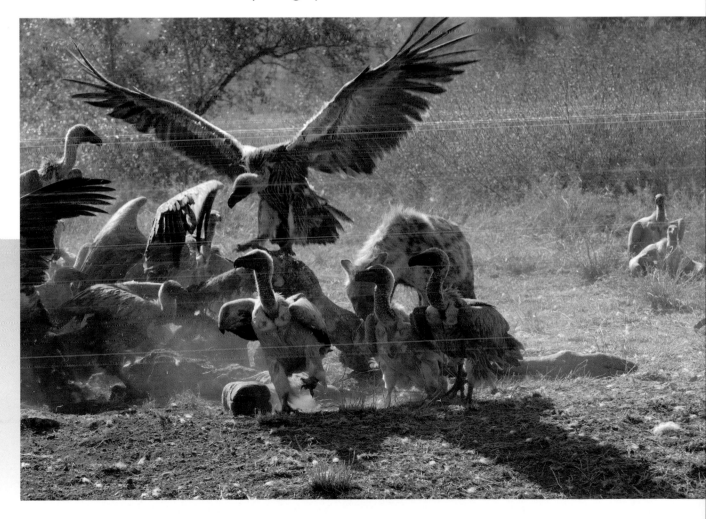

▶ *A large flock of vultures remains unperturbed by the arrival of a spotted hyena. The two scavengers exist observing a mutually beneficial truce and, while short-lived conflicts do occur, rarely will either party suffer.*

Jackals

Watching the activity of vultures are jackals and hyenas, and other interested parties, which take the vultures' lead to identify carrion. There are three species of jackals found in Africa: black-backed (also known as silver-backed), striped and golden.

Jackals are highly adaptable and range from South Africa as far north as Asia and west through Somali-Masai and the Sudanese Arid Zone. Different species prefer

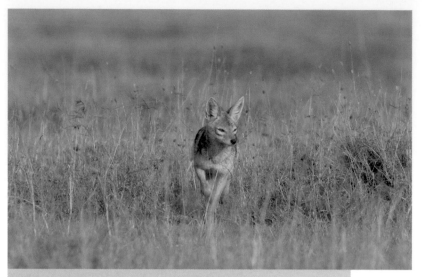

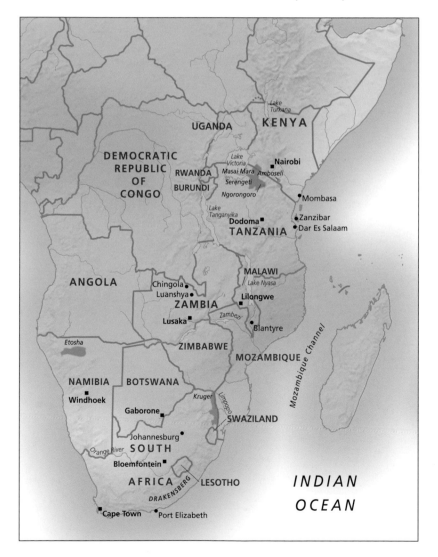

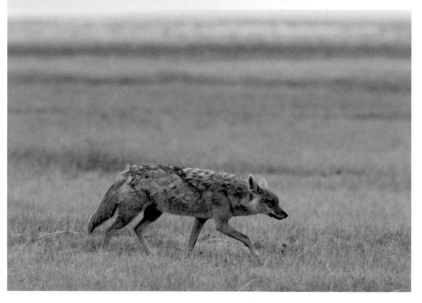

▲ ▼ *Jackals are perhaps the most numerous carnivore in Africa. They are highly adaptable and range from South Africa and into Asia. Their agility enables them to steal food from larger carnivores such as hyenas and wild dogs, although they are wary of lions.*

varying habitats, and the golden jackal is better adapted to the desert than the others, and also the most numerous carnivore on the east African plains; the black-backed jackal prefers acacia/commiphora woodland, while the side-striped jackal is more common to the broad-leaved deciduous woodland of the northern and southern savannahs.

Despite their relatively small size jackals compete aggressively with other predators and scavengers. Golden jackals are dominant over vultures and a single jackal can keep a flock of vultures at bay. They are wary of lions but will steal meat from wild dogs and discourage attempts at repossession with fierce threat displays. Their agility enables them to steal from feeding hyenas. Jackals often work in pairs, pestering the hyena until it snaps at one, at which point the second darts in and grabs the food. However, the relationship between jackals and hyenas is mutual as they rob from each other and often they are content to share a meal.

▼ *A jackal wanders nonchalantly along the edge of Lake Magadi in the Ngorongoro Crater, while a flock of flamingos passes warily in the opposite direction.*

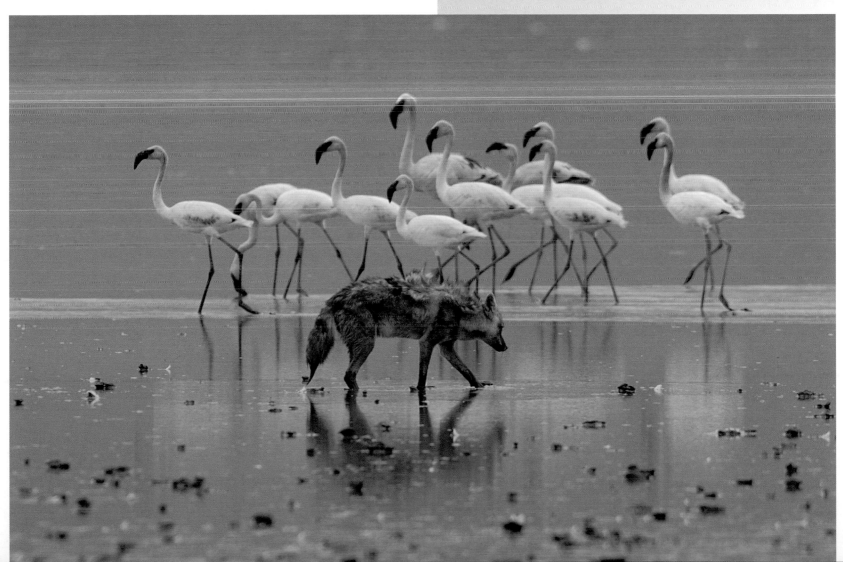

Hippopotamuses

Despite their massive bulk hippopotamuses are surprisingly agile. They move with grace through water, aided by the density of their bodies, which is only slightly greater than that of the water, enabling them to sink gently and meander light-footed along the river or lake bottom. By inflating their lungs, the additional air reduces the density helping them to float with minimal effort. They are equally adept on dry land, where they spend much of the night-time grazing, and can easily out-sprint a human.

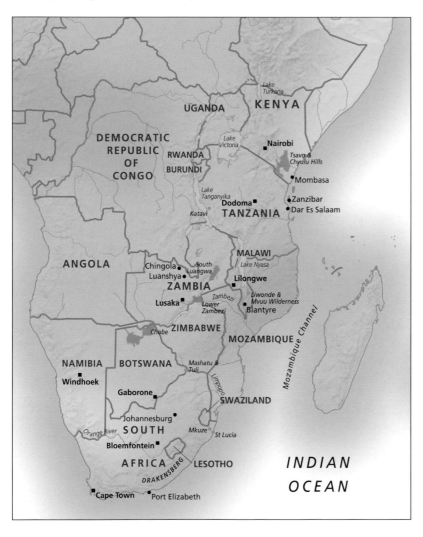

Africa's most dangerous

Hippopotamuses are the cause of more human deaths in Africa than any other mammal. In fact, it is quite possible they kill more humans than all other mammals combined. Such statistics are contrary to the humourous and cumbersome appearance of the hippopotamus. In reality their docile appearance, exacerbated by lazy and frequent apparent yawns, belies a nature of extreme aggression. The 'lazy yawn' is a focused display of hostility and a bearing of deceptively long, razor-sharp teeth – a warning against territorial intrusions. Their rage can be directed towards other hippopotamuses infringing on their territory or against any other intruder, including humans. They are capable of out-sprinting humans over short distances, and a single bite is likely to cut the victim in half. Most incidents involving humans occur on the water when small boats and canoes inadvertently encroach into hippopotamus territory.

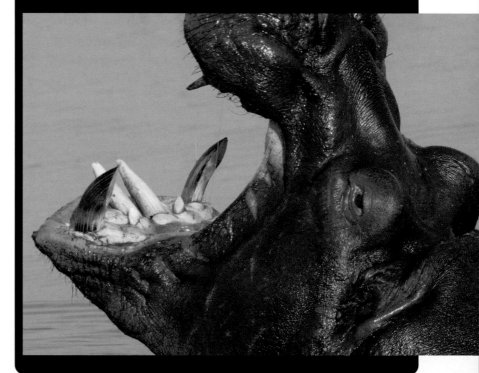

During the dry season hippopotamuses often resort to wandering large distances in search of grass. However, rather than return to their home territory each day some will use a nearby pool as a kind of hippopotamus hostel or bunk house, thereby extending their grazing range. Large gatherings can form at these pools and the lack of any long-term social structure can lead to an experience reminiscent of a boys' locker room with a cacophony of snorts, burps, farts and fighting.

Photographic tip

Set the camera to a narrow aperture (a high f-number) for great depth of field and be sure to focus on the eyes. Hippopotamuses have long noses and it can be difficult to get both eyes and nose sharp.

▼ *Despite their enormous size, hippopotamuses are graceful in water and well adapted to their environment.*

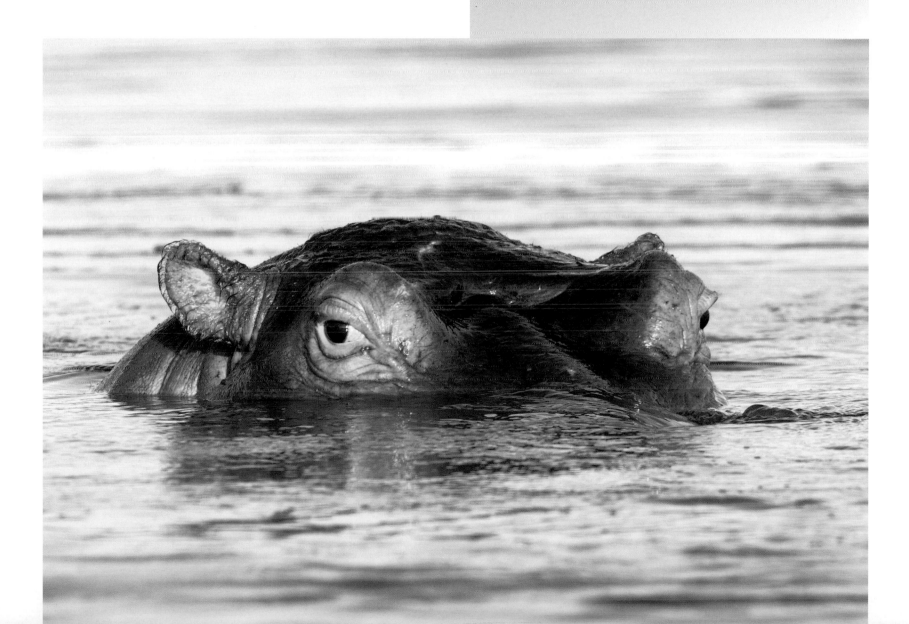

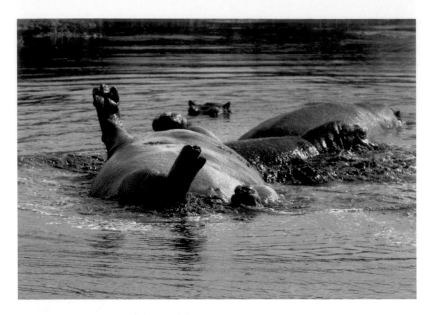

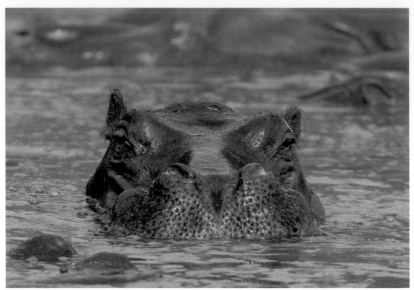

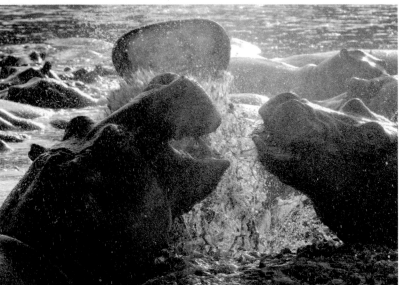

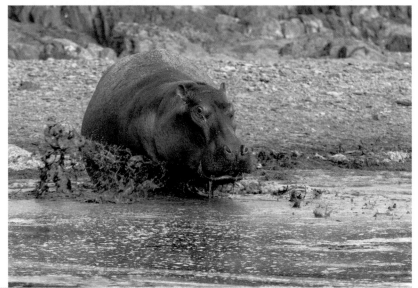

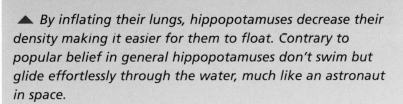

▲ By inflating their lungs, hippopotamuses decrease their density making it easier for them to float. Contrary to popular belief in general hippopotamuses don't swim but glide effortlessly through the water, much like an astronaut in space.

Long periods of calm are often interrupted by a crescendo of noise as two or more of these giants dispute territorial rights. Hippopotamuses find safety in the water and will head to the nearest waterhole or river with surprising speed and agility at any sign of danger.

Buffalos

The buffalo is Africa's only cow-like mammal and the only native African member of the family that includes wild and domestic cattle and bison. Although a danger to humans, buffalos are non-territorial and social animals and when food is in plentiful supply they are highly gregarious, forming herds numbering 2,000 or more. In the dry season they split into smaller groups of females and young, while the males form bachelor herds of mature adults. Older males that have lost their dominance disperse to form a 'retirement' herd that resembles a gentlemen's club and it is these that are of prime interest to lions and pose the greatest threat to people.

With the exception of lions, the sheer bulk of a buffalo – they can weigh over 1,500lbs (685kg) – leaves them with few or no other predators. However, calves, which are fiercely protected by females and other members of

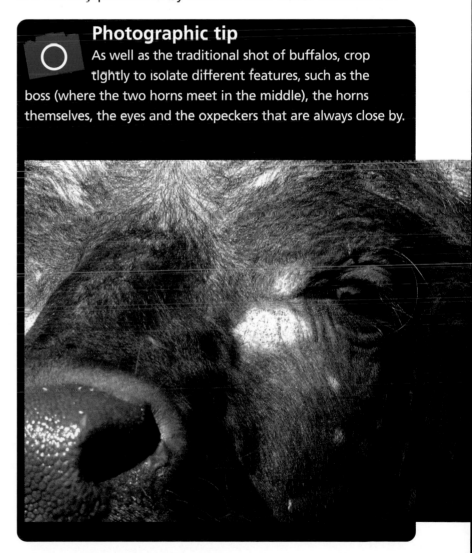

Photographic tip

As well as the traditional shot of buffalos, crop tightly to isolate different features, such as the boss (where the two horns meet in the middle), the horns themselves, the eyes and the oxpeckers that are always close by.

the herd, can fall prey to spotted hyenas. Preying on buffalos is a risky business. Lions risk a mobbing attack and are frequently 'treed' – sent scurrying into a nearby tree for safety – and sometimes trampled or gored. When fleeing, buffalos will bunch in tight, slow-moving groups, making it harder for lions to single out individuals.

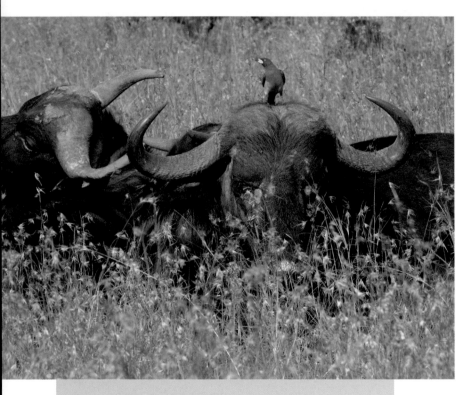

▲ *The buffalo is Africa's only native bovine mammal. They are social animals sometimes seen in herds numbering around 2,000 animals, although smaller groups are more common. Their main predators are lions, although even they must be careful in attacking an animal that weighs in at over 1,500lbs (685kg).*

Love and hate

Buffalo hide is often infested with ticks, fleas and other parasites that are feasted on by birds such as the oxpecker, and it would be unusual to see a herd of buffalo without a flock of these birds in close proximity. On the whole, the relationship is mutually beneficial. The birds are fed and the buffalo is cleaned. However, it is not uncommon for oxpeckers to keep wounds open and feed on the blood. By watching them interact it is obvious that the buffalo isn't always pleased that the oxpecker is around.

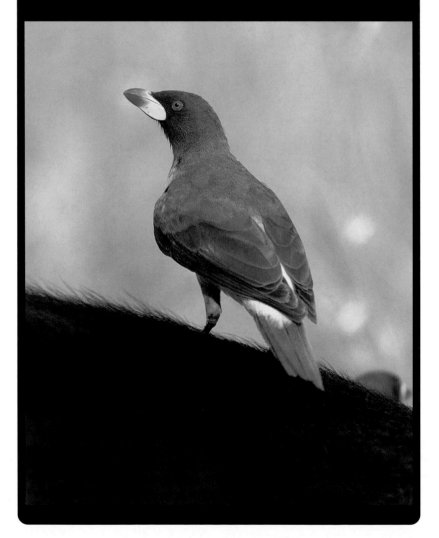

Crocodiles

Crocodiles have a fearsome reputation that is well deserved. Approximately 65 million years of evolution have turned them into one of the world's most refined and effective killing machines. Conversely, they can also exhibit a gentler nature.

They occur throughout Africa mainly in freshwater rivers, lakes and lagoons but can also be found in swamps and estuaries. They differ from alligators with a snout

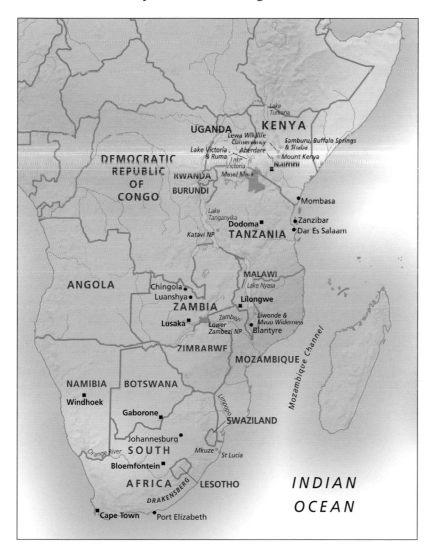

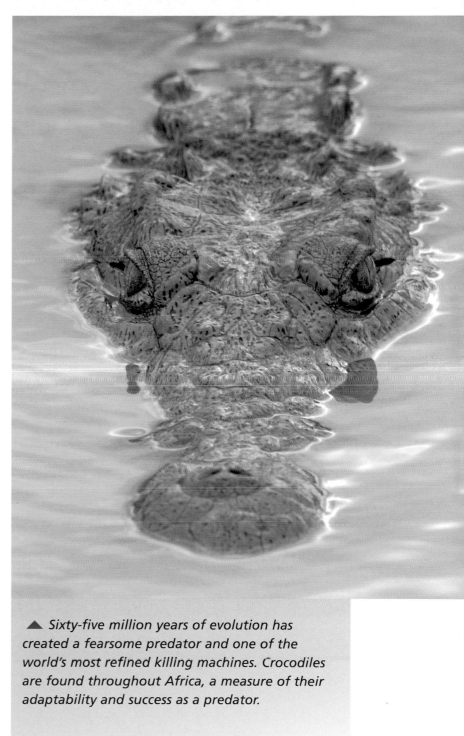

▲ *Sixty-five million years of evolution has created a fearsome predator and one of the world's most refined killing machines. Crocodiles are found throughout Africa, a measure of their adaptability and success as a predator.*

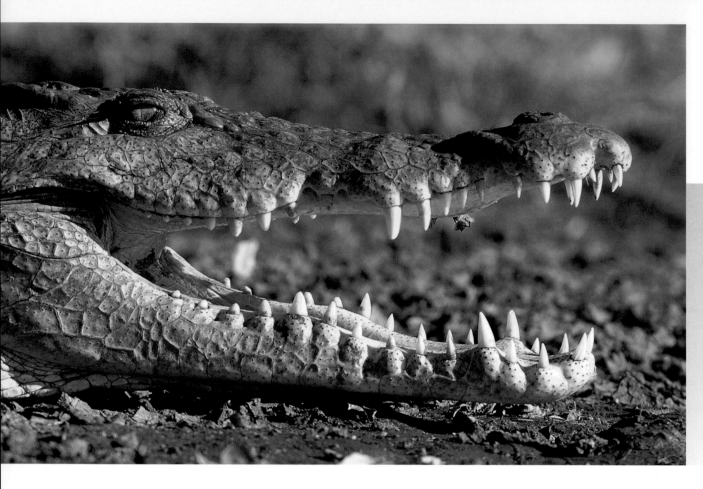

◀ Look closely and you will notice that crocodiles have no molars, meaning that they are unable to chew meat. Instead, they clamp their prey between those powerful jaws, using their teeth to gain a firm grip. They then enter a death roll, literally shaking their victim limb from limb.

that is more pointed and a visible fourth lower tooth. Also, alligators are only found in North, Central and South America.

Crocodiles are strict carnivores and are happy to eat a mixture of live prey and carrion. One of their typical tactics is to lie submerged at the edge of rivers where they wait for mammals to come within range before striking. Alternatively, they will drift invisibly towards their potential prey, hoping to catch it off guard. Commonly, adult crocodiles will co-operate when hunting, allowing them to catch larger prey such as wildebeeste and zebras. Fish also form a large part of the diet, particularly the smaller, younger crocodiles that aren't equipped to hunt large mammals.

Several females will mate with a single male and lay their eggs close to the water in a mound of vegetation and mud. The eggs are guarded and the mother will help the hatchlings to the safety of the water by carrying them with a gentleness that belies her aggressive nature.

The prevailing temperature during the middle third of the development period determines the sex of the hatchling. In the parts of the nest where the temperature is below 89°F (31.7°C) and above 94°F (34.5°C), hatchlings will be female. In between, the hatchlings will be male. Recent studies have shown that apparent global warming is affecting the temperature of crocodile nests causing more males to be born than is usual, and this has possible long-term consequences for the survival of the species.

Photographic tip

Get down to eye level to photograph crocodiles. The level point of view creates a tension between the subject and the picture viewer that is far more compelling than images shot from above.

The death roll

The well-known practice of spinning violently in the water with their prey – known as the death roll – is a result of crocodiles' inability to chew. Large prey must be dismembered and the energy and violence of the spinning action tears limbs from prey.

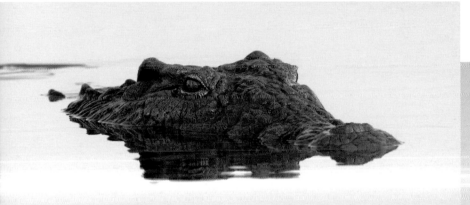

◀ *Crocodiles hunt from the water, never on land. Once prey is identified they will drop below the water line and swim closer until they are within striking distance. When it occurs, the powerful lunge usually comes as a complete surprise to the victim. Crocodiles can leap a distance out of the water equivalent to their own body length, which is why you should never walk within 20ft (6m) of the riverbank.*

▶ *Being cold blooded, after a night of cool weather crocodiles will bask in the sun in order to raise their body temperature. To speed the process, they will open their mouths wide, as shown here.*

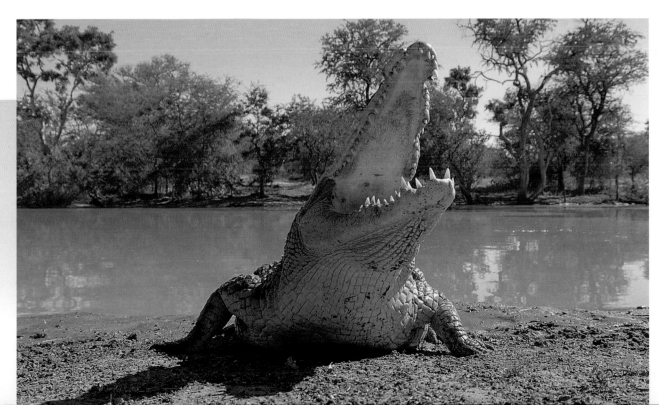

Flamingos

If the wildebeeste migration is a spectacle of motion then the soda lakes of Kenya and Tanzania are a pageant of extraordinary colour. The Rift Valley lakes form one of the harshest environments on Earth. Their origins are volcanic and the scorching, sulphurous waters with their foul smells, corrosive properties and heavy pollutants mean death to any creature foolhardy enough to drink from them. Yet it is here that three million lesser flamingos and

50,000 greater flamingos thrive and stage a parade that is one of the most stirring sights in the natural world. Flamingos are sublimely beautiful and the contrariety of their existence is in equal measure mysterious and fascinating. Like an enigma, their appearances ebb and flow with equal swiftness and frequency.

Their colouring derives from the compounds in the microscopic foods they digest, which are distributed in their bodies in disproportionate amounts. It is this differing level of intensity of distribution that causes the varying shades of pinkness. Ugly though it may be, the

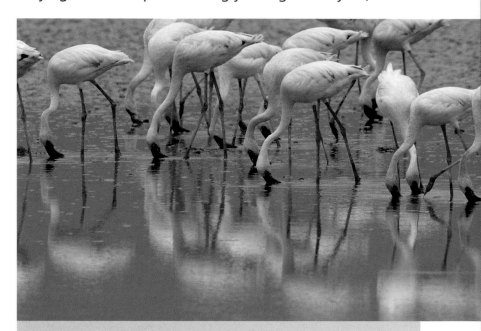

▲ *Flamingos feed on microscopic algae that is trapped and sucked into the bill via the hair-like lamellae on the inside of the mandibles. Their pink colouring derives from the compounds in digested algae.*

high-arched bill ensures huge quantities of microscopic algae are trapped and sucked in via the hair-like lamellae on the inside of the mandibles. It is thought that their fickleness in choice of lake is caused partially by predation – the panic following an attack by a Marabou stork being superseded by a more measured dispersal to safer grounds. Like all creatures, flamingo survival is a balance between the availability of food, the number of feeders and the presence of predators.

The best lakes for photographing flamingos in Africa are Bogoria (formerly Hannington), Nakuru, Elmenteita and Magadi in Kenya; and Natron, Embagai Crater (in the Ngorongoro Plateau) and Manyara in Tanzania. Of all the lakes Natron is the most densely populated and forms the only active breeding ground when each year it fills with water momentarily, as rain drains off the highlands in Kenya, to the north. Photographic opportunities abound: individual birds, groups of birds, birds feeding, birds displaying, birds in flight. Slow shutter speeds blur movement to create a distinct sense of motion, while fast ones capture the action in frozen animation. A polarizing filter will help to reduce reflections and saturate the bold colours for added effect.

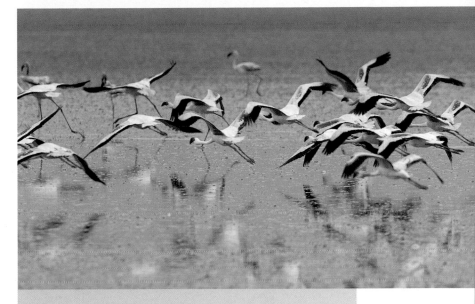

▲ *Vast flocks of flamingos can take flight with equal measures of swiftness and frequency, leaving one feeding ground for another for no apparent reason.*

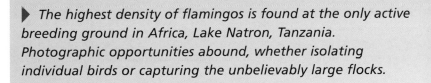

▶ *The highest density of flamingos is found at the only active breeding ground in Africa, Lake Natron, Tanzania. Photographic opportunities abound, whether isolating individual birds or capturing the unbelievably large flocks.*

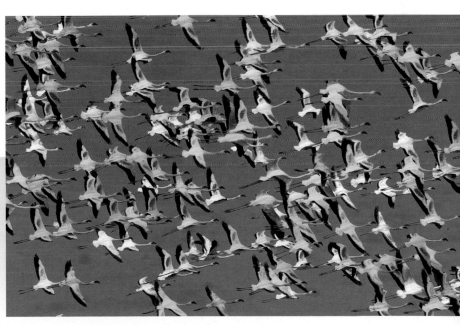

Rhinoceroses

There are two species of rhinoceros found in Africa. The black rhinoceros is greatly endangered and found only in small pockets. Numbers are so few and the risk of poaching so great that some of these animals have a 24-hour armed guard. The white rhinoceros – the name derives from a misinterpretation of the Dutch word weit meaning wide – is the largest and most numerous. Their total population is thought to be around 8,500 and stable due to ongoing conservation efforts. However, there is a sub-species, the northern white rhinoceros, with a population thought to number no more than 30 animals. Despite their common names they are indistinguishable by colour. The primary difference is the shape of the mouth. As the Dutch noticed, the white rhinoceros has a wide, straight upper lip and hard lip pads suitable for grazing. The black rhinoceros, on the other hand, has a prehensile lip that curls around new twigs and shoots to draw them into the mouth, indicating the feeding habits of a browser.

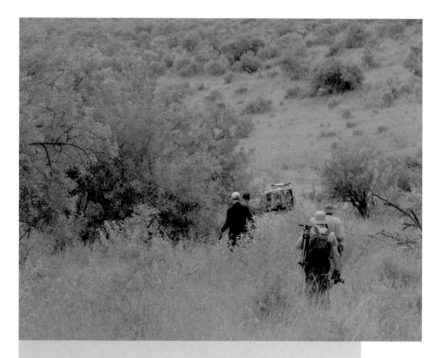

▲ I find the best way to photograph white rhinoceroses is on foot. Here I lead back to our vehicle a photographic group after spending time with three imported animals from South Africa in the Masai Mara National Reserve in Kenya.

Although the eyesight of both species is very poor, they have excellent senses of smell and hearing. Both tend to be solitary animals although, of the two, the white rhinoceros is the more social and it is not uncommon for mother and calf pairs to remain together for long periods. The white rhinoceros is also more placid and easier to approach. The black rhinoceros may tolerate intruders into its territory, including humans, but is far less predictable than its white cousin. A charge may be initiated without warning and speeds close to 30mph (45 kmph) are quickly achieved. Despite their bulk (black rhinos can weigh over a ton and white rhinos closer to two and a quarter tons) rhinoceroses are capable of

making rapid changes in direction. Other than humans, adults have no predators. The potentially lethal power of the horn and a volatile temperament combined with great speed and agility make the black rhinoceros unusually dangerous to predators, including people – hence its place in the 'big five'. However, young calves sometimes fall prey to lion and hyena. The larger size of the white rhinoceros makes them almost impossible to prey on and humans present their only real threat.

Conservation

Both white and, in particular, black rhinoceroses are endangered and continued poaching for rhinoceros horn together with habitat destruction means that protective measures introduced at government level have proved largely ineffective. The horn, which has a street value comparable to gold, continues to be used in traditional Chinese medicines and in Yemen for making traditional dagger handles.

Attempts were made to limit poaching in some countries by the medical removal of the horn, a painless exercise undertaken with the animal under anaesthetic. However, once the practice became widespread it was seen to have a detrimental effect on breeding, further hindering attempts at recovery in the wild.

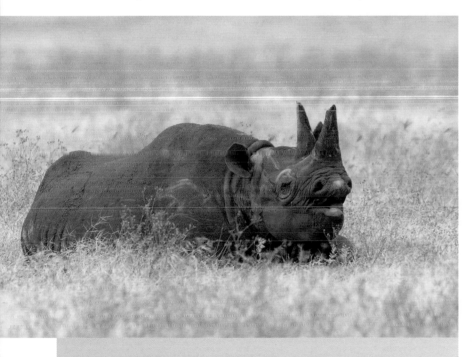

▲ *Black rhinoceroses are greatly endangered and found only in a small number of areas. I photographed this animal, which had been party to a recent territorial scuffle, taking a break in the midday heat in the Ngorongoro Crater in Tanzania.*

Photographic tip

A wideangle lens creates an interesting perspective of a rhinoceros (see page 156), which can be difficult to photograph. Also look out for humourous expressions or behavioural traits rather than simple portrait shots

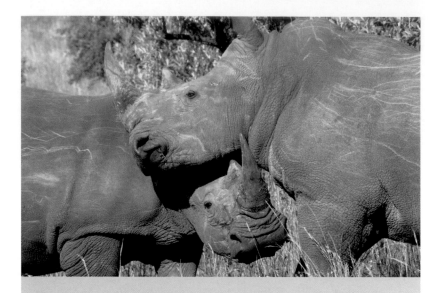

▲ Two white rhinoceroses vie for territorial dominance. Despite the lethal potential of the horn, animals are rarely mortally wounded during such disputes.

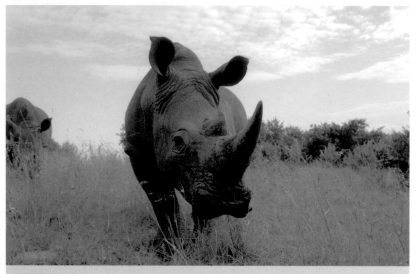

▲ Getting close to the subject and photographing with a wideangle lens (24mm in this instance) provides a different perspective on rhinoceroses, making the head and horn appear more prominent in the picture.

◀ A young white rhinoceros (this one is around one year old) enjoys the cool temperature of early morning to indulge in some playful charging. After running around in circles for about a minute, he abruptly stopped and continued to feed with his mother nearby.

Elephants

Loxodonta africana – the magnificent African elephant – is the largest of all land mammals. Ears spread, standing tall they are an awe-inspiring sight. Elephants are both intelligent and emotional, capable of experiencing fear, joy, tenderness, happiness and excitement, and any photographer who spends time with a herd will quickly realize that every individual has a character and personality all of its own.

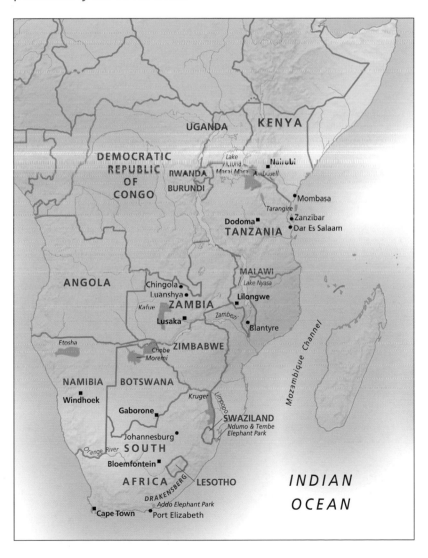

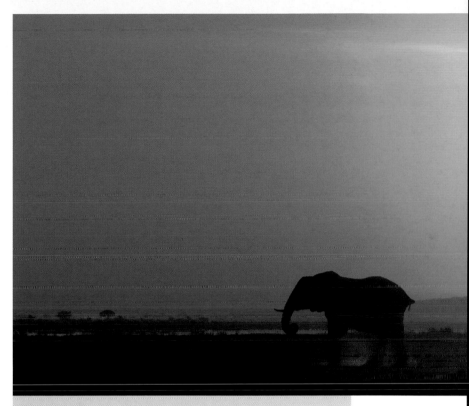

▲ *An adult elephant makes his way to the Chobe River at dawn in the Chobe National Park, Botswana. Chobe is one of the best areas in Africa for sighting elephants.*

The social structure of elephants is complex, extending, well beyond the immediate family unit, and their unselfish concern for the well being of other herd members puts many humans to shame. Young calves receive reassurance and parental guidance from aunts and older sisters as well as mothers and the entire herd will provide aid to a wounded family member. Fallen allies are defended with tusks and trunks so aiding their escape and the dead are mourned and buried under a potpourri of dirt, branches and leaves.

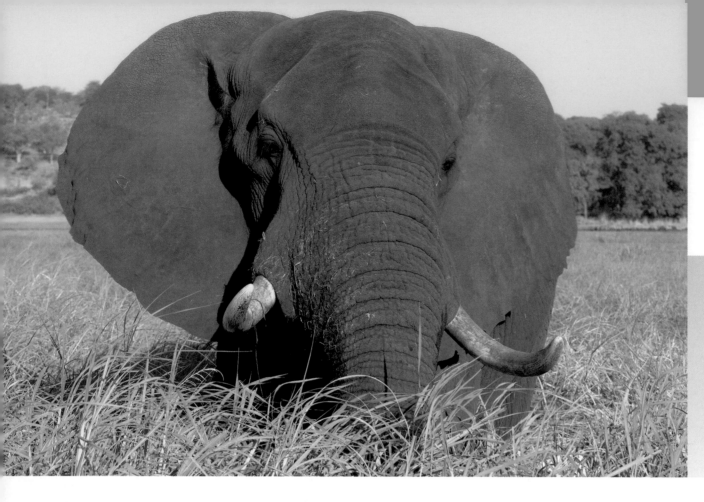

The most distinctive feature of the elephant – its trunk – is, in fact, a flexible elongation of the upper lip which, consisting of thousands of muscle pairs, is an immensely powerful 'limb'. Two features distinguish between African and Asian elephants. The more commonly known distinction is the shape of the ears, which are larger on the African elephant. Also, the Asian elephant has a uniquely shaped tip of the trunk, having only one process (finger-like outgrowth) as opposed to two opposing processes, a feature of both the savannah and forest elephants of Africa.

The other main feature of elephants, and the cause of its once rapidly declining numbers due to poaching, are the tusks, which are a major source of ivory. Despite a ban on the sale of ivory, poaching continued until, in 1989, a government-approved burning of stockpiled ivory worth US$2.5 million in Kenya was performed in an apparent effort to send a clear message that the ivory trade would be tolerated no longer. However, the validity of this gesture is questionable given the allegations made against corrupt politicians and members of President Daniel arap Moi's inner circle, many of whom are believed to have made fortunes from the trade they were publicly eschewing. Even today, the debate about elephant conservation continues.

African forest elephant

The African forest elephant was previously thought to be a sub-species of *Loxodonta africana* but subsequent tests have identified it as a separate species: *Loxodonta cyclotis*. Smaller than the savannah elephant and darker skinned, they inhabit dense forest areas, primarily in south-central Africa in countries such as Gabon.

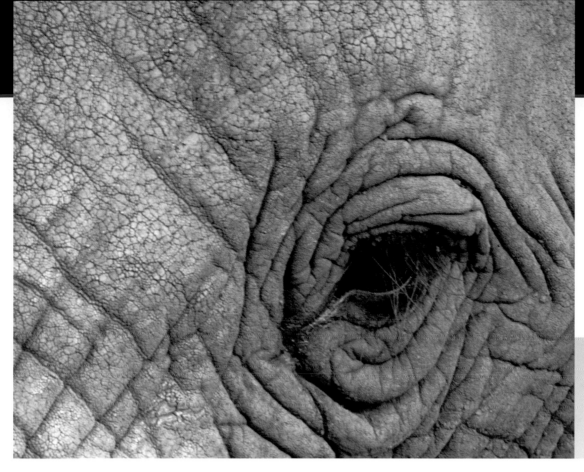

◀ *To protect their sensitive eyes from dust elephants have a screen of long, thick eyelashes.*

▶ *Ear-scarred and torn, a lone male elephant shows the signs of a long life in Chobe National Park, Botswana. Adult elephants have no predators other than poachers, and while fights within a herd of young males are not uncommon they rarely result in fatal wounds.*

Defenders of youth

Elephant herds are highly protective of young calves and potential threats, real or assumed, are met by a circling around the calf, which is quickly lost in a forest of legs. Even pointing a camera towards a newborn elephant can cause this protective mechanism to engage, making photographing a difficult ta baby elephants a difficult task.

Photographic tip
Keep an eye on background clutter, such as branches of trees, which can draw attention away from the main subject of the picture. Using a very shallow depth of field can blur a distracting background.

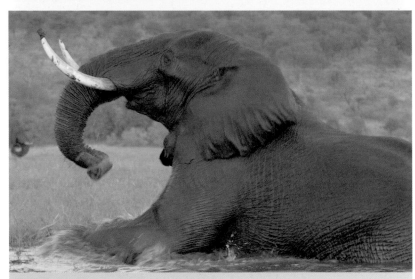

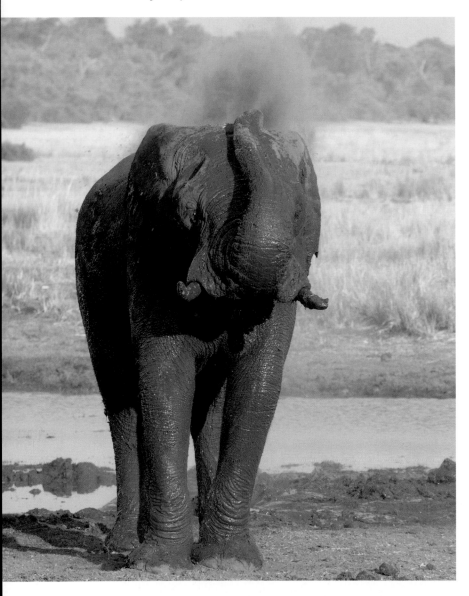

◀ ▲ ▼ *Elephant skin is quite sensitive and they will cover themselves in mud and dust for protection against the intense African sun. They use their trunks to spray dirt over their entire body (left) and cool off with a playful dip in any nearby water source (above).*

It's in the trunk

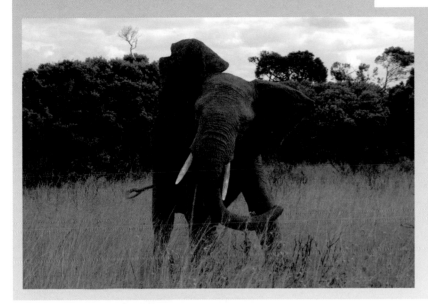

The position of an elephant's trunk is the best means of interpreting its intentions. With the ears spread wide or flapping: if the trunk is thrust forward the elephant is displaying a threatening pose; with the trunk in a tea-pot spout position, the elephant is initiating a mock charge – hold your ground and it will stop before reaching you (in theory); when the trunk is held tight against the body the elephant is making a serious charge and you're in trouble.

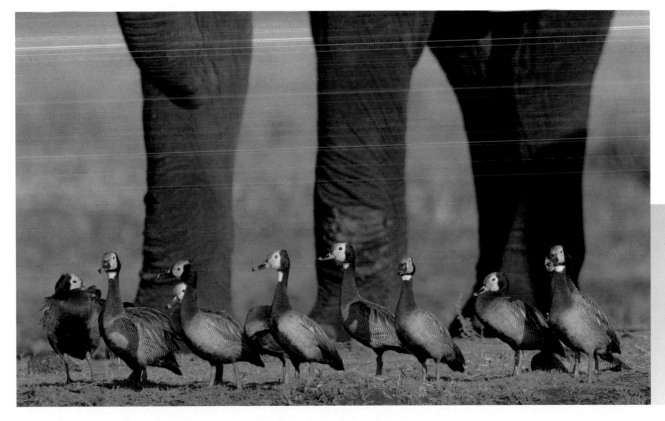

◀ *The giant legs of an African elephant dwarf a flock of ducks by the Chobe River in Chobe National Park, Botswana. I have composed this image specifically to highlight a sense of scale.*

Knowing how to handle your camera instinctively is a key skill for wildlife photographers. Never will a cheetah or leopard, or any other animal for that matter, stop what it's doing so you can figure out how to change the metering mode or switch between single and continuous autofocus. Fiddling with your camera is one of the main reasons for missing photo opportunities.

▼ *Knowing how to operate your camera without a second thought is an essential skill in wildlife photography. To capture this image of a leaping wildebeest I had no time to think. Out of the corner of my eye I saw the movement, instinctively framed the image and fired the shutter in one swift movement.*

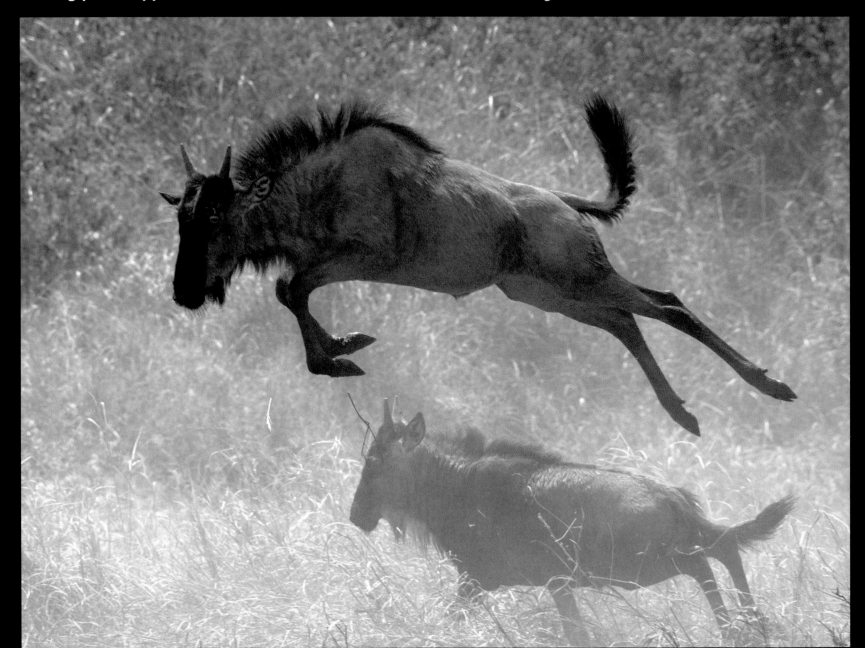

Camera handling

Practise using your camera before you go on safari. It is time well spent, as these are skills that you can use whenever you take photographs. Learn how to adjust all the main settings – such as metering mode, shutter speed, aperture, autofocus mode, drive mode and the ISO (if you have a digital camera) – without needing to look at what you are doing. The great wildlife moments are fleeting, and the fractions of seconds you can save by spending time getting to know your camera will be the difference between getting the shot, or not. Also practise changing film, memory cards, lenses and other accessories, as the less time you spend doing this the more likely you are to get the picture.

▶ *Always have your camera switched on and set for immediate shooting so that any fleeting moments of interest, such as this pair of giraffes battling for dominance, can be captured before they are gone.*

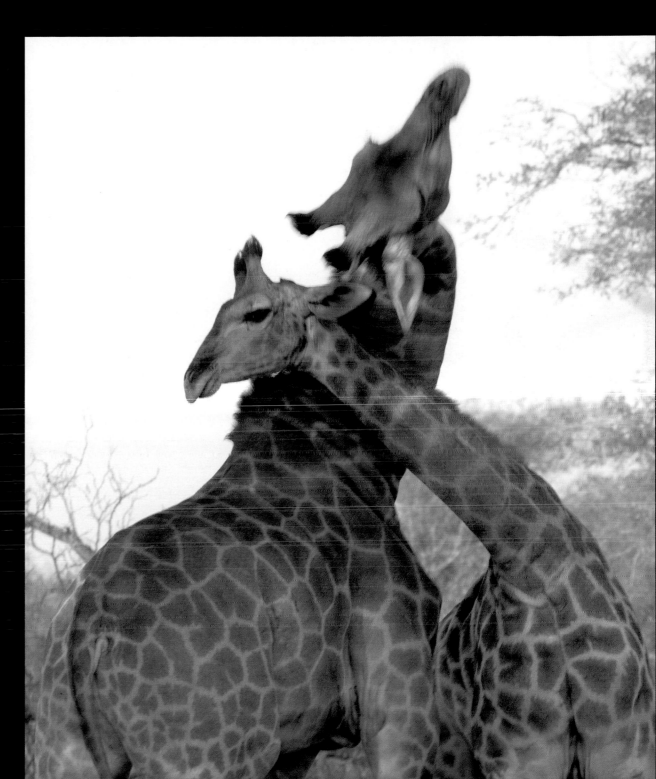

Always have your camera to hand and ready to shoot in case a 'grab shot' presents itself. Have your most versatile zoom lens fitted and a fresh roll of film or an empty memory card inserted. The camera should be switched on and the settings in their most automatic positions – continuous autofocus mode, multi-segment metering, continuous frame advance – to enable you to simply grab the camera and shoot. If the action continues long enough then you can think about improving the shot.

When hand-holding the camera your arms should be kept tight to your body, which should be well balanced with a low centre of gravity, and you should breath steadily.

When possible, support the camera using a beanbag or a tripod head mounted on a sturdy clamp. Be aware of movement in the vehicle. The simple action of one person shifting their position can cause the vehicle to rock. Minimize your own movement and wait until the vehicle is steady again before taking pictures.

▲ *Whenever possible support the camera using a tripod, beanbag or other solid support. Here, a photographer uses a tripod head attached to the roof of a vehicle to keep a large 200–400mm zoom lens steady.*

Exposure

The main complication when calculating exposure is dealing with the high levels of contrast that often occur. On sunny days in particular the range of tones between the shadow areas and the highlights (known as the subject brightness range or SBR) will typically be too great for the dynamic range of the film or sensor you are using. This problem is more easily overcome when photographing landscapes by using a graduated neutral density filter. However, although these filters can be useful in wildlife photography they are often imperfect as they are too rigid in their design.

The answer is often one of compromise. If it is impossible to bring the SBR within the dynamic range of the film or sensor then you must decide whether to expose for the highlights or the shadows. Typically it is better to opt for the former, especially when shooting digitally, as featureless black is more acceptable than large areas of washed out highlights. To expose for selected areas within the overall scene you will need to utilize the spotmeter on your camera (if it has one), using the viewfinder to position the meter's sensor area over the brightest area of the scene. Ideally, you should use the camera's manual exposure mode or the exposure lock function so the settings aren't adjusted automatically.

▼ *Subjects such as this black and white pied kingfisher can be difficult to expose for in bright sunlight. If the contrast range exceeds the latitude of your film or the dynamic range of your digital sensor then waiting for more overcast conditions is often the only solution. Alternatively, fill-in flash may help to reduce the tonal range.*

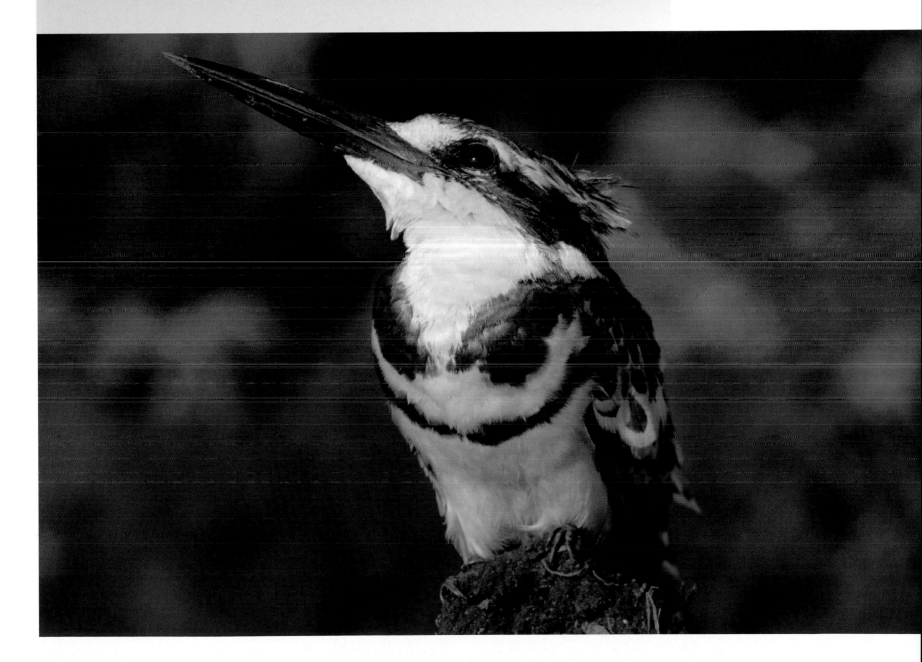

Beware of highlights

Many wildlife scenes have areas of highlights that aren't immediately apparent and can spoil your photographs. For example, the patches of white fur around the bottom lip of a lion and the tusks of an elephant are easily ignored but regularly 'burn out' in photographs. Even droplets of water on a hippopotamus's back can create spots of highlights. Using a digital camera, I regularly underexpose shots by around half a stop to automatically account for these problems and I always have an eye open for them when composing the picture.

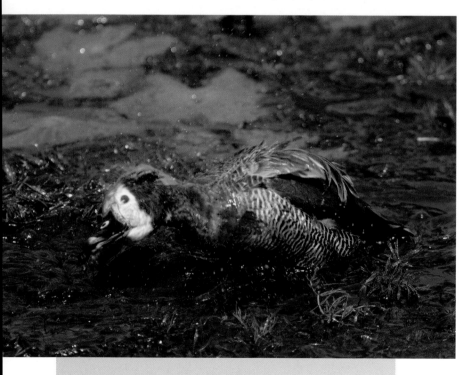

▲ *In the bright conditions of daytime Africa highlights are a problem. Even small patches of white can easily become burned out.*

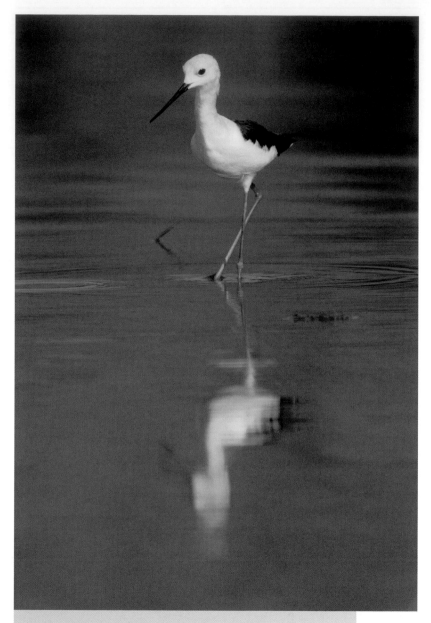

▲ *When you are faced with a subject that is predominantly white, use your camera's spotmeter function to expose for the highlights.*

Bracketing

Bracketing is the practice of taking several identical or similar pictures at different exposures, thus ensuring that at least one of the images is faithfully exposed. The drawback of using the technique in wildlife photography is that the scene and subject change markedly between each shot, therefore the best composed and the best exposed shot might not be one and the same.

▲ *If you are unsure of your exposure settings use the bracketing technique to expose several similar images with slight variations in exposure between each one.*

The sunny f/16 rule

A simple and highly effective method of calculating exposure on cloudless, bright sunny days is to use the sunny f/16 rule. Set the aperture to f/16 and the shutter speed to a value equivalent to the ISO of the film you are using (or its equivalent digital ISO). For example, if the loaded film is Fuji Provia 100F then the shutter speed would be 1/100sec (or its nearest equivalent 1/125sec). You can then adjust the actual exposure to any equivalent setting (f/11 at 1/200sec or f/22 at 1/50sec). Despite its simplicity this technique is remarkably accurate.

▲ *On a bright sunny day the simple but effective sunny f/16 rule makes calculating exposure easy.*

When photographing predominantly white subjects using the sunny f/16 rule you need to make a slight adjustment, underexposing by one stop. Thus sunny f/16 becomes sunny and white f/22. Other than that, the technique is the same and equally effective.

Selecting exposure settings

Many new photographers set their camera to the fully automatic and allow it to make exposure decisions for them. Unfortunately, the camera has little idea of the nature of the subject and less still of what is in the photographer's mind, more often than not the results are a disappointment. A basic knowledge of the role of the aperture and shutter speed will help create pictures that more closely resemble the image held in your mind's eye.

Aperture

The aperture controls the amount of light entering the camera at a given time. Its size is denoted by a scale of f-numbers marked on the lens and/or shown on the camera's LCD screen and in the viewfinder display. These range from around f/2 up to about f/32. The bigger the number the smaller the aperture; because an f-number is a fraction of the focal length – for example f/16 is smaller than f/8 as 1/16th is smaller than 1/8th.

The aperture affects the depth of field (see page 171) – which means the extent of the area in front of and behind the point of focus that appears sharp. The wider the aperture the shallower the depth of field, while the narrower the aperture the greater the depth of field. Objects that appear sharp are seen as a part of the picture and affect how we interpret the image when we see it. Heavily blurred objects tend to be ignored, which can help to focus our attention on the main subject of the picture by isolating it from its surroundings.

◀ *For predominantly white subjects, a useful variation of the sunny f/16 rule is the sunny f/22 rule, which is as simple and works equally as well.*

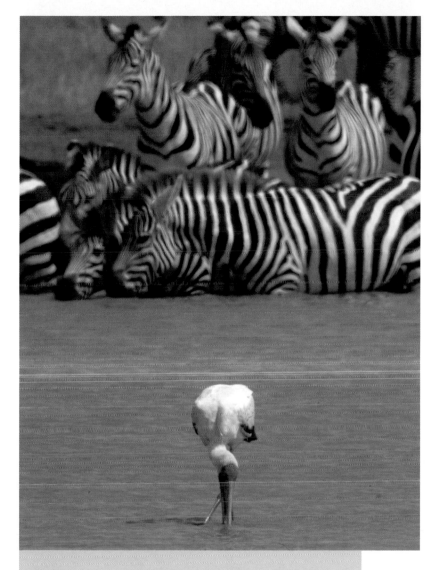

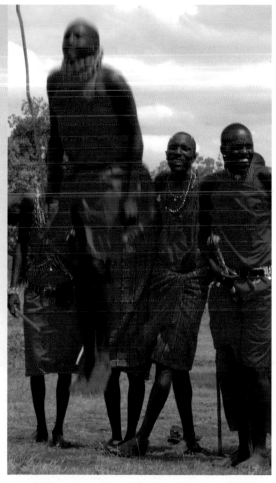

Shutter speed

Shutter speed controls the duration of the exposure and is measured in seconds or, more typically, fractions of seconds. Most modern cameras have shutter speeds that range from 30 seconds to around 1/4000sec or faster, as well as a 'bulb' setting for longer exposures.

Shutter speed affects how motion is represented in the picture. A slow shutter speed blurs motion, giving a sense of movement and creating visual energy. A fast shutter speed freezes the appearance of motion making it easier to distinguish detail.

▶ *The shutter speed determines how motion is depicted. A slow shutter speed will blur movement, creating a sense of motion, as shown, while a fast shutter speed will freeze movement making it easier to identify detail.*

▲ *Aperture affects depth of field and how much of the scene appears sharp. Here I have set a medium aperture that is enough to distinguish the zebras in the background but not so much that they detract from the main subject, the stork in the foreground.*

Changing the ISO value

Digital cameras have the facility to adjust the ISO rating for each image taken. A low ISO such as ISO 100 makes the sensor less sensitive to light but reduces the occurrence of digital noise and improves picture quality. At higher settings digital noise increases, becoming quite apparent at ISO settings above 400, although the extent to which this is the case depends on the camera.

Film is less flexible but the factory-given ISO rating of a film roll can be changed at the point it is loaded. This is a technique known as up-rating or down-rating film and is used to generate extra film speed in low-light conditions and when a faster film is unavailable, or to down-rate film to enable slower shutter speeds. To do either you must switch off the automatic DX-coding used by the camera, and set the ISO rating using the relevant camera function. The camera will now assume the new ISO rating and give exposure information accordingly. You should then mark the film canister as being 'pushed' or 'pulled' respectively so that it will be processed accordingly. Equally, you must inform the processor by how much the film is pushed or pulled; every doubling or halving of the nominal ISO value represents a one-stop change.

African light

There is a certain quality to African light that makes Africa a magical place for photography. However, it can be difficult to master, in particular its intensity after the early hours and before the sun begins to set.

The ideal time of day for capturing beautiful light is before 8.30am and from two hours before sunset until dusk. At these times African light has a rich, golden glow and its oblique angle produces the contrast that gives form to images. During the day the intensity of light increases, becoming very harsh on cloudless days between 10am and 3pm, peaking in the middle of the day.

When the weather is overcast, conditions are better suited to photography as the illumination is softer. Even so, light levels are often surprisingly bright.

◀ *Africa is renowned for the quality of light at sunrise and sunset. The warm glow and low angle of the sun provide endless photo opportunities, which I have exploited here to capture a silhouette of a cormarant.*

Focus and depth of field

There is only one point of focus, and usually in wildlife photography it should be the eye of your subject. When we look at another creature our first instinct is to look at its eyes. If the eye is obscured or unsharp then we lose a point of reference and the message is weakened.

When aligning the autofocus sensors in the viewfinder keep the active sensor trained on the nearest eye. When photographing moving subjects turn on your camera's continuous autofocus function (if it has one), which allows the camera to adjust the focus distance to match the movement of the subject. After the eyes, the nose is the next most important feature. Often with wildlife subjects, the eyes and nose are at different focal distances and it can be a challenge to keep both features within the available depth of field, particularly when using long telephoto lenses.

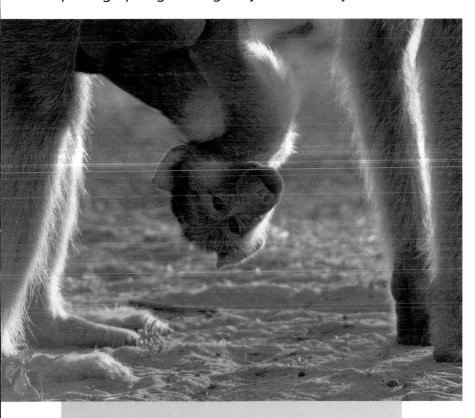

▲ *Exposing a backlit subject for the shadow areas will create a beautiful halo of golden light around your subject, as this image of a baby baboon shows.*

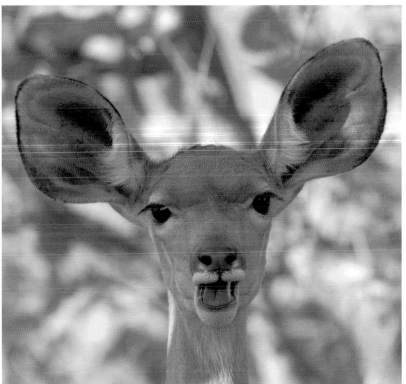

▲ *To isolate the head from the distracting background I have set a very wide aperture that has minimized depth of field.*

171

Although other factors will affect depth of field (camera-to-subject distance and focal length), for most species, in most situations, setting an aperture of around two stops closed from maximum (if the maximum aperture of the lens is f/2.8 then set an aperture of f/5.6) will provide enough depth of field to keep both the eyes and nose sharp. For subjects that have particularly long noses you will need to increase the depth of field. This is very general advice and depends a great deal on the situation. If the conditions make it impossible for both the eyes and nose of the animal to be sharp then choose the eyes.

Creative use of depth of field

The extent of depth of field in an image will determine which pictorial elements are emphasized and how the image communicates a message. A shallow depth of field – where foreground and background detail is blurred – will isolate the subject from its surroundings, placing the emphasis on the animal. Extensive depth of field – where close and distant objects appear sharp – will change the emphasis of the picture to one where the surrounding habitat becomes an integral part of the image.

▲ *The eye is the most important aspect of wildlife photograph to be sharp and should almost always form your point of focus.*

▲ *How you manage depth of field will determine how the subject appears in relation to its environment. Extensive depth of field will create a greater sense of place, while a short depth of field will isolate the subject from its surroundings (as shown here).*

The advantages of autofocus

At the time of its invention, autofocus revolutionized wildlife photography. However, without a complete understanding of how different autofocus systems work it is easy to produce pictures of inferior quality.

Most cameras have two autofocus settings: one for moving subjects and one for still subjects. The name of this mode varies from one camera to the next, however, they tend to work in similar ways. The mode intended for still subjects will usually detect and set the focus distance and then lock it until autofocus is deactivated (typically by releasing pressure on the shutter-release button or by deactivating the AF Lock function). If the subject moves away from the original focus point, so long as autofocus remains active the focus distance will remain unchanged, leading to out of focus pictures. In order to refocus on the subject autofocus must be deactivated and reset. This autofocus mode is ideal for subjects that are relatively static, such as landscapes and portrait images of still animals or people.

When using the autofocus mode designed for moving subjects the focus is never locked even after it is attained. If camera-to-subject distance changes, for example when photographing a moving animal, the camera uses its range of autofocus sensors to continually track the movement and change the focus distance accordingly. This makes it the ideal system for photographing moving subjects.

▶ *Autofocus can be a useful tool when photographing some wildlife subjects, such as erratically moving animals. I used continuous autofocus with focus tracking to capture this image of a baboon as it pirouetted from one tree to the next.*

In this autofocus mode, priority is typically given to the shutter, and pictures can be taken whether or not the subject is in focus. Most cameras allow this priority setting to be changed to focus priority via the menu settings. I advise that you do this, after all, there is little value in taking an out of focus picture.

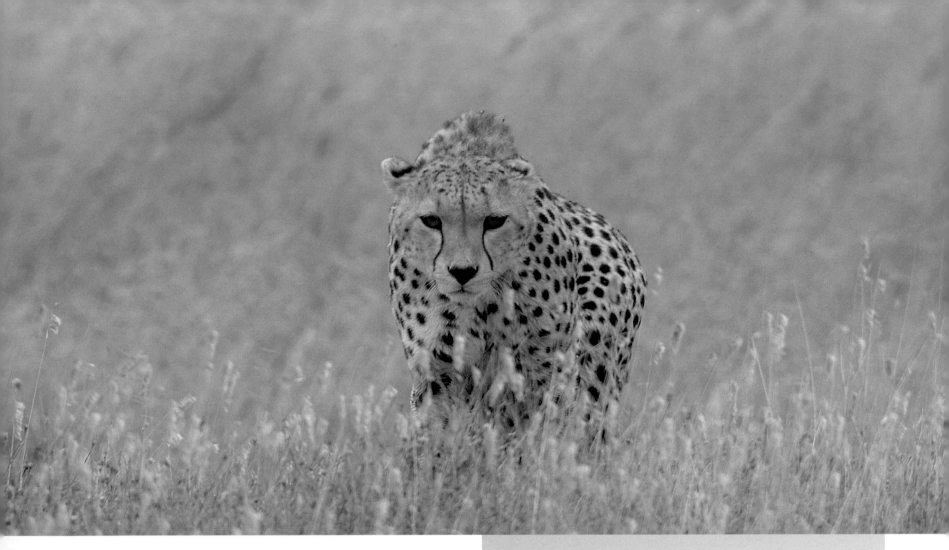

▲ The continuous autofocus function on my Nikon D2X helped to keep this cheetah in focus as it stalked towards the camera.

◀ I used the focus-tracking function on my camera while panning to ensure the main subject of this image, the avocet, remained in sharp focus.

When to use manual focus

Although the majority of modern cameras are autofocus-based, manual focus still has an important part to play in wildlife photography. Autofocus systems have limitations, including the need for a certain level of brightness and a clear line of sight to operate effectively. In low-light conditions or when the subject is partially obscured, for example by foliage, then autofocus systems have a habit of 'hunting' – the process of continually searching to attain focus, shifting between the closest focusing distance and infinity without ever locking onto the subject. This leads to many missed opportunities, and in such cases it is often more productive to turn autofocus off and focus the lens manually. Remember to use the eye as the point of focus.

▼ *When foliage or other obstructions obscure the subject, switching to manual focus will make focusing on the subject quicker and simpler.*

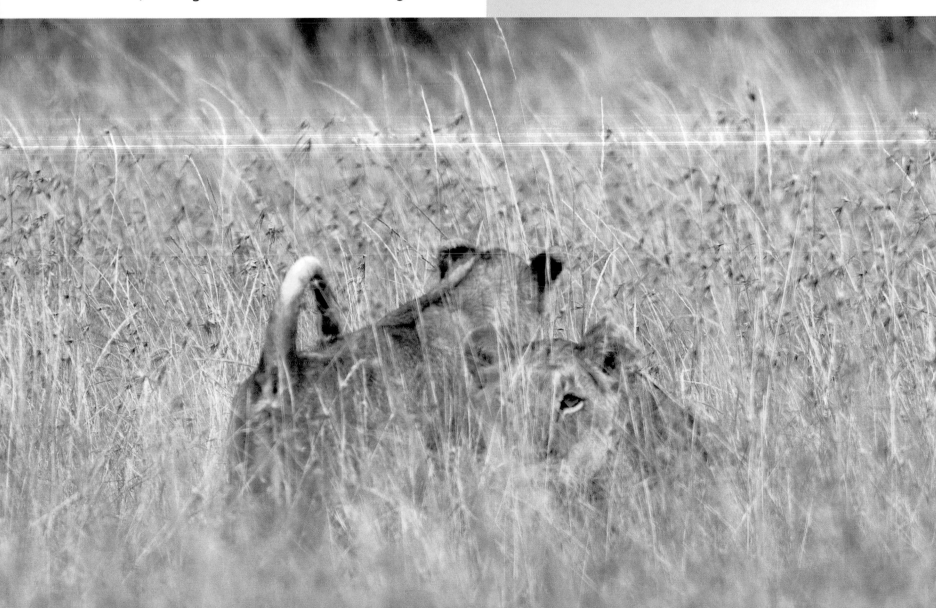

When to use filters

I rarely use filters when photographing wildlife but there are occasions when they add to the composition and quality of the image. Even so, my selection of filters is narrow and compensates for the limitations of the sensor (or film), rather than being used for artistic influence.

81-series filters

Of all the filters, the ones I most recommend fall into the 81-series of warm-up filters. These filters, which come in varying strengths, absorb the blue light waves that are prevalent in daylight from mid-morning to late afternoon and result in images with a cool, blue cast.

The dark skins of some mammals, such as rhinoceroses and elephants, also reflect a significant amount of blue light with a similar result. By absorbing some of this blue light the 81-series filters create pictures with a warmer, golden glow that is far more appealing.

Polarizing filters

Polarizing filters are essential in landscape photography. They polarize light entering the lens and remove most or all of the glare from reflective subjects, saturating colours and darkening blue skies.

Two versions of polarizing filter exist: linear and circular. Both affect light in the same way but a linear polarizing filter will adversely affect your camera's autoexposure functions, so only use the circular variety.

▶ *I wanted to saturate the vivid red of this Masai warrior's clothing and so added a polarizing filter set at around half strength.*

Ultraviolet (UV) filters

Ultraviolet (UV) filters absorb ultraviolet light, which we can't see but that appears on colour film and, to a lesser extent, in digital images as an intensified blue cast and more apparently as haze. By absorbing ultraviolet light UV filters help the camera to record the scene much as we see. In Africa you are more likely to witness the effects of UV light in the high mountains, such as Kilimanjaro, or close to the coast, for example in Namibia's Skeleton Coast National Park and in Saint Lucia Wetland Park in South Africa.

UV filters are also often used to protect the front element of the lens from dust, dirt and scratches. If you opt to use UV filters in this way, buy the most expensive filter you can afford, as the quality of the filter will ultimately affect the optical performance of the lens.

Neutral density (ND) filters

Neutral density (ND) filters cut down the amount of light entering the lens by a fixed amount without affecting the colour. They are available in strengths of between one and three stops in half-stop increments and are predominantly used to enable slow shutter speeds in bright conditions. They can be particularly useful in Africa where the level of illumination is often too bright to enable shutter speeds slow enough to create motion blur, even in overcast conditions.

Graduated neutral density (GND) filters

A variation on the ND filter is a graduated ND filter. Half the filter is clear while the other half acts like a normal ND filter, cutting down the light entering the lens by varying amounts. The purpose of these filters is to bring the subject brightness range within the latitude of the film/sensor. They are particularly useful when photographing landscapes, when the tonal value of the sky is significantly higher than that of the foreground.

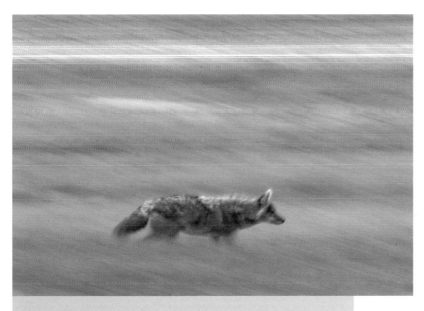

▲ *I wanted to blur the movement of this jackal but the level of illumination was too bright to set a shutter speed slow enough. I used a three-stop neutral density filter to reduce the level of light reaching the sensor.*

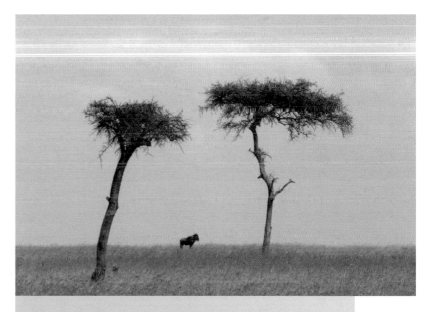

▲ *To even out the difference in tones between the foreground and the sky, for this image I used a one-stop graduated neutral density filter.*



Charge of the wildebeeste

Wildebeeste are always great subjects for movement and action photography, since they rarely stand motionless for very long. For this picture I wanted to emphasize the morass of limbs that is distinctive of a large herd on the move. I switched the camera to shutter-priority mode and set a relatively long shutter speed of 1/30sec. Framing was key to the composition. I deliberately selected a patch of ground where there was little clutter and where the colours blended. Then I waited until there was a small break in the herd so that no animal was cut off at the right edge of the frame. Panning the camera I fired a sequence of three images of which this is my favourite.

▼ *Wildebeeste, Serengeti National Park, Tanzania.*

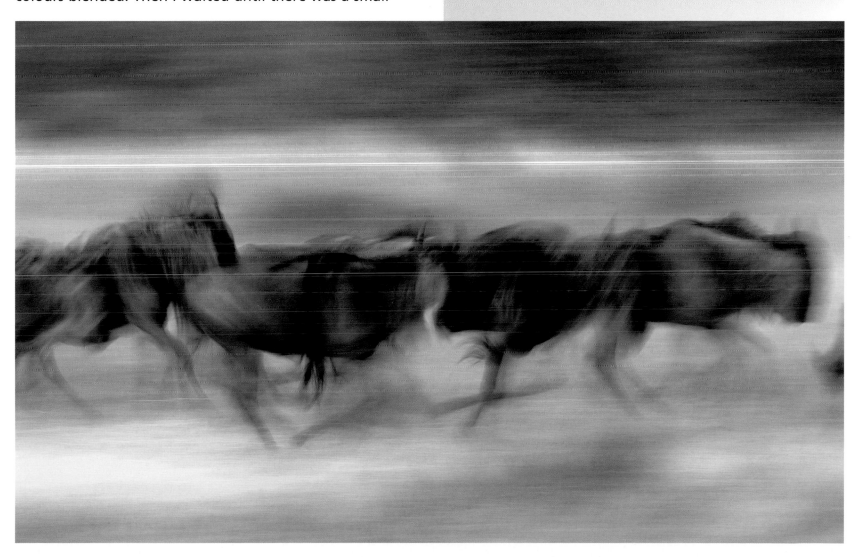

Round the horn

Rhinoceroses aren't the easiest subject to photograph with any degree of aesthetics. They are also extremely dangerous animals to be around. The most prominent feature of a rhinoceros is its horn and this is what I wanted to emphasize in the photograph. Although

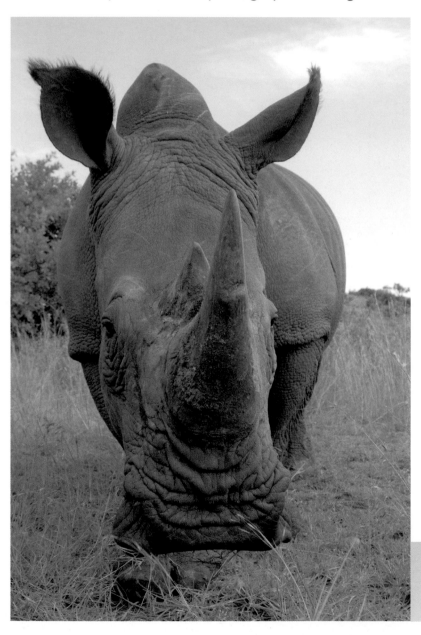

photographing rhinoceroses from a distance with a telephoto lens is by far the safest option, the distance that you use a telephoto lens from compresses the appearance of space between objects.

To achieve my planned shot I used a wideangle lens close to the subject. Getting in close has allowed the rhinoceros's size to create a frame-filling image, and the exaggerated perspective has distanced the neck and rump of the animal bringing the horn to the fore.

Black & white and brown all over

Although we see the world in colour, sometimes when making photographs it is helpful to think in black & white. This shot was pre-planned even before I left home. I needed to produce some work for a gallery where my work is exhibited and I conceived the idea of a series of sepia-toned prints. Because of the contrariety of zebra patterning I knew they would make a good subject for one of the new series. Light was important to this image because the picture needs a high level of contrast to succeed. That meant shooting during the brighter part of the day, typically a time less conducive to good wildlife photography and when zebras are rarely on the move. In order to create image blur I shot the image from a moving vehicle. Unlike the image of the wildebeeste on the previous page, I maintained a relatively fast shutter speed (1/100sec) to stop the four zebras from blurring beyond all recognition.

◀ *White rhinoceros, Masai Mara National Reserve, Kenya.*

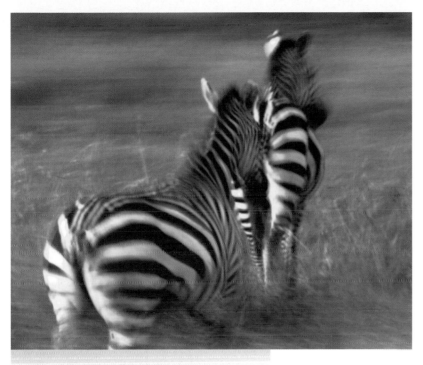

Burchell's zebras, Serengeti
National Park, Tanzania.

Flame-birds

If you conceive an idea, shoot it. I had been by Lake Magadi in the Ngorongoro Crater for some time watching the (relatively) small flock of flamingos come and go, as they do. The shot I had hoped to get was impossible because of the small number of birds present and my mind began to wander. The technique I have used here, of zooming a lens during the exposure, isn't new but the contrasting colours of the flamingos and the deep blue of the water interspersed with the white crust of the soda lake intrigued me. The technique requires a shutter speed slow enough to allow the zooming of the lens to be registered, and a relatively steady hand, or better still a tripod. It was important to focus on the centrally positioned bird, as there is a difference between aesthetic blur and the subject simply being out of focus. This is one of those pictures that you either love or hate so I'll leave you to make your own mind up

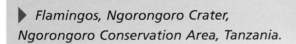

▶ *Flamingos, Ngorongoro Crater,*
Ngorongoro Conservation Area, Tanzania.

David and Goliath

I was with a group of photographers when I shot this image of a lilac-breasted roller defending its territory against a bateleur eagle. On the ground we were following the wildebeest migration through the Western Corridor in Serengeti National Park. It was late afternoon and we had been there for much of the day. The action was intense and the sound of shutters filled the air. While the action continued around me I stopped shooting for a moment and glanced around to check on happenings elsewhere. From the corner of my eye I saw the eagle soaring and it was a moment before I noticed the pursuing lilac-breasted roller. I had my 400mm lens fitted to the camera and decided to track them through the roof opening in our jeep. As I studied the interaction via the viewfinder the purpose of the pursuit became increasingly apparent. I had the camera set in continuous autofocus mode with tracking enabled and struggled to keep the two birds in the frame as they weaved across the sky. Almost immediately after I released the shutter the action was all over. The eagle, somewhat oblivious to the attention of its tiny aggressor, sailed effortlessly away and the roller returned to its still intact territory emboldened no doubt by its bravado.

▲ *Bateleur eagle and lilac-breasted roller, Serengeti National Park, Tanzania.*

Nose dive

The purpose of a photograph is to communicate and, in so doing, to elicit from us an emotional response. The more intense our feelings, the more compelling the image, and it is this that sets great photographs apart from others. The role of the photographer is to select the message you wish to communicate and use the tools at your disposal – cameras, lenses, compositional guidelines – to convey that message in as strong a way as possible.

I had been watching this young elephant away from the main herd for a few moments and decided to concentrate on his antics for a while, in preference to the main event that was occurring just off-picture to the right. While a 'straight' shot of an attractive subject that is competently focused, exposed and composed will be perfectly good, there are only so many of these prosaic images that you can include in your portfolio. In order to create an image that adds something new you have to be patient, in this case I was on the verge of turning back to the main herd when the perfect moment occurred and my patience paid off.

▶ *Young African elephant, Chobe National Park, Tanzania.*

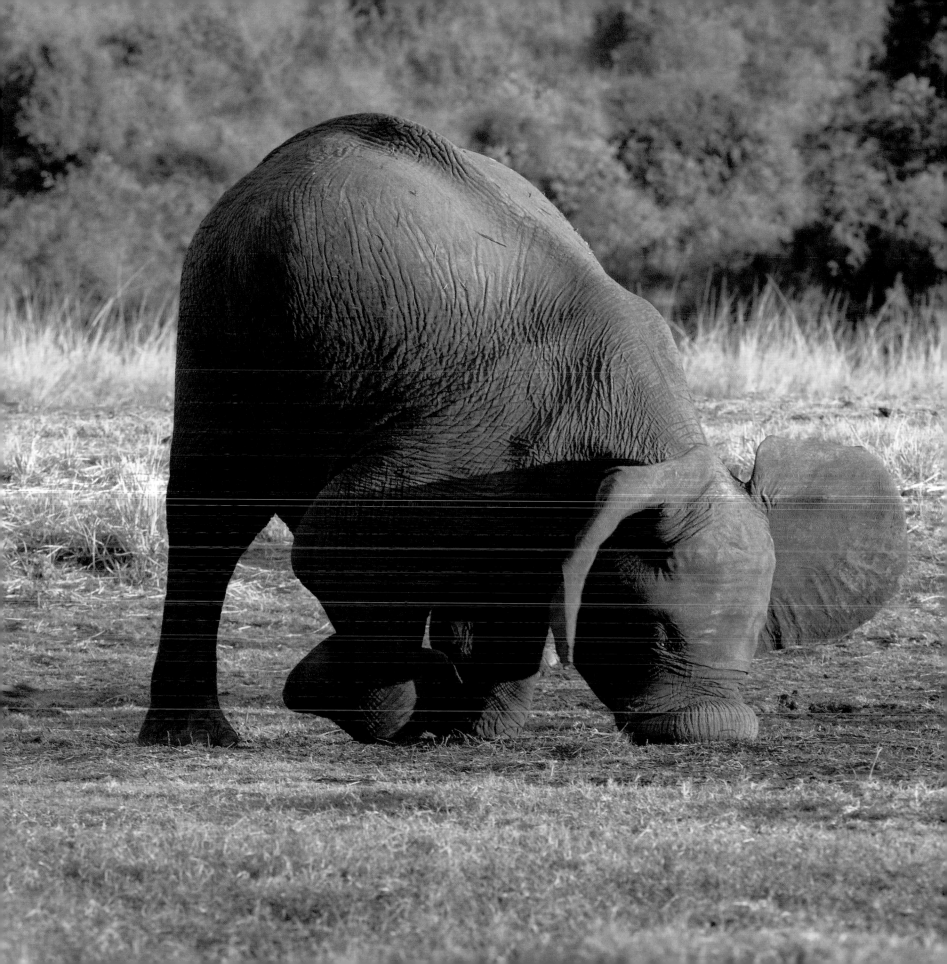

▲ *African elephant herd, Chobe National Park, Tanzania.*

Elephant dawn

This is one of my favourite pictures from a recent assignment in Chobe National Park – and I very nearly wasn't there to take it. It was early morning and I had driven into the park rather than take the boat along the Chobe River. There was little action save a sleeping pod of hippopotamuses and my patience was beginning to wane. I began to stow my gear ready to move on when I hear the sound of cracking branches from the bush. The sound was distinctive and I knew immediately that it was

elephants. However, they were still out of sight and there was no guarantee that they would appear at all.

I had a decision to make. Should I unpack my gear and stay or continue on. There was no contest in my mind, at least I knew the elephants were there and the light was still good. Elsewhere I could be driving into nothing other than empty space. I unpacked the cameras and waited some more. While I waited I took the time to visualize the image and to prepare my camera settings: 'If they appeared through the gap to my left how would I

compose the shot? And what about that space behind me?' Pre-visualizing image potential and planning for potential photo opportunities is a sensible way to pass the time. You may never get to act out your plans, but neither will you be caught off guard. As it turned out the elephants emerged from the gap behind me. The light was perfect and the camera was already set-up to expose for the highlights, creating the dramatic silhouette.

Oxpecker picnic

Oxpeckers are common birds in Africa, feeding on the ticks that inhabit the hides of animals. What drew me to this particular scene was the large number on the buffalo's back. Even so, as I framed the image through the viewfinder I wasn't certain what I was planning to do. As I watched the melee continue I noticed that the birds would take turns to fly away before returning moments later to a new perch elsewhere on the back. I realised that they were fighting over tick-picking rights and focused on one bird and waited. Often when there is a large group of animals in one place it is tempting to flit between them trying to keep pace with their antics. However, this is a recipe for missed opportunities, pinning your hopes on a single member of the group is much more likely to be rewarded. On this occasion I struck lucky as my chosen bird (far right, in flight) was challenged by another and took flight, creating an image that is full of action.

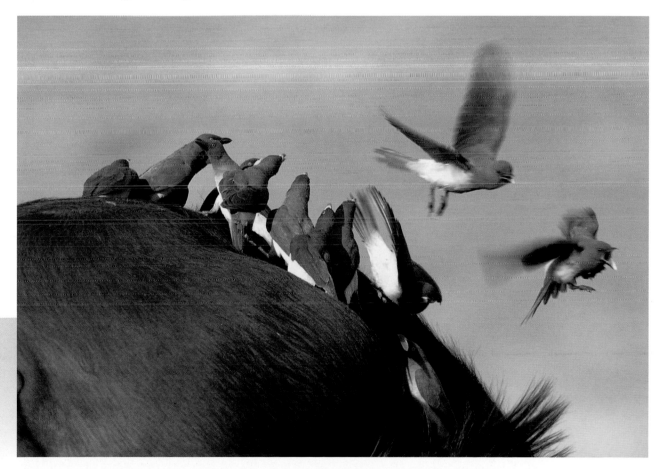

▶ *Oxpecker birds, Masai Mara National Reserve, Kenya.*

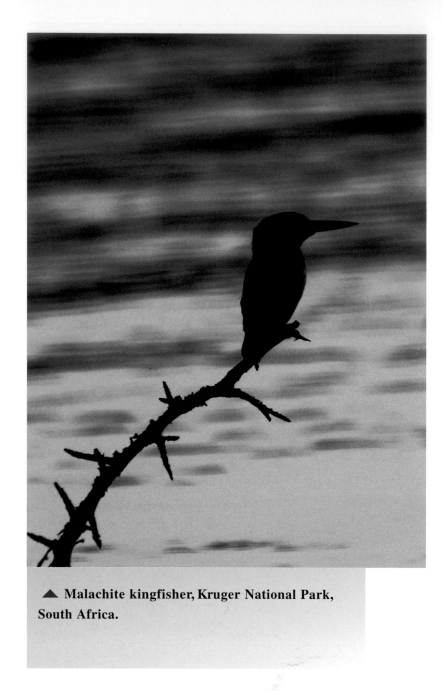

▲ Malachite kingfisher, Kruger National Park,
South Africa.

Night fishing

This is another shot I very nearly wasn't around to take.
It had been a long day and the night was drawing in
quickly. I was holed up in a hide some way from Satara

Camp in the Kruger National Park with the gates
closing soon. I was on borrowed time. Most of the
animals and birds present during the day had long
gone, bedded down for the night, protected from the
cold. Something made me stay. I waited a further
twenty minutes and nothing stirred, so I began packing.
The spare body and various lenses were tidied away
and I began to sort my memory cards. I would leave
the main camera and the 800mm lens until last, as I'd
carry them as they were. One last look and I caught a
beautiful flash of blue: the unmistakeable markings of
a malachite kingfisher.

There was no chance of any action shots, the light was
low and I had no flash equipment to hand. But as the
bird settled on the branch the glow of the lake was the
perfect backdrop for a silhouette. I took a meter reading
from a bright area of water and overexposed by one stop
to compensate for the water being lighter than midtone.
Using a wide open aperture (f/5.6) gave me a shutter
speed just fast enough to keep the image from blurring.

As I hope this and the other images in this book show,
photography is about so much more than f-stops and
focal lengths or whether digital is better than film. The
purpose of photography is to communicate, and effective
communication is devoid of ambiguity and irrelevance.
Painters have the advantage of beginning with a blank
canvas to which they add pictorial elements as they see
fit. If something exists in the landscape that they wish to
exclude, they simply don't paint it. Photographers, on the
other hand, are less lucky. We start with a complete
picture and must decide the subjects we wish to exclude
and find some means of doing so.

Compelling photographs share a common form. They
lack information that has no purpose and have a clear
point of interest, which is emphasized by harmonious
sub-elements. All the components in a compelling
photograph create a clarity of vision.

Translations

When safari guides often communicate via the radio or when passing in vehicles using Swahili, Zulu or Afrikaans animal names, rather than English. They are used interchangeably, so the name for an elephant might be given in Swahili while that of the leopard in Zulu. The reason given depends on which driver you ask, however, the general consensus seems to be so as not to excite travellers about a possible sighting that may not materialize. The table to the right gives the translations used for each of the animals that form the 'magnificent seven'.

English	Afrikaans	Swahili	Zulu
Lion	Leeu	Simba	Ibhubesi
Leopard	Luiperd	Chui	Ingwe
Rhinoceros	Renoster	Faru	Ubhejne
Elephant	Olifant	Ndovu	Indlovu
Buffalo	Buffel	Mbogo	Inyathi
Cheetah	N/A	Duma	Ingulule
Wild dog	N/A	Mbwa mwitu	N/A

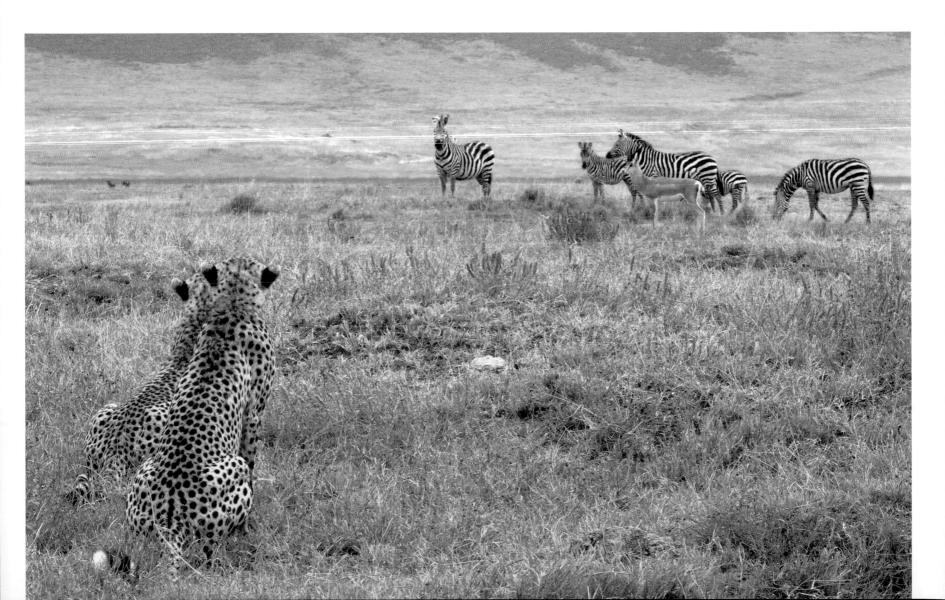

Useful contacts

African photographic safaris

Natural Photographic
3 Roman Road
Weymouth, UK
DT3 5JQ

www.naturalphotographic.com
info@naturalphotographic.com

Travel Information

On-line African travel guide
The Africa Guide

www.africaguide.com

South African National Parks
Official website

www.sanparks.org

Kenya Wildlife Service
Official website

www.kws.org

Tanzania National Parks
Official website

www.tanzaniaparks.com

Serengeti National Park
Official website

www.serengeti.org

Equipment Supplies

Photography field supplies
Wildlife Watching Supplies

www.wildlifewatchingsupplies.co.uk
sales@wildlifewatchingsupplies.co.uk

Photography equipment
Warehouse Express

www.warehouseexpress.com
sales@warehouseexpress.com

Essential reading

The Safari Companion – A Guide to Watching African Mammals
Richard D Estes
Chelsea Green Publishing Co.
ISBN: 0 9583223 3 3

The Secret Language and Remarkable Behaviour of Animals
Janine M Benyus
Black Dog & Leventhal Publishers
ISBN: 1 57912 036 9

Conservation

Canopy – Building bridges between corporations, scientists, and communities to meet the needs of business, wildlife, and society

www.thecanopy.org

Index

Photographers' Institute Press an imprint of The Guild of Master Craftsman Publications Ltd,
166 High Street, Lewes, East Sussex BN7 1XU
Tel: 01273 488005 Fax: 01273 402866
www.pipress.com